The Documentary Art of Filmmaker
Michael Rubbo

CINEMAS OFF CENTRE SERIES
Darrell Varga, series editor

ISSN 1912-3094 (Print) ISSN 1925-2927 (Online)

The Cinemas Off Centre series highlights bodies of cinematic work that, for various reasons, have been ignored, marginalized, overlooked, and/or obscured within traditional and dominant canons of film and cinema studies. The series presents cutting-edge research that provokes and inspires new explorations of past, present, and emerging cinematic trends by individuals and groups of filmmakers from around the world.

No. 1 · *Filming Politics: Communisim and the Portrayal of the Working Class at the National Film Board of Canada, 1939–46* | by Malek Khouri

No. 2 · *Rain/Drizzle/Fog: Film and Television in Atlantic Canada* | edited by Darrell Varga

No. 3 · *Revisioning Europe: The Films of John Berger and Alain Tanner* | by Jerry White

No. 4 · *The Documentary Art of Michael Rubbo* | by D. B. Jones

UNIVERSITY OF CALGARY
Press

CINEMAS OFF
CENTRE SERIES
ISSN 1912-3094 (PRINT)
ISSN 1925-2927 (ONLINE)

The Documentary Art of Filmmaker

Michael Rubbo

D. B. JONES

© 2017 D. B. Jones

University of Calgary Press
2500 University Drive NW
Calgary, Alberta
Canada T2N 1N4
press.ucalgary.ca

LIBRARY AND ARCHIVES CANADA CATALOGUING IN PUBLICATION

Jones, D. B., author

The documentary art of filmmaker Michael Rubbo / D.B. Jones.

(Cinemas off centre series, 1912-3094 ; no. 4)
Includes bibliographical references and index.
Issued in print and electronic formats.
ISBN 978-1-55238-870-9 (softcover).—ISBN 978-1-55238-871-6 (open access PDF).—ISBN 978-1-55238-872-3 (PDF).—ISBN 978-1-55238-873-0 (EPUB).—ISBN 978-1-55238-874-7 (MOBI)

1. Rubbo, Michael—Criticism and interpretation. I. Title. II. Title: Michael Rubbo. III. Series: Cinemas off centre series ; 4

PN1998.3.R83J66 2017 791.4302'33092 C2017-900119-1

 C2017-900120-5

The University of Calgary Press acknowledges the support of the Government of Alberta through the Alberta Media Fund for our publications. We acknowledge the financial support of the Government of Canada. We acknowledge the financial support of the Canada Council for the Arts for our publishing program.

 Canada Canada Council for the Arts Conseil des Arts du Canada

Printed and bound in Canada by Marquis
♻ This book is printed on Enviro 100 paper

Cover photo of Michael Rubbo courtesy of Matteo Taussig
Copyediting by Ryan Perks
Cover design, page design, and typesetting by Melina Cusano

Contents

Illustrations

CHAPTER 10

10.1 Atwood pulls a paper bag over her face. Screen grab. *Margaret Atwood: Once in August* (1984). The National Film Board of Canada.

10.2 Sketching beside the lake. Screen grab. *Margaret Atwood: Once in August* (1984). The National Film Board of Canada.

CHAPTER 11

11.1 Rubbo directing Rufus Wainwright. *Tommy Tricker and the Stamp Traveller* (1988). Still photograph by Jean Demers, courtesy of Productions la Fête.

11.2 Rubbo on break with "Vincent" (Tchéky Karyo). *Vincent and Me* (1990). Still photograph by Jean Demers, courtesy of Productions la Fête.

11.3 Rubbo's letter art. Courtesy of Michael Rubbo.

CHAPTER 12

12.1 Harry Vatiliotis at work. Production photo. *The Little Box That Sings* (2000). Courtesy of Michael Rubbo.

12.2 Dolly Walker-Wraight with portrait of Marlowe. Production photo. *Much Ado About Something* (2002). Image courtesy of Films Transit International.

12.3 Shakespeare and Marlowe, identified. Screen grab. *Much Ado About Something* (2002). Image courtesy of Films Transit International.

12.4 Shakespeare and Marlowe—which is which? Screen grab. *Much Ado About Something (*2002). Image courtesy of Films Transit International.

12.5 The remembered fight. Production photo. *All About Olive* (2005). Courtesy of Michael Rubbo and Ronin Films.

12.6 "Will you stop interfering?" Screen grab. *All About Olive* (2005). Courtesy of Michael Rubbo and Ronin Films.

12.7 Rubbo with Olive Riley. Photo courtesy of Michael Rubbo.

Chapter 13

Acknowledgments

Over the years, many people gave me valuable assistance, in one form or another, in completing this book. They include John Balaban, Peter Bartscherer, Donald Bidd, Robert E. Cargni, Paula Marantz Cohen, Karen Cooper, Roger Tellier-Craig, David Denby, Sheila Fischman, Claude Lord, Bernard Lutz, Don McWilliams, Morgan Meis, Stephanie Miller, Ragnhild Milewski, Lois Siegel, Jerry White, Donald Winkler, and, especially, Michael Rubbo. The National Film Board of Canada gave me access to its files on Rubbo's films. I'm indebted to Drexel University's Westphal College of Media Arts & Design, Drexel's old College of Humanities & Social Sciences, and the National Endowment for the Humanities for research support.

Introduction

Purpose and Method

In late 1979, Michael Rubbo's sister wrote him from Melbourne that his film *Solzhenitsyn's Children ... Are Making a Lot of Noise in Paris*

> was shown just one night at the National Film Theatre. Yes, the response was really good. People in the foyer were saying how good it was. I met a Canadian filmmaker who gave a lecture at the gallery. He was still talking about the Canadian Film Board, saying how every now and again, really good stuff was made. Started to tell me about this really good filmmaker who made *Waiting for Fidel*. He just about fell over when I said you were my brother.

At the time, Rubbo, an Australian, was in his second decade with the National Film Board of Canada. About twenty years later, while waiting outside a theater in Sydney for a festival screening, he

> met a film student from the [Australian National Film, Television, and Radio School], which I had once been invited to head. She had never heard of me, and she said that none of my films were taught there.

Rubbo's absence from the documentary film curricula of the Australian Film School is typical of the wider world of film study and criticism. His work, although often mentioned, doesn't have the presence there that it should. After all, Piers Handling, who more than anyone else has promoted a critical appreciation of Canadian film, once called Rubbo "one of the most important filmmakers in the world."[1]

My aim in this book is not to seek an explanation for the comparative lack of attention to Rubbo's work. Rather I hope to make a case for its great merit. In so doing, I aim to establish Rubbo's role in the development of the personal documentary and to identify what makes his best films distinctive, enduring, and deserving of more attention than they have received. Of these two aims, the first is primary, in the sense of contributing to the history of documentary, but the second is more important and potentially more rewarding for the reader. If Rubbo's best films deserve the claims I will make for them, then they have much to offer, both to documentary filmmakers who want to deepen their work and to general audiences seeking insight, understanding, and pleasure.

Rubbo's most salient contribution to documentary style is the effective use of a personal, often spontaneous, and frequently intervening voice. Although he may not have been the first to employ a first-person, self-reflective, on-camera narrative voice, he was among the first to do so after the triumph of observational cinema, achieved the richest results, and had the most influence. His best films make no claim to objective or universal truth about the realities he explores; they are presented as his interpretation. They are told not merely from Rubbo's point of view; they recognize, with empathy, the points of view of others. Their narrative progression is organically causal and character-driven, achieving in documentary some of the values normally sought in serious literature and dramatic film. His best films confront important issues, yet they are driven by an urge to understand, not to judge, condemn, or incite. Further, despite the narrative and exploratory character of his films, they are not primarily reportorial, analytical, or argumentative in tone but rather impressionistic, even painterly. In his best films, the combination of these qualities serve a drive to discover truth and to recognize that he has not found it.

To establish Rubbo's place in the history of documentary film, as well as the enduring value of his work, I will offer a critical appreciation of his films, organized chronologically in order to convey his development as a filmmaker. With the exception of work Rubbo has recently presented on YouTube, which I only sample, I will discuss all of the films I was able to locate (including the feature films he made during a hiatus from documentary). He directed two short films for the United Nations Habitat program, but neither I nor the UN has been able to find them. Nor will I discuss films on which he is credited but did not direct, but I will include them in the filmography. The exception is a minor children's film on which he is credited for the commentary, but which contributed to his early development as a filmmaker.

To build my case for Rubbo's films, I describe the more important ones at length. Some readers might find these descriptions tedious. I hope not. When writing about *The Searchers* or *Rear Window*, a critic can assume the reader knows the film and its director pretty well; if they don't, they can easily get hold of a copy. This is not the case with several of Rubbo's films, only some of which are readily available. Outside of Canada, it can take some work to track others down. Moreover, documentary is a content-based medium: the reader needs to know what's in a documentary in order to follow what is being said about it. This is especially true for films as densely packed with varied imagery as Rubbo's films usually are. And the content in Rubbo's film is interesting in itself. Visuals, although expected in film books, often aren't very helpful. Production stills are usually not from the film itself. Still frames, or "screen grabs," are taken from the film but reveal little about how a film develops over time. The only way I know to convey an approximation of this on the page is with words.

This book includes some production photos, screen grabs, and a few other illustrations. Although screen grabs tend to be less sharp, for technical reasons, than production photos, they can occasionally support, or at least illustrate, my commentary on the films.

Narration is a key component of a Rubbo film. Because he often appears in his films as a participating subject as well, I distinguish narration from dialogue so that the reader can tell one from the other. I sometimes include hesitations and repetitions in order to approximate what the reader would hear if watching the film.

This study makes no pretense to biography or, with a brief and minor exception, to probing Rubbo's psyche. It's about the films. Often I recount his experience with getting his films produced and distributed. I include biographical information when I am aware of it and if I think it is helpful to the reader, and I also draw on insights into his films from Rubbo himself. I've known him since 1970, when I was at the National Film Board on a freelance assignment and saw his film on Vietnam at its first in-house screening. In 1971, on my way to a job in Australia, I did very minor and not very helpful advance work for his Indonesia film. In 1973, I interviewed him and reviewed his two Asian films for an Australian film magazine, *Lumiere*. Back in Montreal in 1974, I was present at a rough-cut screening of *Waiting for Fidel*, where the film's most notorious scene was debated. I included short passages on his work in my two books on the National Film Board and wrote entries on two of his films for *The International Encyclopedia of the Documentary Film*.[2] He has been a guest speaker for my students and colleagues at La Trobe University (where I tried to recruit him to teach), at Stanford, and twice at Drexel University. He has been a guest in my house on a few occasions.

I relate these facts about my relationship with Rubbo in the interests of full disclosure. However, I hope the reader does not immediately suspect that my admiration for his work is significantly colored by my long, if sporadic, association with him. Rubbo and I may be friends, but we are not close, and we are not ideologically aligned. Our relationship has motivated me to keep up with his films, and this in turn has helped me notice patterns and recurring tropes, attitudes, and quirks that we associate with directors we call "auteurs." It has enabled me to observe his development over time. In any case, my observations about his work are based ultimately on the films themselves, and they can be tested by the reader against his or her own viewing of them.

For readability, I've limited footnotes to instances where I think them essential. When directly or indirectly quoting Rubbo, or mentioning a biographical fact, the source, unless otherwise noted, is from personal correspondence or conversation with him over the years. For NFB correspondence or other documents, I give enough information to enable a determined researcher to track them down if he or she can enlist the help of the Film Board's outreach services and if the

documents still exist. I refer repeatedly to Tom Daly, Rubbo's mentor and his favored producer at the NFB, and I occasionally provide some background on the organization itself. Readers who would like to know more about Tom Daly can consult my book about him. They can read more generally about the NFB in either my book about it, which focuses on documentary, or Gary Evans's more recent and comprehensive history.[3]

Learning the Craft

The True Source of Knowledge These Days; Early Films at the NFB

Twentieth-century Australians were consummate travelers. Perhaps their country's remote location, far from the world's centers of activity and culture, provoked an urge to explore other lands. Michael Rubbo's love of travel began in his childhood. He collected postage stamps, enchanted by their depictions of foreign landscapes and cultures. While an undergraduate studying anthropology at the University of Melbourne, he hiked in New Guinea's jungles with an Australian patrol officer, visited Japan twice, and explored Fiji. He went twice to Indonesia, a country he would return to years later to make a film. And he led a student group on a six-week tour of India.

On several of these trips, he recorded his adventures and impressions to use in telling others about them when he got back home. He shot some 8mm footage in Fiji but disliked the results. On other trips, he took photographs. And he painted. Back in Australia, he would exhibit his pictures, emphasizing, he recalls, not the art but the storytelling. His photos and paintings supported his stories.

When free from his responsibilities to the student group in India, he went on his own to Calcutta, where he sought out the great filmmaker Satyajit Ray, best known in the West for his Apu Trilogy. Rubbo had seen several of Ray's films and was moved by Ray's characters and

his affection for them. When he arrived in Calcutta, Ray was out of town. While waiting for him to return, Rubbo made tape recordings of conversations with one of Ray's stars, Sharmila Tagore. "She was just a schoolgirl when Ray found her. I think he saw her in a classroom." She had led an affluent, somewhat sheltered life. India's most famous poet, Rabindranath Tagore, was the brother of one of her great-great grandmothers. Rubbo remembers her being amazed

> at the way Ray had picked her out of that sheltered environ-
> ment, how he was certain, with very little testing, that she
> would be a wonderful actress. She said with a sort of mus-
> ing wonderment that he knew her face so well that if she
> turned this way, there would be a certain look which would
> mean a certain thing, or the other way, and she would be
> communicating something else, emotions she didn't even
> understand herself. He was something of a magician for
> her and she was filled with reverence for him. That and the
> fact that she had the most beautiful lilting voice charmed
> me so much and made that tape with her one of my most
> precious possessions.

Sharmila Tagore's first screen appearance was in *The World of Apu* (1959), the third in the Apu Trilogy.

After he returned to Calcutta, Ray agreed to sit for an interview with Rubbo.

> I remember climbing the outside stairs of a drab white con-
> crete apartment building in Calcutta, going up level after
> level until I came to an apartment with a heavy concrete
> balcony. We sat outside on the balcony with the crows mak-
> ing a deafening noise often obscuring him on the tape. He
> had a deep and melodious voice, and he told me how hard
> it was to keep his pure vision, of the pressure he was un-
> der to become more like the Bollywood filmmakers of the
> Mumbai coast, films with singing and dancing, and how
> his more observational anthropological films struggled for

appreciation in his own country although they were considered amazing elsewhere.

It may have been the experience with Ray that gave Rubbo the idea of becoming a filmmaker. He had been toying with pursuing graduate studies in anthropology, but was turned off by the discipline's increasing emphasis on statistics and other forms of measurement. Film intrigued him for its storytelling potential. He applied to and was accepted by Stanford University's graduate film program, which in those days—the mid-1960s—did not require previous filmmaking experience but looked for well-educated college graduates with inquiring minds. Attending Stanford would also feed his love of travel. He had never been to the Western Hemisphere. He received Fulbright and Ford Foundation grants in support of his studies.

Stanford's film program was oriented toward documentary, used 16mm for teaching and filmmaking, and typically took two years to complete. After a year of coursework, students would make a "thesis" film. Each year's incoming class was small, typically between ten and fifteen students.

The head of the program at the time, Henry Breitrose, was an admirer of the NFB, and he often screened NFB films for his students, including breakthrough titles such as *Corral* (1954), *Lonely Boy* (1962*)*, *City of Gold* (1957), *Day After Day* (1962), *The Back-breaking Leaf* (1959), *Bethune* (1964), and *Memorandum* (1965*)*. The Film Board was established in May 1939, about four months before Canada declared war on Germany. It was designed and for its first five years headed by John Grierson. During the war, it became a source of Allied propaganda, producing newsreels for theatrical release. It grew rapidly during the war and emerged from it a full-scale production house. But Grierson, who advocated propaganda during the war, had been clever enough to ensure that the Film Board's mandate—"to interpret Canada to Canadians"—included other kinds of films as well. Hence, the end of the war did not imply the end of the Film Board. And he hired talented and dedicated people. Thus the Film Board had enough public support to weather attempts to cut it down to size or even eliminate it. And by the late 1950s, despite its status as a government organization, it had emerged as the world's leading producer of

1.1 Rubbo with Stanford classmate Bonnie Sherr (later Klein) circa 1965. Courtesy of Michael Rubbo.

serious short films—especially experimental animation and innovative documentary, both of which it had pioneered. It had a staff of roughly a thousand employees (depending on how they were counted), including writers, directors, cameramen, soundmen, editors, musicians, artists, animators, and all sorts of technical people. It was a smaller version of a comprehensive production studio in Hollywood's heyday. But because it was a government organization, regular employees, essentially civil servants, came to enjoy roughly the same job security as tenured college professors. Its films won scores of major international awards. It was a mecca for young people who wanted to work in documentary or animation. Among the students who were impressed by the Film Board were Bonnie Sherr and Rubbo himself. Both would eventually work there, Rubbo first and then the recently married Sherr, who henceforth went by the name Klein. (Klein started at the Film Board in 1968, directing several films for the Challenge for Change

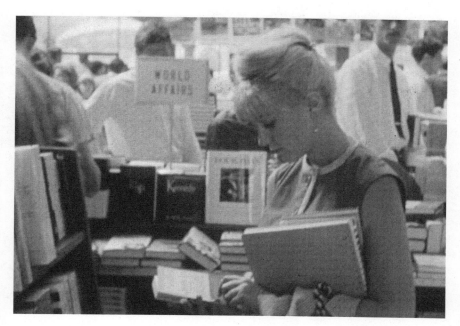

1.2 The Stanford Book Store. Screen grab. *The True Source of Knowledge These Days* (1965). Courtesy of Stanford University.

program on the community-organizing tactics of Saul Alinsky. Her best-known film is *Not a Love Story: A Film About Pornography* [1981], an investigation of the business of pornography, including strip joints, sex supermarkets, and peep shows.)

Rubbo first had to complete his thesis film. He decided to make a documentary reflecting on his educational experience at Stanford. The purpose of education was to learn, to gain knowledge, but Rubbo questioned higher education, both at Stanford and elsewhere. On a shoestring budget, he made a half-hour film contrasting Stanford with its near neighbor, the University of California at Berkeley, and with the real world outside of academia. His film was technically rough, with very little sync sound, but it foreshadowed aspects of his future filmmaking and remains interesting today. Called *The True Source of Knowledge These Days*, it asked where truth should be sought. Was a Stanford education the source of knowledge? If so, was truth found in

1.3 The Stanford Computer Center circa 1965. Screen grab. *The True Source of Knowledge These Days* (1965). Courtesy of Stanford University.

books, in contemplation, or in the new computer center? (The film's attention to computer science was prescient; few saw that Stanford was giving birth to what would become Silicon Valley a decade later.) Was the University of California at Berkeley, where Mario Savio had just launched the "free speech" movement, a more authentic school? Or was truth to be found through reflective participation outside the university? Rubbo's film, although in no way critical of Stanford or the University of California, implicitly favors the last route.

Made just before the Vietnam War had flared up into a major conflict, the film suggests that for truth-seeking students, participation in the great moral causes of the day—the most salient of which, for American students, was the voting drive in the South—provides a path to knowledge that avoids both the sterility of safe, abstract learning and the materialism of career preparation. Truth was to be sought in engaged concern for others, particularly the weak or disadvantaged. Although the film has very little sync sound, it includes unscripted

1.4 A Stanford football player recounts his Mississippi summer. Screen grab. *The True Source of Knowledge These Days* (1965). Courtesy of Stanford University.

student comments in voice-over; Rubbo narrates in places. The only sustained sequence, which occurs in the last third of the film, features a Stanford football player recounting how he was beaten up and peed on by a mob of white supremacists when he was volunteering in Mississippi followed by a female Stanford student, who had taught as a volunteer in a "freedom school" in Mississippi, recalling how moved she was by the hunger her young charges had for civil liberty.

Viewed in retrospect, *The True Source of Knowledge These Days* exhibits several traits that foreshadow Rubbo's mature work. The film is impressionistic. Images and sounds are laced together at an energetic pace to create a mood or disposition rather than an ordered discourse. Rubbo exhibits empathy for his subjects; he may favor the politically active, but he respects, in this case, the humanity of the career-minded or even the mere good-timers. There is an element of boldness, of sensing what is going to be important: he engaged a young San Francisco musician named Jerry Garcia to produce some music for the film.

There is a moving climax, where the pace slows, underscoring the film's more serious content. The two students' voice-overs foreshadow Rubbo's predilection for using intermediaries. There is an underlying drive towards discovering truth. Every one of Rubbo's later important films would possess at least one of these qualities.

As he was completing his thesis film, Rubbo had his eye on securing an internship at the NFB. He loved their work, especially *Lonely Boy*, a portrait of the young Paul Anka. In the late 1950s, the Film Board had created a series called "Candid Eye," which consisted mostly of unscripted documentaries made possible by the invention of lightweight 16mm sound-recording equipment. *Lonely Boy* was made after the Candid Eye series had ended, but it was shot in much the same unscripted style. It had a deeper structure than the Candid Eye films had, and it was shot with supreme self-confidence. It is coherent and it feels complete; to borrow a principle of dramatic art from the French critic Raymond Bellour, its end responds to its beginning[1]—which was not often the case in the early days of unscripted documentary (or even now). At the same time, it notices, includes, and integrates seemingly trivial moments that are touching, revealing, or amusing. One thing that influenced Rubbo were instances in which the filmmakers broke down the pretense and illusion of passively observed reality, which was then the prevailing documentary aesthetic. At one point in the film, for example, one of the codirectors is heard off camera asking a nightclub owner to repeat a kiss he had just planted on Anka's cheek. Both the owner and Anka break out laughing, asking why the filmmakers wanted that. The camera moved, they're told. They repeat the kiss. Rubbo also loved a shot in which a photographer can't get his flash to work, then, befuddled, looks up at the overhead light as if that were part of the problem. For Rubbo, this reflected the Film Board's willingness to celebrate "life's little, awkward moments." Both the self-reflexivity and the attraction to the unspectacular but revealing would influence Rubbo's development as a director.

Rubbo sent his film to Montreal. Brietrose wrote him a recommendation. Rubbo himself wrote to Tom Daly, the head of Unit B, which had produced the NFB films Rubbo liked most. When Rubbo finished final requirements for his degree in 1965, he had not yet heard back from the Film Board, so he hitched rides to Montreal. Arriving

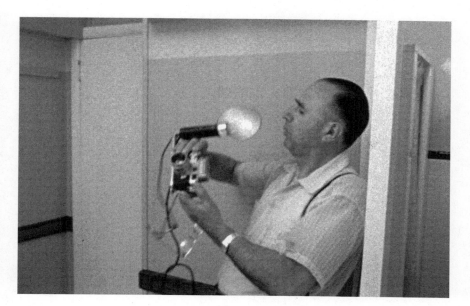

1.5　"Could you do the kiss again?" Screen grab. *Lonely Boy* (1961). The National Film Board of Canada.

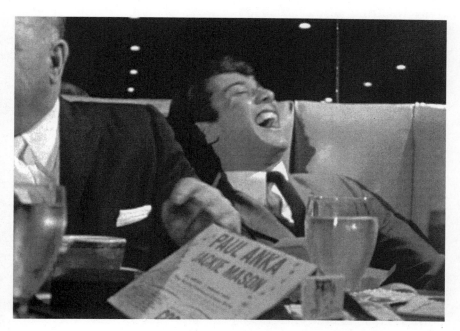

1.6　Befuddled photographer. Screen grab. *Lonely Boy* (1961). The National Film Board of Canada.

unannounced, he asked to see Tom Daly, and was ushered into a screening room where Daly just happened to be watching Rubbo's *The True Source of Knowledge*. With Daly were two of the Film Board's most talented filmmakers, Roman Kroitor and Wolf Koenig, who had codirected *Lonely Boy*. With Daly as producer, Kroitor, Koenig, and Colin Low had directed most of the groundbreaking films that had so impressed Rubbo. The group as a whole was known for its pursuit of perfection and a sense of aesthetic integrity. They often called it "wholeness," which for them was an essential aspect of truth. Daly was particularly driven by a quest for truth that accounted for all things, as opposed to a merely factual, ideological, or partisan truth.

They were impressed by Rubbo's film. Instead of an internship, they offered him a paid job as a production assistant. For a young filmmaker of Rubbo's bent, it was a dream job: steady pay working and learning in a self-sufficient production house that included its own lab, a talented staff representing all the major roles in documentary filmmaking, and a tradition of excellence and innovation in documentary film.

And creative freedom—eventually. Newly hired filmmakers typically worked as assistants, or were assigned films of minor importance—films for schools, for other government agencies, or part of some predefined program of films offering little room for individual expression. Rubbo's first NFB documentary was *The Long Haul Men* (1966), a short film following two American truckers as they haul a load of shrimp destined for Calgary, Alberta, from the Mexican town of Guymas. The film is a paean to trade and especially the men on whom trade depends. We follow the truckers from the US-Mexico border to the US-Canada border. (The film was made long before the North American Free Trade Act of 1994 permitted drivers to cross borders.) It is an unpretentious, pleasing film, with occasional moments of understated humor characteristic of the Film Board's work in those days. Rubbo enjoyed the experience of working with two of the Film Board's best craftsman: cameraman Tony Ianzuelo and sound recordist Roger Hart. But the film bears none of the traits that would become integral to Rubbo's established style. Before the film was completed, the producer (not Daly) stepped in and imposed a narrator on Rubbo. Fortunately it was the gifted Stanley Jackson, and the film is enjoyable if not distinctive.

The next seven films of Rubbo's (informal) apprenticeship were either for or about children—or both. He was assigned to three short films to be made by cutting live-action footage of animals into narrated anthropomorphic stories. Rubbo's only role on the first of these, *The Bear and the Mouse* (1966), was narrator. The film is about a mouse that rouses his family to free a trapped bear by gnawing through the binding on its primitive wooden cage. Rubbo assumes different voices for different animals, sounding cute and innocent for the mouse, raspy for a crow, guttural for a big black bear, and so forth. And he is the omniscient narrator as well. Introducing the mouse family, he settles on the film's protagonist: "This one is cleaning his whiskers. He always tidies himself up before going off for a walk. His name is Mouse." Later, Rubbo cheers the mouse family on as they work to free the bear: "Quick, chew little mice." They free the bear just before the trappers arrive.

Rubbo directed and narrated *That Mouse* (1967), about a vain white mouse who arrogantly rides through the forest on the back of a bear. The mouse gets his comeuppance when various animals get together and trick him into climbing onto the back of a large black dog, which he mistakes for the bear. The dog shakes him off, hurling him into a nearby pond. Chastened, the white mouse grows up and has a family. Again, Rubbo assumes different voices for different animals. The third animal film, *Adventures* (1968), is about a baby raccoon trapped by a farmer who wants him as a pet for his son. The raccoon escapes and has various adventures before returning home. Rubbo directed and wrote the film, but did not do the voices.

All three animal films are surprisingly entertaining. They exhibit a gift for storytelling. They also foreshadow Rubbo's talent for writing and delivering commentary that engages with both picture and audience. And they demonstrate a willingness on Rubbo's part to throw himself into a project enthusiastically, without fear of embarrassment. A half-century later, the films are still popular with young audiences.

Rubbo then made four films inspired by meeting a woman who was teaching drama to children in an intriguing way. The first of these, *Mrs. Ryan's Drama Class* (1969), is a straightforward, black-and-white chronicle of an after-school, once-a-week volunteer drama class taught by one Mrs. Ryan. The narrator is Stanley Jackson again. Mrs. Ryan

uses an improvisational approach to drama. The students, who range from ten to twelve years of age, think up their own ideas and create their own characters. It takes numerous sessions before Mrs. Ryan is able to get them sufficiently interested in the classes. Between sessions, Rubbo briefly interviews Mrs. Ryan about her progress with the students. The students do role-playing exercises, such as pretending to be a growing plant, or freezing on command and then making up stories about their "statues." Their first complete story, "Museum," has them pretending to be exhibits that come alive as monsters and chase down a patron. Eventually the students put on a performance for the whole school called "Pandora." The show was inspired by the myth, but the students invent the details.

Although dated a year earlier, *Sir! Sir!* (1968) grew out of the production of *Mrs. Ryan's Drama Class*. It is a twenty-minute film recording an improvisation in which two students who had appeared in *Mrs. Ryan's Drama Class* and a dozen of their teachers trade places for a class session. The young "teachers" are dressed in suits, the adult "students" more casually. In the film's only narrated passage, Rubbo explains that there were no rehearsals, just a statement of the premise. Like *Mrs. Ryan's Drama Class*, *Sir! Sir!* is filmed in black and white using direct-cinema style. We see the microphone often, members of the crew occasionally, Rubbo himself once or twice. It's an engaging film. Anyone who was educated in a North American public school will recognize the behavior of both parties. The young teachers try very hard to act like the teachers they have known, attempting to maintain order and get through a lesson plan. The adult students seem to be having a great time acting out the disruptive behaviors and minor mischief-making they have had to contend with over the years. Of the two groups, the young teachers have the worse time in their roles, perhaps because they are taking the exercise more seriously than the adults. After "class," and a brief scene in which a student is detained after school for bad behavior, Rubbo debriefs the young boy who played the main teacher. Rubbo asks him if, after this experience, he would like to become a teacher. With a class like that, the exhausted, much-relieved boy says, "Not for a million dollars." He doesn't seem to be just role playing when he says that.

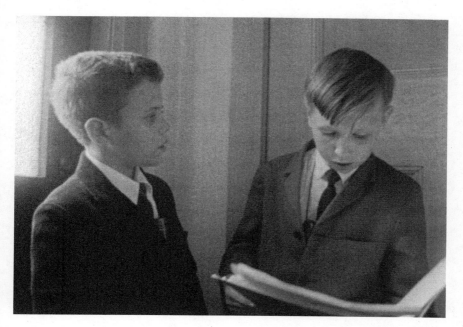

1.7 The two "teachers" prepare their lesson. Screen grab. *Sir! Sir!* (1968). The National Film Board of Canada.

With the same group of children, Rubbo directed *Here's to Harry's Grandfather* (1970). The story was written by the children and largely improvised, but it is substantially different in style from either of the first two films. It is in color and, at fifty-eight minutes in length, was intended for television. And while the story is largely improvised, much of it was improvised prior to filming; the film is replete with shots that could have been taken only if the action was known beforehand. There is no self-reference at all. The few words of narration are spoken by one of the actors. The story involves a group of campers, boys and girls, who are bored with camp and decide to find the house where the grandfather of Harry (who played the main teacher in *Sir! Sir!*) once lived. The group encounters another band of campers and must outwit them to find the house. Once there, they explore a creaky attic, peruse old magazines, gaze at photos, dress up in old clothes, and play house. The kids are engaging. An intriguing feature is that the kids seem naturally to

assume traditional gender roles, with the boys doing the adventurous things and the girls cooking meals or nursing a sick camper.

A year later, Rubbo cut a shorter version of *Here's to Harry's Grand-father*, called *Summer's Nearly Over* (1971). The story is essentially the same, with the campers trying to find Harry's grandfather's house and encountering a hostile group of other campers along the way. This shorter version works better than the longer film. The main stylistic difference between the two versions is that Rubbo narrates this one.

Although these seven films with or for children have their charms, they are not particularly memorable. They are interesting for their place in Rubbo's development as a storytelling documentary filmmaker. The animal films' effectiveness results largely from Rubbo's engaged narration. Documentary narration is rarely given the attention that its potential contribution to a film warrants. Already in the animal films, Rubbo is exhibiting a flair for spoken commentary that responds to and contextualizes the image—and engages the audience. The films with Mrs. Ryan's students, although quite distinct from one another, presage Rubbo's interest in not merely recording the action but instigating or meddling with it in the midst of filming—all in the interests of telling a story. And finally, Rubbo's experience in making films for or with children led to a breakthrough opportunity.

Making It Personal

Sad Song of Yellow Skin

Although Unit B's films had inspired Rubbo's interest in the NFB, and its key filmmakers were responsible for his getting hired, he never had a chance to work with the unit. Around the time Rubbo joined, the Film Board was adapting to a radical restructuring—or, as some regarded it, de-structuring. During the two decades prior to 1966, filmmakers were assigned to units each headed by an executive producer, some of whom administered their units autocratically. Directors found this structure constraining. Units were assigned to specific kinds of films; one might be limited to making science films, another to children's films. The exception was Tom Daly's Unit B. Daly had learned to work with his filmmakers as a member of the team, sometimes even editing a film himself. It was his unit that had produced most of the Film Board's groundbreaking films of the late 1950s and early 1960s. They could generate their own subjects, and their films won most of the prizes. Filmmakers in other units envied the freedom Unit B filmmakers had and the success they enjoyed. They wanted the same for themselves, and they agitated strongly enough that eventually they got it. The unit system was dissolved, and directors became members of a large, unstructured "pool," as it was called. Directors would henceforth seek out producers who might support them. Producers, in turn, would court some filmmakers and projects, and avoid others. Once teamed up, the producing-directing team would present a proposal to a

program committee, which would recommend that funding be provided or denied. Although higher-ups in the organization had ultimate decision-making authority, the program committee's recommendations were usually accepted, if money was available. (This process applied only to films funded with "free" money, which was a portion of the Film Board's budget that it was allowed to spend on films it originated itself. Since its establishment in 1940, a substantial portion of the Film Board's work was sponsored by other government agencies, which were expected to contract with the Film Board when they wanted a film for a specific purpose.)

Some directors floundered in this new context. In the absence of structure, there was no one responsible for finding work for them. (For this and like reasons, the pool system lasted only about six years, to be replaced by the "studio system," somewhat like the old unit system, if not as rigorous.) Filmmakers who were both assertive and talented did well. An example of the latter is Donald Brittain, one of the prime movers in the campaign to dismantle the unit system. His *Memorandum* (1965) was one of the earliest, and is still one of the strongest, films on the Holocaust. Brittain was an excellent writer of narration. His *Memorandum* narration (spoken by Alexander Scourby) was extensive if not quite wall-to-wall. Yet it was compelling. At the same time, most of the footage was completely unscripted. Taken aesthetically, *Memorandum* could be seen as a cross between the Film Board's wartime style of documentary, which involved heavily narrated visuals assembled from combat and archival footage, and the new, unscripted shooting style introduced at the Film Board by the makers of the Candid Eye series. And it incorporated the newly liberated perquisites of Unit B films. It was shot without a script. It took eighteen months of editing to come up with an effective structure.

As a newcomer who arrived just after the demise of the unit system, Rubbo accepted whatever assignments were available. His film on Mrs. Ryan was the first of his own choosing. He had taken the idea to Tom Daly, who, as Rubbo remembers the exchange, agreed to produce the film as a challenge to Rubbo himself, to find out if he had it in him to become a serious documentary director. Neither he nor Daly was excited by the result, but the film was serviceable, and Daly was willing to work with him again.

Mrs. Ryan's Drama Class, along with Rubbo's other early NFB films, lacked a passionate provenance or social significance. Who would care much about what went on in Mrs. Ryan's drama class? Even for Rubbo, it was not an issue of burning importance. But now there was a potential subject Rubbo could care deeply about: the Vietnam War, which in 1969 had been a full-scale conflict for several years. With his track record of films about children, he believed that if he could find an angle that fit the Film Board's children's program and also, in keeping with the Board's government mandate, had Canadian content, he might have a chance to make a documentary on the war. He learned of a Canadian-sponsored foster-parent program for orphans in Saigon. The program could make a good film subject, he thought, and so he took the idea to Daly. Daly agreed to produce the film if they could get it programmed, which they did.

He filmed a few sequences with a Montreal foster family connected to the program, and then he flew to Saigon with a small crew. But not long after arriving, he discovered a subject that interested him much more: a group of three young American journalists with the anti-war Dispatch News Service (a Washington-based alternative news group that in 1969, shortly after Rubbo was done filming and had left Vietnam, broke Seymour Hersh's story of the My Lai massacre, distributing it to thirty newspapers). The journalists— Dick Hughes, who ran a home for orphaned street kids; Steve Erhart, who was researching articles about a community living in closely packed hovels in a disused cemetery; and John Steinbeck IV, who was fascinated by a Buddhist colony on an "Island of Peace" in the Mekong River—had been living among the Vietnamese and working to ameliorate the effects of the war. Rubbo was attracted by their initiative and the casual courage it took for the three Americans, unanimously against the war, to place themselves in a doubly dangerous situation.

Rubbo wanted to build his film around these three young men, but because they were not Canadians, the film would lack Canadian content. He wired Tom Daly. Perhaps taking into consideration that the crew was already in Saigon, and valuing Rubbo's enthusiasm, Daly gave Rubbo's new proposal his blessing. Rubbo filmed for three weeks.

A limited budget for location filming was one of the few disadvantages of making documentaries at the Film Board, even in its glory

days. But the short shooting time was counterbalanced by the ability to extend the editing, for which there were no location costs. Consequently, filmmakers like Rubbo (and Brittain) tended to shoot intensively on location in order to have as much material as possible for editing. (Starting with *Sad Song of Yellow Skin*, Rubbo developed a reputation, doubtless exaggerated, of working his crews so hard that replacements occasionally had to be sent in.) While filmmakers might be pressured to complete the editing of a project by a target date, they could resist such pressure in order to get a film to work as well as it could. Some of the Film Board's best documentaries, such as some of Unit B's films and Brittain's *Memorandum*, had emerged only after a long and arduous editing process.

Sad Song of Yellow Skin benefitted from this unofficial dispensation. Working with an editor, Rubbo's first rough-cut was disappointing. Both he and Daly thought the film was dreary, dead, pedestrian, and lacking organic coherence. It was an essay.

Daly suggested to Rubbo that he start over, edit it himself, and try structuring the film in a way that mimicked his own Vietnam experience, which was one of initial bewilderment and gradual discovery. Thus the finished film opens with a series of brief, seemingly random shots, most of them full of motion: the sizzling contents of a wok; a man biting the head off a chicken; an old man pedaling a cyclo; a lovely young Vietnamese woman in a white *ao dai* riding a bike; a corpse laid out in a crude pine coffin. Cut in with such shots are occasional snippets of American television piped into Vietnam: President Nixon speaking on the war; a report on the weather. Some of the shots look like the cinematic equivalents of brushstrokes: by themselves, they are not completely clear. Some are so tight that they block off the context, or the movement is so fast as to blur the image. Often the camera is panning, following a cyclo driver, say, or a person riding a motorcycle, with movement in the foreground and background as well. In one wide, deep shot of a busy intersection teeming with people and vehicles—buses, bikes, motorcycles, cyclos—there are at least six planes of action moving either right to left or left to right. Although most of the images foreshadow scenes that will be developed later, a first-time viewer doesn't know that yet. It's confusing. The one clue orienting us is Rubbo's narration, the first words of which are "The war ... will not

… end … until Saigon is badly hurt. A Vietnamese told me this on my first day there."

The rest of the film shows us a Saigon that has been badly hurt. It shows it through intermediaries who know more about what's going on than Rubbo. Soon introduced, the three Americans become the organizing principle for major sequences in the film. The scenes with Hughes are with or about the street kids he is housing and mentoring. Erhart is seen mostly in the cemetery settlement, so teeming with people and crowded with shanties that, Rubbo says, a stranger entering it without a guide is immediately lost. Steinbeck's Island of Peace appears largely man-made. The community is headed by an old man who is called "the coconut monk," because he once spent seven years in a coconut tree praying for peace under a vow of silence. He has constructed, on pylons rooted in the river mud, a long concrete map wide enough to walk on representing a unified Vietnam.

These three milieus become the bases for three interlacing stories, each showing a particular aspect of the city, and each deeply moving on its own. Rubbo's narration interacts with the words of the three Americans, who are sometimes shown on camera speaking to Rubbo, other times heard in voice-over. The three stories become something like documentaries within a documentary, although they are not separate entities. The cemetery story's ending, which is the film's penultimate scene, is a wrenching sequence on the funeral of a dead opium addict, an ex-dancer, who leaves behind two young orphaned girls. The film ends on the Island of Peace with a hauntingly beautiful, calming ceremony at sunset.

Through these intermediaries the film develops in the audience a feeling of intimacy with Saigon while at the same time eroding any certainty that we might have had going in. The more we learn, the less we know. This progression reflects Rubbo's personal experience in Saigon. In a 7 February 1969 letter to the NFB, he wrote:

> The people have hidden the horror and their losses deep inside and this may in fact be the hard thing to find. As Tran [Tran Hu Trong, Rubbo's guide] says, "We smile when you might cry." Perhaps (the thought just occurs to

me) the Americans really don't know what they've done to
these people.

His doubts mount in a letter to the NFB two days later, when he writes:

> [You] would expect the Americans to be bitterly despised
> by the Vietnamese. They probably are, and yet to my sur-
> prise there seems to be a peculiar love-hate relationship
> between them. If they despise the Americans, they also
> despise themselves for needing Americans.

On February 10, he confesses that

> I was rather shocked to find that many people seem fer-
> vently and rabidly anti-communist. I mean they espouse
> loyalty to the government and talk of v.c. "atrocities" with
> more warmth than is necessary to guarantee loyalty.

Rubbo concluded his February 9 letter with a confession: "Let's just
say that reality is a shock when it comes up against the simplistic ideas
that have served one till now."

Even the three men Rubbo relies on to guide and interpret for
him confess to not fully understanding the Vietnamese they mean to
help. After a scene in which Rubbo interviews Wei—a diminutive but
dashing young charmer whom Rubbo describes as the "chief hust-
ler of Dick's house ... [who] pimps, steals ... sells more refrigerators
than anyone else ... and [over images of Wei playing some sort of card
game] may win or lose a hundred dollars a day"—Hughes tells Rubbo
that what Wei gave him in the interview was something he knows is
marketable, in a "very sellable pigeon English." We witness an argu-
ment between Hughes and Wei. One of Hughes's few house rules,
Rubbo says, is that there can be no money dealings between people
in the house. Hughes is angry at Wei, Rubbo says, because "Wei has
taken money from us for the interview in the street." Later in the film,
Hughes confesses that only recently he realized that even after living
with the kids for several months, he was "being completely put on,"
that they harbored a deep resentment of him "as an American, so deep

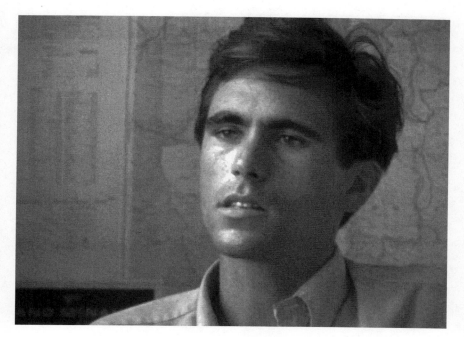

2.1 Dick Hughes. Screen grab. *Sad Song of Yellow Skin* (1970). The National Film Board of Canada.

that they didn't even realize how deep." They knew there "were just some things I'd never understand."

Steve Erhart's limited ability to connect with the residents of the cemetery settlement frustrates him. He'd like to get closer to them, he says, but it is hard. No one will talk about the war; it is too dangerous. In his commentary, Rubbo remarks that "to these people, we were just Americans. And in their context, Americans either kill or give. Every encounter is reduced to these two alternatives." Trying to entertain some cemetery children and give away sticks of ice cream, Erhart realizes he is making a fool of himself. When there are few takers, he turns to the cameraman (and thus to us, too) and offers him a stick of ice cream. Afterwards, Erhart asks Rubbo's guide, Trong, if it was wrong for him to try to give away the ice cream. Trong says there are two ways of giving, one good, one bad. Erhart's was the latter (although we're not told why).

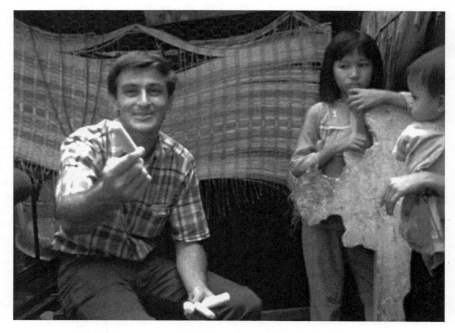

2.2 "Would you like an ice cream?" Screen grab. *Sad Song of Yellow Skin* (1970). The National Film Board of Canada.

And Steinbeck's observations about the inhabitants of the Island of Peace seem cautious, as if he wants us to know he is not intimate with them and is thus largely speculating. Rubbo says that Steinbeck "calls himself a friend, not a follower, of the monk. He … says it's the only place he can find truly happy Vietnamese."

Rubbo would occasionally use intermediaries in his later films. In an undated, internal, informal memorandum he wrote in October or November 1979 for a potential Film Board publication (which apparently was never published), he explained why the strategy appealed to him:

> I like to use somebody who is deeper into the situation that interests me, than either myself or the audience. This intermediary has the advantage of predigesting the experience. I suppose it's a bit like (to use an awful analogy) the

mother bird who chews up the food before thrusting it into the beaks of her young. I don't know why I think that audiences should need to be spoon fed in this way, or perhaps it's me that needs the spoon feeding. Anyway, I like the guide who takes a little of the strangeness out of the situation. Thus in Sad Song I used the three young American journalists who were already half inserted into the twilight world of Saigon to show us around. They had the access that I knew I could never get in the time available to me. Time is a factor.

And these three men certainly knew the twilight world of Saigon.

Perhaps two of them knew it too well.

From John Balaban's gripping memoir, *Remembering Heaven's Face*, about his own time in Saigon doing humanitarian work, we learn that Steve Erhart, a friend of Balaban's, became involved in Saigon's drug culture, never returned permanently to the United States, and died in India at age thirty-five.[1] Steinbeck spent considerable time on the Island of Peace, but back home he suffered from drug and alcohol addiction, dying at age forty-five.[2] Only Dick Hughes emerged with his idealism and sense of purpose intact. He continued his work with Vietnamese orphans after the surrender, establishing several additional homes for boys. Later, while pursuing an acting career in the United States, he remained involved in helping Vietnamese war orphans.

Another contributor to the seemingly contradictory sensation of both increased intimacy and distance is Rubbo's personalization of the narration. He speaks it himself, often haltingly, as if searching for words as he narrates; he does not seem to be reading from a written commentary. For example, because the Americans in Saigon think of the Vietnamese, friendly or unfriendly, as "gooks," Rubbo says, "it is hard for a young American who is neither a soldier … or an AID man … who … wants to … know the Vietnamese people."

Rubbo tells us that he lived in Dick's house for several weeks and that on his very first morning there, "two of the kids stole my still camera." They quickly sold it, and then came back in the house, "singing songs— 'I'm a hundred percent yours tonight, Baby.'" Recording these

2.3 "I'm a hundred percent yours tonight, baby." Screen grab. *Sad Song of Yellow Skin* (1970). The National Film Board of Canada.

words several months after the incident, Rubbo is still angry about it—you can hear it in his voice—but at the same time, he implicitly criticizes his self-regard by showing, with no special emphasis, the horrid scars that one of the singers sports on his chest, neck, shoulder, and face. If we choose sides, it is with the kids—we hope they got a good price for the camera—and Rubbo seems to want us to think that way.

The personal voice emerged during the editing process. Rubbo did not want an anonymous, voice-of-God narration. In Vietnam, he had toyed with the idea of asking Steve Erhart to narrate the film. He "was very eloquent, very poetic, a good writer who could [in speech] string sentences together in a very evocative way." On one of his last days in Vietnam, Rubbo

> rented a hotel room in a squalid, run-down place near the river, because it was as far away from the noise of the city

traffic as you could get. It was a dark, suffocating room, everything closed off to keep the traffic noise out. There was no crew there, just Steve and I and a heavy tape recorder, the Nagra. Steve and I smoked some pot and recorded his musings about the opium lady. I'd not smoked much pot in my life, probably he'd smoked a lot, but I think it was a great help in getting us into the mood for him to speak in that dreamy sort of way about the woman having once been a dancer and the mistress of a prince.

Viewers of the film will know what Rubbo meant about Erhart's way of speaking when they listen to Erhart's account of the opium lady. But Erhart had no direct involvement in the portions of the film that feature Hughes and Steinbeck, so Rubbo abandoned the idea of Erhart narrating the film. After he took over the editing, and was organizing the material so as to reflect his own experience in discovering Saigon, it made structural sense for him to speak the narration himself. But it was a controversial decision. In a tribute to Tom Daly that he wrote in 2011, Rubbo credited his mentor for it:

> Tom went out on a longer limb for that film than I even knew. He was not one to pass on the pressures he was under. *Sad Song of Yellow Skin* was one of the first documentary films made with a personal voice. Some people at the board considered it very novel and others, self-indulgent. With *Sad Song*, the filmmaker became a character in the story. This had not been my intention at all and was really a function of being out of my depth, of trying to make sense of what I saw and felt and feeling the need to tell something of that process, or so it seemed. ... It was a style that Tom would never have used himself, but he so much enjoyed helping us be ourselves filmically that he never made an issue of it and I carried it on in film after film, all produced by him.[3]

However, it is not just the film's architecture, reflexive devices, and personalization that account for its power. It's that they are harnessed

coherently toward one goal: to get at the truth of the situation as Rubbo encountered it. The personal references are never inserted arbitrarily, and they don't seem designed to showcase the filmmaker. They serve the film and, if anything, deprecate the director. (His anger about the stolen camera seems petty juxtaposed with the badly scarred kid.) He wants to learn, and he acknowledges his reliance on the American interpreters. He evinces a genuine affection for the Saigonese—a cyclo driver; prostitutes; an army deserter; an always-smiling mother of fourteen living on $2 a day; street hustlers; bargirls; many others—but he never pretends that he knows them. And in the film's riveting final two scenes, he seems to step back—as he had in *The True Source of Knowledge*—as if in awe or amazement, to allow us to absorb the contrasting realities before us.

In the funeral sequence, after a few moments with some young prostitutes and their *mamasan*, Rubbo says that there was another woman—"almost a friend"—in the cemetery whom he had wanted to film. Over some old black-and-white footage of her smoking opium, Rubbo says of her, "She played with another army, this one—with the French in Hanoi, in … 'fifty-four. But last night, in her little cupboard … with her opium pipe, she died. Now, all that we have left is some images that Trong took of her … last year."

The residents prepare her for burial. An older man sprays mouthfuls of alcohol around her chamber in the hope of disinfecting it. Two other men line a cheap wooden casket with sawdust. One man collects money for the funeral. "Everybody was giving fifty … a hundred *piastres* … which is a lot of money for these people," Rubbo says. The woman's emaciated body is carried down from her loft and placed in the casket. Among the many people standing around watching are the woman's two young daughters. The older one is thirteen years old. Tears welling in her eyes but trying to be brave, she holds her much younger sister in her arms. In voice-over, Erhart says that the woman "was very small, and [had] very fine bones. She was a very beautiful, delicate little thing … and she used to dance … in the cabarets … in Hanoi, when the French were there. And she … was the mistress of a prince. And after a while, she was hooked … on the black phantom, opium. I was thinking of her, living there, in a tomb … and she was once a dancer." The coffin is closed and nailed shut.

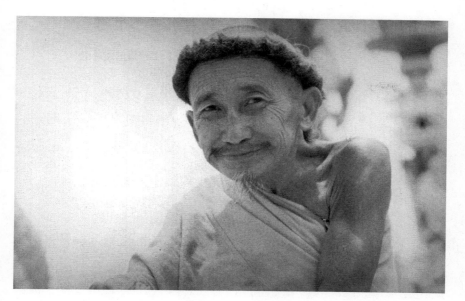

2.4　The Coconut Monk. Production photo. *Sad Song of Yellow Skin* (1970). The National Film Board of Canada.

From this sad scene, Rubbo cuts to a large bell being rung on the Island of Peace. Some kind of prayer ceremony is going on. Apparently it is routine; the residents of the colony pray about ten times a day. The coconut monk has incorporated into his Buddhism and Taoism lots of Catholic symbols. Rubbo says that while the war rages all around the island, here "the only war is symbolic war," which the monk "fights with apples and palm-leaf grenades." The old monk is on his map, walking with a staff. Steinbeck explains that the monk "believes that if you manipulate a symbol for a thing properly, you manipulate the thing itself." Then Rubbo narrates: "So he manipulates the symbols of his map. Each day he walks between Saigon and Hanoi." We learn from Rubbo that the monk came from a wealthy family and was educated in France as a chemical engineer. Returning to Vietnam in 1945, he underwent "a classic Buddhist change, seeing the misery around him, and feeling a compulsion to do something about it. The government calls him a fool, and confines him to this peaceful island."

"He's a fool perhaps," Steinbeck rejoins, "but who drops the na-palm in Vietnam? Other crazy men. And what are the results of these two insanities? Carnage, and ... a lovely society." These are the film's last words, but not its last word. Over the credits, as the sound of the bell fades, we hear gunfire from automatic weapons, as a reminder of Steinbeck's "other crazy men."

Sad Song of Yellow Skin is a beautiful, moving film—its title is that of a Vietnamese song popular at the time, one that expresses loss and longing against a backdrop of centuries of national struggle—but in distribution the film encountered several problems. It was made for television, primarily, but the Canadian Broadcasting Corporation, the expected exhibition channel for NFB documentaries, at first rejected it. All those self-references bothered them, and the film's unabashedly personal narration appalled them; Rubbo's delivery was, to them, non-professional. Eventually these objections were overcome and the film was broadcast. However, although the film received the prestigious Robert Flaherty Award from Britain's Society of Academy of Film and Television (now the British Academy of Film and Television Arts) in 1971 and a Special Award from the Canadian Film Awards (which in 1974 were taken over by the Academy of Canadian Cinema and became known as the "Genies," Canada's counterpart to the Oscars), it never got the degree of attention that the later, American-made *Hearts and Minds* (1974) received. It wasn't angry or certain enough for most of those who wanted to watch films about the war. Piers Handling, an early advocate for Rubbo's films (who in 1994 became the head of the Toronto International Film Festival), wrote in his 1977 article "The Diary Films of Mike Rubbo" that in Rubbo's films, "there is a com-plete lack of insistence about what he says, and this is combined with his personal thoughts as to what is happening on the screen, avoiding any attempt at persuasion."⁴ Rubbo's hatred for the war is clear in the film, but it is understated. He shows American soldiers as clumsy but not intentionally destructive intruders into Saigonese culture. They get their boots shined and they look for girls. They seem to feel out of place. Rubbo doesn't attack them personally but suggests they're pawns, not monsters. For Rubbo, American culture's most obnoxious intrusion into Saigon arrives via television. Piped into a Saigon bar is a clip of President Nixon asserting that Americans will support the war

if they are told its purpose. Following Nixon, a television announcer introduces "that bubbling bundle of barometric brilliance—Bobbi," a leggy blonde who reports on the weather in the United States and in Hue. At her mention of Hue, Rubbo cuts in other television footage—of corpses littering the ground after the Tet Offensive, and then cuts back to Bobbi ending her weather report with a flirtatious little dance-like move.

Despite its disapproval by the CBC and much of the professional media establishment, the film had meaningful influence, both within the National Film Board and on Rubbo's subsequent growth as a director. *Sad Song* broke three institutional taboos: it was overtly and thoroughly personal; it had no Canadian content; and it criticized Canada's closest, far more powerful neighbor on a very sensitive issue. It also validated Rubbo's intuitive judgment: he went to Saigon planning to film one subject but, once there, pursued another—something he would do again on occasion, with excellent results. In its implicit judgement about the morality of the war, it proved prophetic in a way that *Hearts and Minds*, which was made after the moral verdict on the war was already in, could not. The film's success gave Rubbo the confidence and impetus to ratchet up his personalization of the documentary a few steps further.

Nudging Things Along

Persistent and Finagling

After *Sad Song of Yellow Skin*, Rubbo was eager to make another film in Asia. He had proved himself able to cope with the difficulties and dangers inherent in filming in challenging environments. And he had an idea he had long harbored. But until he could develop and secure approval for it, Rubbo took on a project as local and domestic as *Sad Song* was exotic and risky. He learned of a small group called STOP (the Society to Overcome Pollution), mostly thirtyish middleclass women, mostly mothers, who wanted to come up with a dramatic educational event to mark Survival Day (a day for environmental activism) in Montreal. He decided to chronicle their efforts over a three-week period.

The resulting film, *Persistent and Finagling* (1971), is in black and white and was made on a low budget, no travel being involved. Perhaps its low cost encouraged Rubbo to take on a more active role than he did in *Sad Song*. He not only narrates the film, but appears in it on a few occasions. More than that: he interacts with his subjects and occasionally goads them. He chronicles events but also openly helps shape them.

The film opens in medias res, at night, the camera panning across windows before settling on one and zooming in on it, where inside we can see some people discussing something. Before cutting inside, Rubbo's commentary sets the scene: "September the twenty-fourth.

Survival Day is just three weeks away. The STOP executive meets at Sheila Shulman's house to plan its campaign. They—Sheila, Kay, Ann, and Sally—want to do something that will really catch the attention, and the imagination, of Montrealers." Now inside, we see the four women discussing and planning. The third shot of the film is a cutaway to Sheila's husband Larry speaking with Rubbo, who is mostly off camera. Larry makes a comment that seems dismissive of the group. The women had petitioned Mayor Jean Drapeau to mark Survival Day by closing off to traffic the city's main shopping street. They have just read the mayor's letter turning them down. The same idea has been tried in several other cities, the mayor had written, and "is not likely to catch the imagination of our citizens." Soon we are back with Larry, who remarks to the now on-camera Rubbo, "This is a group of middleclass women, who are trying hard to do something but are a little afraid of crossing over." They are, he is implying, afraid of confrontation.

Soon the women come up with the idea of organizing a bus tour of Montreal factories that pollute the city's air and water. They start gathering information. Ken Webb, a young student of air pollution, is helpful; he gives them a list of about fifty-five polluting factories along with a suggested route for the bus tour. Establishment scientists, however, disappoint them. At the University of Montreal, the women, in Rubbo's words, "lay siege to the scientists in their citadel on the hill." A tweedy pipe-smoking water pollution expert is evasive. Professors in another lab strike an attitude of scientific detachment. One says that not enough is known about pollution for scientists to get involved. But apparently enough is known for the public to get involved: pollution is the public's responsibility, they say.

Reaction shots of the women suggest they are getting discouraged. "They still lack," Rubbo says, "a tour director, a panel of experts, and a finalized route for the bus—in other words, practically everything." Sheila cancels a meeting of the group in order to attend a lecture at McGill University by the American environmentalist Barry Commoner, who had recently authored an influential book, *The Closing Circle*. In a brief conversation with Sheila before the lecture, Commoner counters what the water pollution experts had said. "You've really got to know what the facts are," he tells her, "but that isn't really your responsibility, it is the responsibility of the scientific community." In his lecture,

Commoner maintains that scientists should make the facts available, and people should act on them.

For their tour director, STOP thinks they have a promising prospect: the head of Montreal's Department of Health. He had worked with them before and likely would be sympathetic to their cause. But after they tell him about the tour, he gives them a bureaucrat's version of what the scientists had told them: "It would be a kind of condemnation by the public of these sources [of pollution] before the responsible parties have had a chance to be heard." When they pop the question anyway, he squirms and declines, saying that he would not consider leading the tour unless it placed the city in a favorable light.

Back at the house, Sheila's husband Larry comments again to Rubbo. He says that the women seem to take three steps forward but then one step backward. They are still diffident.

While Sheila and Kay are out with Ken Webb evaluating sites, Ann tries to snag as their tour director Rod Blaker, a local radio personality known for hard-hitting news features. They visit Blaker and describe their plans. He is vain and something of a tease. He grills them with the bravura of an accomplished professional dealing with hopeless amateurs. When he speaks, he inserts gratuitous verbal padding. "Do you have what I might call an information officer, a public relations officer?" he asks. "You seem to me perhaps a little uncertain as to what you want to achieve in this." When Ann invites him to be their tour leader, there is a pause. "You haven't shocked me yet. Go on." When warned that the event might antagonize some people, Blaker nibbles at the bait. He has no desire to antagonize anyone, he says, but he doesn't mind if people feel antagonized by solid information. "So, with that in mind, if you're trying to *soft*-pedal something, you should probably get somebody else. If you're prepared to have something spoken or said *as it is*—to use the famous expression, '*tell* it like it is'—then, you know, *maybe*, I'm your man."

Next comes a sequence intercutting Ann meeting with Blaker, Sheila and Sally with Ken Webb, and the group themselves. The contrast between the coy, bombastic Blaker and the quiet, helpful Webb builds as the women grow increasingly frustrated in their efforts to land Blaker. Each time they visit him, he demands more documentation. At one meeting, he says they need to be prepared for twenty

thousand questions. He wants "yards of material, stop by stop, all the history of each stop, what the factory does, what it has been doing, who its people are, what their problems are, what statements *they* have made with respect to their own problems, what statements *you* make with respect to their problems, and verification of the statements you make by accepted authorities. We're going to have a *trial* at each location." But, he adds, "You know that you're not ready."

Debriefing that evening, the women vacillate between believing they can meet Blaker's demands and feeling worn down and condescended to. They're just amateurs, they've been told, and they are discouraged. Rubbo and Larry, again commenting like a Greek chorus on the women's struggle, feel that Blaker has been too demanding. The next day, Rubbo plays back to the women the tape of their interview with Blaker, "hoping, I suppose, to [encourage them] to keep their options open." They listen, frown, and roll their eyes, but they resolve to go back to Blaker and get him to say yes or no to their invitation.

They catch Blaker, Rubbo says, "on the run, between broadcasts." He seems to be trying to elude them, but he can't. There follows a scene in which Blaker, chalk in hand and pompously pedantic, stands before them at a blackboard and again lectures them. He is still unsure, he says, what their goal is, and he needs more specific information about the factories. In a telling shot—an example of the influence on Rubbo of the shot of the befuddled photographer in *Lonely Boy*—Kay, in the foreground, rests her head on her hand in utter dismay, as Blaker bloviates about the need to tailor their plan to the media, to grab attention, to provoke people to complain. "Look," he says while erasing the board, "it sounds like a cop-out, but please don't take it that way. As far as I'm concerned, you are *not yet ready* to proceed."

After the women regroup—"What a huge drag," Sally says of Blaker and his demands—they start distributing flyers in the neighborhoods near the factories. They are reluctant to prod residents to testify against their industrial neighbors. They are surprised to find that most of the residents are friendly to their cause.

Meeting again with Blaker, it looks like more of his annoying condescension and demand-making is in store for them. "I'll make it very brief: I don't think you're *ready*. I have some question in my mind as to whether you are ever going to *be* ready, um, I don't think you're

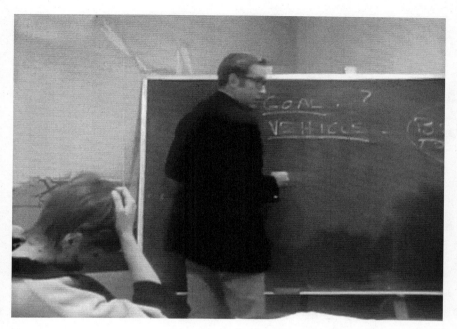

3.1 Blaker insists on more information. Screen grab. *Persistent and Finagling*
(1971). The National Film Board of Canada.

treating the thing with the degree of planning and organization which
it requires, and I think you're confused about your goals ... but per-
haps to your relief, I'll tell you that persistency does seem to have some
value. Yes, I will do the job." But, he adds, "I do so with *great fear.*"
A poorly documented tour could do STOP more harm than good, he
says. The women promise to have all the information he has asked for
by the following day. "My neck is on the line," he says, but "I guarantee
you, at this point, I will be on deck." Relieved, the women relax, and
so does Blaker. At ease now, Blaker smiles, and tells them they're "just
a bunch of absolutely, totally persistent ... finagling *females*, who have
dithered me to the point where I don't know how to say no."

Later, at Sheila's house, Rubbo and Larry, rather than congratulate
the women, complain that they've let Blaker bully them. "You like
being tortured by him," Rubbo says. "I would have told the guy where
to get off," he blusters. But Sheila won't let *Rubbo* bully her. Every idea

3.2 Sheila reminds Rubbo that he's agreed with Blaker's every suggestion. Screen grab. *Persistent and Finagling* (1971). The National Film Board of Canada.

that Blaker suggested, she says, "*you've* taken on, as what *you'd* like to see done." Chastened, Rubbo does not respond.

On the scheduled day, with Blaker signed on, the tour is ready to proceed. But Blaker hasn't shown up. And he has canceled a hotel room he had reserved for a cocktail reception after the tour, so there is fear that he has chickened out. STOP is ready to proceed without him—their confidence has grown along with their preparation—but at the last moment Blaker arrives and the tour goes on as planned, shown in a montage of stops at various locations with comments by Blaker as well as participating experts and volunteers.

At the reception, where, Rubbo narrates, "drinks await us in the re-captured hotel room," Blaker and a newspaper reporter from the *Montreal Star* engage in a friendly argument about STOP. Although Blaker is complimentary of STOP, he can't help but lecture, maintaining that they remain too amateurish, that they need a public relations person.

The reporter disagrees: "They're proceeding in their own way, and they're groping ... and without *realizing* it, they've been *very* effective, in my opinion." The slippery Blaker stiffens: "No—I'm in *perfect* agreement. We're talking methodology. I want nothing to do with the slick crowd. Don't come *near* me with the guy who's got all the media answers, who's got all the fast, rapid stuff. I don't need that." But true to character, he has to have the last word with the women. When Sheila reminds him of what he had called them, he replies, "I said you're a bunch of amateurs, and, you know, you're disorganized, you don't know what your goals are, you don't know where you're going, but there's one thing I'll say for you: you have all the persistency of a *group* of *women*—and that's great."

Although Rubbo is shown goading the women to stand up to Blaker only once, there is an earlier scene in which Sheila asks Rubbo if, as the film's director, he is happy with what he has seen so far. This suggests, although not conclusively, that the women want to please him. It is hard not to suspect that the production of the film encouraged them to persist with their finagling. They don't want to disappoint Rubbo, and they don't want their failure recorded. But Rubbo doesn't want them to disappoint him (or themselves) either. Hence the goading. His playback of the Blaker interview was meant to challenge the women. With such actions, he has become an active and acknowledged participant in the reality his film is documenting. In several of his subsequent films, Rubbo would insert himself into the progress of events more overtly, occasionally in very imaginative ways.

An important aspect of the film is its portrayal of an antagonist who exhibits the characteristics of a villain but is treated in the round, like a character in good literature. Blaker (who entered politics, with some success, not long after the filming) is pompous, vain, sexist, and condescending, but ultimately he is likeable. He finally does put his neck on the line for the sake of the tour, and the insistent demands on which he conditioned his participation made for a solid, successful event. Here Rubbo has done something very unusual in political or social documentary: he has humanized the enemy. Or more accurately, he has humanized the opponent, making it very difficult to think of him as an enemy. Such humanization would become another frequent characteristic of Rubbo's documentaries.

3.3 Sheila asks Rubbo if he's pleased so far. Screen grab. *Persistent and Finagling* (1971). The National Film Board of Canada.

Because the film has genuine, rounded characters who change in the course of events, it offers more than a simple chronology. The film is the first of several Rubbo films that tell a story in the sense normally used in fiction and hard to do legitimately in documentary. All the more remarkable, Rubbo managed to make an engrossing story about ordinary, unassuming middleclass housewives pursuing a goal that is extremely modest on the scale of things.

With this film, Rubbo added another new twist to his personalization of documentary: he lets himself be one-upped. When Sheila effectively shows him to be a bit of a blowhard—"I would have told him where to get off," Rubbo had boasted—he included her put-down in the film, without any response on his part, thus granting her the last word on that matter. And surely he was aware that those cutaways to him and Sheila's husband commenting on the women and their hesitancy would come off as sexist and condescending, despite the affection and respect the two men clearly have for the women. Complementing

his treatment of Blaker, whom he humanizes by showing his likeable side as well as his annoying traits, Rubbo presents himself as a human being in his own right rather than the all-knowing director with flawlessly correct attitudes. He displays his fallibility and uses it in service of the film.

These salient features combine in *Persistent and Finagling* to create a superb, entertaining if low-key celebration of emerging female confidence and empowerment in the face of male chauvinism. The women overcome the resistance to their bus tour, they lasso Blaker, they show up Rubbo, they conquer their own fears, and they succeed. It may seem quaint now, but it registered an instance of mainstream female awakening circa the early 1970s. In 1975, I showed the film to a class of first-year graduate film students at Stanford University; the women in the class loved the film and thanked me for showing it. It is a fine historical document about unspectacular but engaging people gaining confidence while serving a cause. Unfortunately, the film was not broadcast on television, showcased at festivals, or widely distributed. It has not been remastered onto DVD and so is unavailable. The only production stills available for it are three photos of the tour bus. Forgotten in the Film Board archives, it remains an undiscovered gem.

Filmmaker Front and Center

Wet Earth and Warm People

In 1967, before he even thought of making a film on Vietnam, Rubbo had submitted a proposal for a documentary about Indonesia. The densely populated but mysterious country was Australia's closest neighbor and a source of fascination to adventurous young Australians. Rubbo had twice visited Indonesia as a college student, and he had developed an affection for its people. The original proposal had gotten no traction, given Rubbo's inexperience and lack of Canadian angle. But now, the Canadian-content requirement, although still official policy, had been weakened—mainly by Rubbo himself with *Sad Song of Yellow Skin*. And the Film Board, always interested in broad global issues, was becoming concerned about overpopulation and the problems associated with it. Paul Erlich's alarming bestseller, *The Population Bomb*, was published in 1968. Indonesia was the world's most densely populated large country. Rubbo had little trouble getting the project approved. He filmed it in 1971 on a five-and-a-half-week shoot.

Although he had been in frequent correspondence with a few Australians working in Indonesia, he decided against using Western intermediaries. Instead, he took his personalization of the Film Board documentary one step further. In *Persistent and Finagling*, we glimpsed Rubbo now and then, mostly as an involved bystander egging the women on. In this film, he would be on camera in nearly every scene.

4.1　End of opening shot. Screen grab. *Wet Earth and Warm People* (1971). The National Film Board of Canada.

Rubbo wanted to gain Indonesian perspectives on overpopulation and its attendant problems, but willy-nilly the film became more an appreciative travelogue than a sociological inquiry. The film meanders, starting in Jakarta, moving to Java's interior for the middle third, and returning to Jakarta for its conclusion. There is no clear story line other than Rubbo's travels. But if it is a travelogue, it has moments of beauty and charm, and it is more interested in people than in sights.

The film opens on an early morning in a busy Jakarta street, the camera moving around amidst *betjaks* (the pedicabs that the Vietnamese called "cyclos"), pedestrians, idlers, and cars. The cacophonous confusion recalls the opening sequence of *Sad Song of Yellow Skin*. But there are important differences: instead of a series of very brief shots strung together in a temporal mosaic, the opening of this film is a single hand-held walking shot lasting about thirty seconds, continuing through the title. It ends on young boys staring at the camera. The

length and style of the shot foreshadows the film's meandering path. The shot's concluding image initiates a visual but also thematic leitmotif: people staring at the camera and crew in ingenuous curiosity. While the Saigonese in *Sad Song* seemed grudgingly blasé about the presence of a foreign camera crew, this was still a novelty to most Indonesians in 1971. They are as interested in the film crew as the crew is in them.

The next shot begins on the ultra-modern (for 1971) Hotel Indonesia and then pans to the betjaks lined up across the street after a busy night. The contrasts of old and new, and rich and poor, represent a twin tension in Indonesia. Rubbo enters the frame and speaks with a betjak driver, Husin, whom he knows. After some conversation, Rubbo tells us that Husin will have to go home via rutty back roads, because the city government is engaged in a campaign against the betjaks. The government says the two hundred thousand or so betjaks in the city clog up the roads, but Rubbo suspects the real objection is that they look primitive in a country that wants to appear modern.

Next, on a recently built freeway, Rubbo is in the back seat of a car with General Hoegeng, chief of the national police. Hoegeng stops to order a host of betjak drivers to move off the road. For the next few minutes, the film cuts back and forth between scenes with the general and scenes with Husin the betjak driver. Husin is a cheerful man with a hard life. He has to take daily medication that he cannot afford. While occasional shots depict the general as a typical bureaucrat, standing on ceremony or pushing papers, there is no attempt to portray him as a bad guy or to make fun of him. The contrast is between poverty and plenty, not good and evil. When Rubbo worries that his filming in Husin's compound might get Husin in trouble—for showing poverty—he goes to the general and expresses his concern. The general assures Rubbo that he will take care of it. Of course, he knows he is on camera.

If the film seems to lack a direction, Rubbo senses it. Back in the busy side streets, he laments, "We get bogged down in a maze of stories that start and then ... just ... fizzle out." He learns that the street vendors, like the betjak drivers, are under attack, but his attempts to find out why elicit "hostile looks. We just feel ... personally lost, and out of place. ... There are a hundred and ten million people in these islands of Indonesia ... and we feel as if they're all staring at *us*." Over a panning

shot from inside the crew's minibus showing kids and young men's faces pressed against every window, gawking at them, Rubbo says, "Even in our little bus ... we feel like freaks ... in a cage of people."

The segue to the next scene exemplifies the film's walkabout structure, rescues the crew from stares for a while, and gives the film impetus. Hot and thirsty, the film crew buys drinks from a street vendor, who turns out to be an actor in a "people's theater." He invites the crew to the theater compound. Everyone living here is involved in the theater somehow; even the children mimic the actors and dancers, as if in training for their future profession. In a rehearsal for a puppet show, the puppeteer pokes fun at Rubbo, having his pompous puppet say "I am a film star from Canada," much to the troupe's delight. The sequence lasts ten minutes and includes an actual, intense squabble between two male adults living in the compound, much rehearsing, and an entertaining performance that "seems to last almost all night." It ends with a cutaway to an actor affectionately stroking his sleeping child's temple—one of those small personal moments Rubbo loves to capture.

When the theater manager suggests that Rubbo take his crew to the countryside—because Jakarta is not Indonesia; Indonesia is villages, the theater manager says—the film team heads to a village hours from the city. They get there by *opelet*, a van-like vehicle that frequently breaks down, and they will return by rafting down a river along with some bamboo sellers. In the country sojourn sequence, Rubbo is quieter than earlier (or later), letting us take in the sights and sounds ourselves for longer stretches of time. They are beautiful and often strange—four men clothed in black pants and white shirts marching ceremoniously alongside a rice field, playing gamelan music; all sorts of primitive tools being used in food preparation. Rubbo tries to engage a village official in a discussion of family planning, but not even Rubbo seems passionately interested in the problem at this point.

The comparatively laid-back, quietly observant mood of the rural sequence is interrupted by a film screening that Rubbo organizes for the village residents, most of whom had never seen a film. On the first night, families come from as far as twenty miles away to see it. But the generator conks out, and after three hours of trying to fix it, the crew gives up. They try again the next night, using a spark plug commandeered from the opelet. Rubbo's Indonesian production manager has

prepared a speech for Rubbo to deliver. He does, in stumbling Indonesian, which the crowd finds hilarious. When the projector works, the audience is treated to an NFB film from 1949, *How to Build an Igloo*.

But just before and just after this scene, Rubbo acknowledges his failure to penetrate deeply into the lives of these people. "Making friends we hardly see the hunger ... behind the smiles," he says over a shot of him meeting a villager. Later, over an extreme long shot of a strange dance that at first we can barely discern, he says, "There are many mysterious things here. I think we miss these mysterious things, because we come with our ... technology, our films." And during the raft trip on the return to Jakarta, over a shot of a horde of children running along the river bank after the film team, Rubbo acknowledges a human difficulty: "We're tired, we're dirty, fed up with the stink, with the heat, and with the following and the watching that starts again."

Rubbo spends most of his return to Jakarta interacting with General Hoegeng and Ali Sedikin, Jakarta's governor. With Sedikin, Rubbo engages in a friendly debate about the betjaks. To Rubbo, they seem very practical for a crowded city: they cause no pollution, no noise, no damage to the roads. Sedikin reminds Rubbo that the betjaks crowd the roads, draw people into the city from the villages, and attract transients. In voice-over, Rubbo repeats what he had said earlier, that he suspects the real beef against the betjaks is that they undermine the image of modernity that Indonesia wants to project. But Rubbo's respect for Sedikin grows as he learns more about his point of view. Sedikin is concerned about what kind of life the new generations will have, and he feels responsibility towards them. He takes Rubbo on a visit to a slum and then to a new development. Sedikin shows him a paved road, and then points to the modest new homes being built because of it. Rubbo says that Sedikin believes this illustrates that "people will carry out the development themselves, if you get them out of the muck."

General Hoegeng seems reasonably compassionate, understanding, and dedicated. We see him on his front porch with a few friends practicing a ukulele-accompanied song they will perform on television. He keeps pet orangutans in his backyard; a two-shot shows him and Rubbo each cradling a baby orangutan in their arms. The general usually arrives at work before anyone else. When asked why, he says, "Although I am chief of national police, I'm just a common cop." A few

4.2 Last shot of the film, under credits. Screen grab. *Wet Earth and Warm People* (1971). The National Film Board of Canada.

months later, Rubbo reports, the general lost his job: "They say he was incorruptible. It may be that he was *too* incorruptible. He'd even put his own relatives away, when they deserved it."

The film's concluding shot echoes its opening. As if taking up from where the former left off (on the three children staring at the camera), it is a traveling shot from the back of a vehicle, probably the opelet, of scores of excited children running after the crew as they drive away from a village. The shot lasts a little over forty seconds, through the end credits. At one and the same time, it reinforces the notion that Indonesia has a population problem, that there's probably nothing anyone can do about it, and that the country must be doing something right if they can produce such likeable and apparently happy people. In its way, it is a rebuke to the arrogance of Westerners urging their solutions to Third-World problems.

The CBC did broadcast *Wet Earth and Warm People*, but the film was received tepidly. Although it had a narrative thread—the long sojourn in the village, framed by the two sequences in Jakarta—it was a thin one, and it lacked a deep structure, unlike *Sad Song of Yellow Skin*. And it had none of the character development that made *Persistent and Finagling* compelling. Not much seemed at stake in the film. There was no war—just too many people and too little wealth, and even this issue was merely touched upon in interactions between Rubbo and Indonesian officials or in his narration.

What annoyed people the most was Rubbo's presence on camera. He is involved in at least eighteen separate scenes. To some viewers this seemed self-indulgent. At first, I was one such viewer. After the film was shown at the 1972 Melbourne Film Festival, I reviewed it together with *Sad Song of Yellow Skin* for an Australian film magazine, *Lumiere*. Rubbo's presence, his outfit (a safari suit of some sort), and his on-camera hamming (as I saw it then) annoyed me. But nevertheless I thought the film was very good. I resolved the contradiction, at least to my own satisfaction, by understanding Rubbo's prominent presence in the film as a way of showing the truth of the situation he was in.[1] In such an environment, in those days, a Westerner with a film crew would inevitably become the center of interest wherever he filmed. The truth of the situation was the intrusiveness of the film project; it got in the way of everything else. And yet, knowing something of Indonesia myself, I thought the film's representation of the corner of Indonesian life it depicted was more authentic than anything else on the country I had seen.

When it was broadcast on the CBC in 1972, a reviewer for the *Montreal Gazette* (9 August 1972) called the film "shallow ... having rather more the appearance of a missionary's travelogue." The rival *Montreal Star* (10 August 1972) found it "pointless": "What were we supposed to make of *Wet Earth and Warm People*? What exactly is going on there, beyond poverty and misery and the rainy season?" The same day, the *Ottawa Citizen*'s reviewer said the film was invasive and exploitative.

The film certainly lacks the emotional urgency of *Sad Song of Yellow Skin* or the character development in *Persistent and Finagling*. But it is more than a travelogue, and more than its acknowledgment of

the observer's effect on the observed. It reveals the difficulty that a Westerner experiences, particularly when accompanied by a film crew and its equipment, in establishing close contact with people unfamiliar with foreigners or filmmaking. The difficulty is both epistemological and emotional. How does one find the truth here, and how does one establish meaningful human contact? Rather than hide this problem, Rubbo acknowledges and foregrounds it. Showing a film on igloos to Indonesian villagers is a humorous and self-deprecating way of suggesting the cultural biases that make it hard for a Westerner, however sympathetic, to connect. His complaints about being hot, dirty, and stared at is another acknowledgment of his personal limitations. He worries that the film team may be "missing the many mysterious things" that are around them. One mystery, however, is right before our eyes: why are these people, especially the kids, apparently so unreservedly happy, despite their poverty and their indifference to Western solutions such as family planning? Once you stop looking to the film for information, data, policies, and that sort of thing, and simply experience it, affection for the people and a certain awe for their vitality wash over you, and you might suspect that these people know something about life that we don't.

Family Matters

OK ... Camera; Streets of Saigon;
Jalan, Jalan; The Man Who Can't Stop

In the early 1970s, the Film Board entered one of its periodic stretches of austerity. There was very little money for new, individual productions. Partly to be seen playing a role in unifying Canada, and because outside television money was available for it, the Film Board launched a series of half-hour films made in English-speaking Canada by Quebec filmmakers and in Quebec by Anglophone filmmakers. While the series was derided by the more radical filmmakers at the NFB, Rubbo felt obligated to participate. His contribution was an impressionistic, fast-moving report on Quebec's budding feature-film industry, *OK ... Camera* (1972). It is a lively film, combining man-in-the-street interviews with ordinary French Canadians, interviews with important figures in the Quebec film industry (such as Genevieve Bujold, Denys Arcand, and Claude Jutra), movie clips, and posters. The film is held together by retro intertitle cards and a modern version of silent-movie musical accompaniment. Rubbo does not enter this film, staying behind the camera and even forgoing narration. It's an interesting if inconsequential, dutiful film.

The budget problems at the NFB affected only outside production costs, such as film stock, travel, and location expenses. Jobs were safe; employees were paid. With funds for new filming hard to come by,

Rubbo went back to the footage from which he had cut *Sad Song of Yellow Skin* and *Wet Earth and Warm People*. The material was rich enough, he thought, to cut an original, shorter film from each batch.

The Streets of Saigon (1972) uses many of the same shots as *Sad Song* and much of the same narration. Dick Hughes and his home for shoeshine boys are in the film, but John Steinbeck IV and the Island of Peace are not. Rubbo uses more of his audio tape of Steve Erhart, who becomes in effect a second narrator. (The end credits include the words "with the voice and thoughts of Steve Erhart.") Although only half the length of *Sad Song*, *The Streets of Saigon* gives some of the back-story to the longer film—for example, that Wei is seventeen years old, conscious of his physical smallness, and fond of Dick. We learn that a tough-looking youngster who had appeared in but was not identified in the earlier film is named Nop and is a protector of the younger kids. The reflexive scene in *Sad Song*, when Wei is chastised for having taken money for the interview, is here elaborated on. Wei knows, Rubbo says, that the film crew is exploiting him. When he throws the cash at Hughes, Wei shouts, "'Keep the money for the movie'—that's Wei's final crack."

Edited four years after the filming, and with the war still going on, *Streets of Saigon* is more overtly antiwar and pessimistic. There is not even a mention of the hopeful, peace-seeking coconut monk. Rubbo's closing narration expresses a bleak outlook: "It is four years since the film was shot. In those four years, Dick has opened four other shoeshine houses. In those four years, [over] six million people in these unhappy countries [North and South Vietnam, presumably; perhaps also Cambodia and Laos] have been killed, wounded, or made refugees. Wei has become the manager of one of Dick's houses. Nop is still alive. Twenty thousand Americans, though, have been killed. Steve has left Saigon. And the night that we left Saigon," Rubbo says, "we had a drink with him, at a street bar, and watched the news on TV." Here Rubbo includes the Nixon press conference and Bobbi the weather girl from the longer film.

Jalan, Jalan: A Journey in Sundanese Java (1972), Rubbo's shortened version of *Wet Earth and Warm People*, was to some viewers not just an abridgement but an improvement. Rubbo is absent from both the screen and the soundtrack. There is no narration. Without any further

explanation (beyond the film's subtitle) of where we are or what we are seeing, the film is a distillation of some of the most scenic or exotic shots from *Wet Earth* salted with numerous images not included in the longer film. From *Wet Earth*, we see snippets of the puppet show, the argument in the compound, and men making a bamboo raft. New shots include netting a carp in a fishpond, a cigarette vendor, kids jumping rope, a little girl washing dishes, a young woman peeling a rambutan, people playing slot machines. The scene from the longer film in which four men clad in black and white perform some sort of musical ceremony alongside a rice field is repeated in *Jalan, Jalan* twice, once in the body of the film, and again as the film's closing image. What the two versions have in common is an attraction to children, a sense of wonder at a strange culture, and a seemingly meandering structure. Indeed, *Jalan, Jalan*, which in Indonesian means either to go on a journey or just casually stroll about, could have served as the title of the longer film just as well.

Two of Rubbo's three hour-long documentaries had involved far-away places and unfamiliar people. His next made-for-television documentary took him to another faraway place—but a familiar one and with familiar people. Combining business with pleasure, Rubbo was in Australia visiting family and looking for a film idea about the environment, a concern of his since before *Persistent and Finagling*. He spent some time with Film Australia. Film Australia was established in 1946 as the Australian National Film Board, which was inspired by and largely modeled on the Canadian original. Stanley Hawes, a Grierson associate in Britain and one of his key assistants in the Canadian Film Board's early years, headed the unit for over two decades. In 1956, it was renamed the Australian Commonwealth Film Unit; in 1973 it became Film Australia. But it never reached anywhere near the size or developed the artistic independence or aesthetic excellence of its Canadian inspiration.

The two organizations had exchanged filmmakers occasionally in the early 1970s. The Australians who had spent a year at the Film Board were impressed by the bolder approaches to documentary they saw in Canada. Rubbo wanted to make a film in Australia. He came up with an idea of a documentary about his uncle's campaign to persuade the government of Sydney to redirect the city's sewage from the ocean to

the interior. The sewage was polluting Sydney's gorgeous beaches; inland, it could fertilize farms.

Rubbo proposed a coproduction between Film Australia and the Film Board. At first, he encountered resistance from both sides:

> There was great suspicion at Film Australia that I was ripping them off somehow, that I was making a pitch for scarce resources [money for productions] that they'd prefer to keep for themselves. I remember a very tense meeting, all the production staff, not the manager types, but people like myself, who had me for a lunchtime meeting in a very hot demountable building being used for spare offices. It was a sort of interrogation of my motives and what was in it for them.

The meeting ended with an agreement between the Australians and Rubbo that there would be no film unless it was edited by one of the Australians and that the NFB would be open to a reciprocal production of a film in Canada directed by an Australian. At the Film Board, there was the usual objection that the proposed film would have no apparent Canadian content, and some of Rubbo's colleagues resented that Rubbo had been favored with overseas projects.

In support of the proposal, Rubbo argued that this would be a great opportunity for building on the NFB–Film Australia relationship. A few of Film Australia's key producers and filmmakers hungered for a chance to make films in the Film Board style—more personal, less scripted, chancier. And the film would not cost the Film Board much; Film Australia would supply the crew and much of the location costs. The same, in reverse, would apply to the Australian-directed film. Eventually, both Film Australia and the National Film Board came around, although the Australian-directed film in Canada was yet to be determined.

As a personal documentary, *The Man Who Can't Stop* represented something new for Film Australia, but it also included personal dimensions new to Rubbo. As with *Wet Earth and Warm People* and *Persistent and Finagling*, he narrates the film, appears in it, and influences events. But he now includes members of his extended family. The protagonist

is his uncle, Francis Sutton. The costar is Francis's wife Joan. Their children appear in the film as well. Instead of minimizing his family connection with his subjects, Rubbo's narration emphasizes it: "This is a story," he begins, "about … a homecoming … about an uncle … and about a sewage scheme." He and his aunt leaf through albums of photos. Although they are typical family photographs, several pertain to the serious subject of the pollution of Sydney's beaches. Several photos reference Rubbo's childhood. One photo includes him and two other boys on the beach: "That's me on the left, on one of those great Christmas holidays, long ago." Rubbo expresses amazement that a people so in love with the sea can pollute it so casually.

And as he had done for the first time in *Persistent and Finagling*, Rubbo develops his main subjects as characters, and he constructs a story from their interactions. Francis, who is sixty-one years old, has quit his job as a commercial artist to devote himself full time to what has become known as "the Sutton Plan," which would divert the sewage that now flows into Sydney's coastal waters inland, where it can be stored in a reservoir and used to irrigate farmland, fertilize crops, and cool power plants. This would not only save the beaches, it would make productive use of the effluent. But Francis has made little progress in persuading politicians and officials to take his plan seriously. He is told it would cost far too much. Francis presses for a mere $5,000 grant for a feasibility study, but can't even get that. He'd fund it himself, but he and Joan are almost broke from his zealous, impractical pursuit of the plan. Compounding the indifference he faces, Francis has a diffident personality, which makes it hard for him to confront people or be assertive. But he is tenacious, single-mindedly devoted to solving the problem of Sydney's polluted beaches.

Rubbo structured the film around meetings that Francis has with people from whom he seeks support or advice, as well as the public lectures in schools and other venues in which he explains his scheme. Francis is not charismatic, as he himself admits. In a classroom presentation, one student yawns, two others exchange personal notes, and another looks around at classmates as if silently asking how long this man will drone on.

What turns the film into an engaging human story is the relationship between Francis and Joan. Whereas Francis is shy, Joan speaks

5.1 Francis Sutton. Production photo. *The Man Who Can't Stop* (1973). The National Film Board of Canada.

her mind easily and matter-of-factly. Francis loves her, but she has become exasperated with his quixotic pursuit. Francis is so involved in his scheme that he apparently doesn't do much work around the house, while we see Joan tending the garden or at the top of a ladder, working on the roof. She worries about their dwindling savings. Her affectionate carping is a leitmotif in the film. She can be quite supportive, especially when Francis needs it. When Rubbo suggests that Francis ought to be more politically clever, Joan says, "Francis doesn't have any cynicism in his nature." At a protest that Francis, to everyone's surprise, has succeeded in organizing, Joan is with him. Although attendance is clearly sparse, she says she is "glad to see so many people." Later, when Francis has suffered another setback in gaining support for a feasibility study, she asks him why he can't just stop. They argue briefly. Francis tells Joan, "You [meaning himself] always hurt the one you love, I suppose," his sparkling but misty eyes conveying his love for her. Joan leaves him

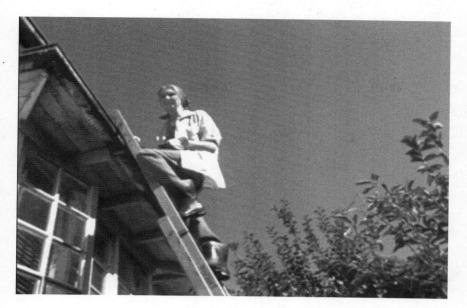

5.2 Joan Sutton working on the roof. Screen grab. *The Man Who Can't Stop* (1973). The National Film Board of Canada.

for a few weeks, then comes back. After being rebuffed by the Australian Ministry of Urban and Regional Development on the grounds that a feasibility study is already underway, Francis is asked if he intends to abandon his scheme now. "Abandon my scheme?" he replies. "No, I don't think so. I think the public spirit should be encouraged to continue." Joan pipes up: "Besides, Francis doesn't abandon things. You know that by now, Mike." She laughs.

At the film's end, Francis reflects on his low-key personality. "I don't think I'm very demonstrative particularly. I'm not at all like that, and I felt that perhaps I wasn't a good person to be involved in such a film." He's right about his personality, wrong about his appropriateness for this film. The film's attraction lies in his diffident persistence and the love between him and Joan. Rubbo's final commentary, over the credits, validates Francis's self-assessment and in its own way affirms it: "There's no clear success in sight. Such stories don't end in a day. Francis works on, and drops me notes from time to time, when there's progress to report."

In addition to its character development, the film takes two other components of Rubbo's style a step further. He intervenes on his uncle's behalf, in one case on his own but quite overtly. After Francis experiences a setback in his effort to get a cost estimate for his scheme and is considering approaching someone who has helped him before, Rubbo says in his commentary, "I pursue another course on the cost question. I make an appointment with Mr. McIntosh, Chief Engineer of [Sydney's] Development of Public Works." Rubbo secures the appointment, but Francis is not invited. The meeting between Rubbo and Mr. McIntosh is testy. McIntosh says that technology is being developed that will purify the effluent sufficiently to eliminate its pollutant effect. For McIntosh, there's no need to worry about the future of Sydney's beaches.

And Rubbo takes his willingness to show himself in an unflattering light further. Early in the film, after Rubbo has asked Joan how she fills her time, she mentions a few things and then adds, "And as you know, I write occasional verse," and laughs.

"I didn't know that," Rubbo says.

"You *do*," she rejoins, and mentions a poem that she had sent him. "You *liked* it." Rubbo mumbles something, apparently to the effect that he doesn't remember the poem. "Oh, Michael, then you were being insincere. You said you thought it was good."

The film was screened on the closing night of the 1974 Sydney Film Festival in the historic State Theatre, which was filled to its capacity of about twenty-five hundred people. Most of the audience that night had come to see Peter Weir's *The Cars That Ate Paris* (1974). *The Man Who Can't Stop*, with which it was double-billed, preceded it. Rubbo wasn't there, but Francis and Joan were. The film's Australian coeditor, Graham Chase, described the film's reception in an undated, handwritten letter to Rubbo a few days after the screening. In it Chase confesses being apprehensive. For one thing, the audience was tired after two solid weeks of film screenings. For another, he was worried that the 16mm print wouldn't project a strong image in such a large theater. But,

> the lights faded—the organ descended—the velvet curtains parted—and on it came. I was nervous as a kitten. ... Well—bugger me—the jaded audience came alive. They

5.3 "Oh, Michael, then you were being insincere." Screen grab. *The Man Who Can't Stop* (1973). The National Film Board of Canada.

were swept away by Francis and Joan. They cheered & clapped—hissed at the board of works—and laughed at all the right places. And as the first credit came on at the end—the applause was thunderous, so much that your last voice bit was lost completely.

After the film, the festival director, David Stratton, introduced Francis and Joan. The audience greeted them with a lengthy standing ovation. Then, according to Chase,

The Cars that Ate Paris was premiered in all its Panavision and colour. So sad—it's not much of a movie and the audience was quite restless throughout. After that, as I descended the marble stairs, I see hundreds of people walloping into Francis (Peter Weir is nowhere to be found).

But Chase goes on to report that distribution of the film isn't going well. Film Australia had offered it to the Australian Broadcasting Corporation (Australia's counterpart to the CBC), which turned it down. Chase doesn't think the distribution people at Film Australia were trying very hard. Meanwhile, in Canada, the CBC rejected the film as well; to them, it was self-indulgent.

The Man Who Can't Stop probably has little importance now as a documentary film about the environment, but it is a beautiful, engaging story of an Australian couple and their era. It is a human and cultural portrait. As a documentary, it is also impressive for its nearly seamless integration of several Rubbo traits: unapologetic personal approach, narration-enhanced storytelling, affection for people, transparency in filmmaking, intervention on behalf of the protagonist, and its subordination of the director's ego to his subject.

It was during the editing of *The Man Who Can't Stop* that the promised reciprocal film began to take shape. Australian filmmaker Bruce Moir, an acquaintance of Rubbo's, happened to be in Canada on a two-month grant from the Australian Film School to study educational television in Ontario. While en route to Canada, Rubbo had wired him about the promised reciprocal production and suggested a subject. Charles Bliss, a Holocaust survivor living in Canada, had devoted his life to developing a symbolic language which he hoped would transcend nationalistic barriers. His efforts from the end of World War II met only indifference and rejection until about 1973, when his symbolic language was found to help children with cerebral palsy communicate. On arriving in Canada, Moir explored the potential film project. When he had finished his obligatory two months on the grant, he moved to Montreal, where Graham Chase, busy editing Rubbo's film, let him sleep on the couch in his apartment while Moir worked to get the film project approved by both the Film Board and Film Australia. He succeeded and, with Tom Daly coproducing both films, crafted an engaging portrait of Charles Bliss, *Mr. Symbol Man* (1973). By the time the coproduction was completed, Rubbo and Moir had become fast friends.

How It Works

Waiting for Fidel; I Am an Old Tree

It's early 1974. Three men—Geoff Stirling, a media magnate and native of Newfoundland; Joey Smallwood, the former premier of Newfoundland and the man credited with bringing it into the Canadian Federation in 1949; and Rubbo—are aboard a small jet en route to Havana along with a film crew. This, the opening scene of *Waiting for Fidel* (1974), underlines the film's *carpe diem* provenance. Smallwood, Rubbo explains, has received an informal invitation from Fidel Castro to come to Cuba and interview him for a film that, Smallwood hopes, might ease relations between Cuba and the United States. Stirling has agreed to pay the outside costs (travel, location expenses, film stock) in return for broadcasting rights, which he hopes to sell to the National Broadcasting Corporation, one of the so-called Big Three American commercial networks. Stirling wanted Rubbo, whose *Sad Song of Yellow Skin* he had seen and liked, to direct. Rubbo jumped at the opportunity—the Film Board had only about a week to decide whether to seize it or not. The mood of the resulting film is excited and hopeful, but already the three men's distinctive characters are beginning to emerge. Smallwood is an admirer of Red China and adores Fidel Castro. Stirling is skeptical about Cuba but thinks a tough-minded if generally positive film will make money and perhaps do some good. Rubbo leans toward Smallwood politically but is thinking in terms of returning to Canada with a film "rich and rare" because of its interview with Castro

and insights into Cuba. All three believe the film might just open the door to better relations between Cuba and the United States.

Waiting for Fidel is Rubbo's best-known film. Even most people who have only heard of it know that the interview does not happen; the title itself suggests as much. Rubbo, Smallwood, Stirling, and the film crew sit around for three weeks waiting in vain for the promised interview. They are billeted in Protocol Residence Number Nine, a mansion once owned by an American textile tycoon who fled Cuba after the revolution. The three dine on splendid food in an immense, echoing room, attended by well-trained cooks and waiters. During the day, they are taken to visit various sites of interest, including a high school, a technical college, a mental hospital, a housing complex under construction, and a museum about the Bay of Pigs invasion of 1962.

The richest aspect of *Waiting for Fidel*, if not the most famous, is the interplay among the three protagonists. Of course Rubbo had been in front of the camera before—first as a self-deprecating, mildly provocative stirrer of action in *Persistent and Finagling,* then as a tour guide in *Wet Earth and Warm People,* and finally as a somewhat more active participant in *The Man Who Can't Stop.* But this time he is a full-fledged character, as fully present as Smallwood and Stirling. Throughout the film, the other two take opposing views of Cuba. Early on, Rubbo uses the camera as well as narration to suggest the antagonism to come. As the team is being driven from the airport, Smallwood and Stirling are filmed in a two-shot in the back seat. "Welcome to Cuba," Rubbo says in voice-over, as the two men, "the capitalist and the Socialist," look out their respective windows. At dinner, a testy exchange occurs after Smallwood recounts a previous conversation with Castro in which he mentioned that Stirling was a very rich man. Stirling says, "I certainly hope you also told him that I give seventy-six cents on every dollar to my fellow human beings." Smallwood rejoins, "No, you don't *give* it, they *take* it. The government *takes* it, in taxes."

"But I give it willingly."

"Well, that's good," Smallwood says as if to close the matter. "That's good."

In such exchanges, Smallwood, who was seventy-three at the time the film was made, demonstrates his political tact (if he is a bit domineering at times), reflecting a lifetime of intense and successful political

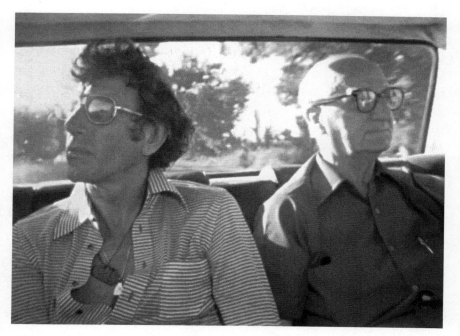

6.1 "The capitalist and the Socialist." Screen grab. *Waiting for Fidel* (1974). The National Film Board of Canada.

activity. Had the promised interview with Fidel Castro taken place, Smallwood and Castro would have been the two main characters. Castro's importance was well established at the time of the film, but Smallwood's achievements were not well known outside of Canada. He was born poor, the first of seventeen children in a remote part of Newfoundland. A generous uncle paid his tuition to Newfoundland's leading Anglican school. From an early age, he had dreamed of one day becoming prime minister of Newfoundland. In his twenties, he worked as a journalist in New York City, where he became a Socialist. He was an avid reader who "felt inferior to no one, an attitude that would enable him to approach anyone anywhere, no matter their prominence or wealth."[1] Back in Newfoundland, he became a passionate pro-labor journalist (in both print and radio) as well as a union organizer, but his overarching goal was to bring Newfoundland into confederation with Canada. A member of the British Commonwealth,

Newfoundland had been invited to join the country in 1867, but turned it down. When it went bankrupt during the Great Depression, it went into a kind of receivership under Britain's control. In 1948, when Britain decided it could no longer maintain it, and Newfoundland wanted to regain control of its affairs, voters were faced with a choice: to go it alone (but perhaps then join the United States, if the country would have it) or to join Canada. Geoff Stirling had advocated joining the United States, which could happen only if Newfoundland first turned down confederation. Confederation won in a close vote, and Canada agreed to accept Newfoundland. Smallwood became its premier (provinces do not have prime ministers). Over the years, he did many things to help Newfoundland economically, but his rule was often thought iron-handed, controlling, top-down. He was a Socialist with a populist bent. His reign lasted about twenty-four years, ending in 1972, only two years before *Waiting for Fidel* was shot. Thus, although he was not Castro's North American counterpart, had not led a revolution or become a hero of the Left, he had more years' experience as the head of a quasi-state than Castro at the time had as a prime minister. He was, moreover, a committed Socialist (although a member of the Liberal Party), and was used to getting his way.

At what appears to be the equivalent of a middle school, where students pay no fees and are fed and clothed but have to work three hours a day making baseballs, Smallwood and Stirling engage in an intense argument. Smallwood is impressed, Stirling is disturbed. About the work, Stirling asks sarcastically, "They get paid for it?"

"Yes—free tuition, clothing," answers Smallwood.

Stirling: "Like our Newfoundland fishermen used to, with no money involved."

Smallwood thinks the work requirement is a good thing; it promotes a positive attitude towards labor. Stirling is outraged that children eleven years old should have to work. Rubbo takes Smallwood's side. Stirling shouts, "If you want to get apologetic for this whole system, *that's fine.* But it isn't *my way* of *looking* at it!"

"No," replies Rubbo, "I want to *learn* something. You don't want to *learn* anything!"

Smallwood accuses Stirling of looking at work as a penalty. Stirling counters that he looks at work as an opportunity to develop one's

6.2 The three men debate the Cuban system. Production photo. *Waiting for Fidel* (1974). The National Film Board of Canada.

"God-given talents." Smallwood would like to see every child in Canada have to do some work; Stirling says children should be allowed to have a childhood.

At dinner, the argument resumes. Stirling says that his employees are much better off than Cuban workers. Smallwood reminds him that Cuba is "a *poor country.*" To bring hostilities to an amicable end for the night, Smallwood says, "One thing I think we can agree on: if we can get an interview with Fidel Castro, it should be interesting."

Their next outing is to a mental hospital. Its treatment of patients appears to be humane and accepting. An affable doctor tells us that the patients are given paid work, and we see them enjoying recreational activities. The film lingers on a discussion with a woman who has a sad face and a bruised left eye. She says that her parents emigrated from Cuba to the United States and that she could have joined them, but chose to stay. She calls Castro "a very great and very busy man." When Smallwood asks her in what sense is he great, she replies, "The only way

6.3 The debate continues. Production photo. *Waiting for Fidel* (1974). The National Film Board of Canada.

one can be: serving other people." When Rubbo asks her what kind of passport she has, she says that she has a Cuban one, of course, being Cuban, and then adds, "My dear man, I'm the one who's a patient here, not you." While we don't witness arguments here among the three men, Rubbo, narrating, says he is "quite impressed. Stirling is … more skeptical. And we argue constantly about what is natural in human society." By the time they visit the next site, where, we are told, a whole new small city is being constructed mostly by amateur builders, and the rent for a dwelling is just 6 percent of the breadwinner's salary, the division among the men has become acute. The community's "enthusiasm makes me a bit giddy," Rubbo says. "It seems intoxicating to Joey … no doubt recalling his own blockbusting days." While Smallwood is asking all sorts of questions about the project, Stirling is sitting off by himself, and we begin to hear him in voice-over reading some doggerel he has written:

Oh to live in gay Havana in the concrete blocks of clay,
And the workers from the anthills coming out to start
 each day.
Oh, the pure, right endeavor as they shovel dirt and clay,
Singing songs of inspiration as they toil day after day.
No more need to worry of redemption, no need to bow
 their heads in prayer,
For they know that they are chosen, made of nothing more
 than clay.
Ah, the gay and happy workers, toiling daily for the state,
If they reach their happy quota, on Sundays they can sleep
 in late.

Midway through Stirling's rhyming, the scene shifts to the mansion, where Stirling is reading the poem in sync. He seems pleased with it. Smallwood, annoyed, asks Stirling, "Geoff, did you write that? It was clever." Rubbo asks Stirling if he believes those sentiments or is just being cynical. Stirling says he's just being cynical. "You're poking fun," Smallwood says, adding that he is irritated "at the *slur* on the concrete boxes. I *wish to God* every family in Newfoundland, in St. John's, had homes as good as these."

A visit to a prestigious technical university provokes discussion, not an argument. Unlike Stirling, Smallwood is entranced. As premier, he had made education a top priority. In 1965, at Memorial University (Newfoundland's most prominent), he announced that students would no longer have to pay tuition and that they would get living allowances. He was wildly cheered.[2] The three men speak with the student body president and with other student leaders. One explains the difference between Socialism—it rewards workers according to their contribution—and Communism—it rewards workers according to their needs—and is utterly unfazed by Stirling's skeptical comments and questions. The student leader and a grinning young woman at his side, who bobs her head with him in constant agreement, display the serene confidence of true believers. When Stirling mentions that in a capitalist country, a worker can buy stock in the company he works for and eventually become majority shareholder, the student body president says that he worked for Chemical Bank in New York for a year,

and the amount of stock he could buy was infinitesimal in relation to the total amount of stock in circulation.

The arguments between Stirling and Smallwood about the merits of the Cuban Revolution are only part of the contrast drawn between them. They not only have opposing ideologies—they have opposite personalities. Smallwood is fighting off, we sense, the fear of having become something of a has-been. In downtime (on a beach, beside a pool, at a patio table), Smallwood composes questions he will put to Castro during the interview. We hear them in Smallwood's voice-over. They sound slightly self-important, presumptuous, and sometimes rather silly: "Prime Minister," Smallwood rehearses, "You're a doctor, Doctor Fidel Castro. Doctor of what?" Before the revolution, Cuba was bedeviled by crime, alcoholism, drugs, prostitution, unemployment, and poverty, for which "Cuba was really notorious … infamous, even. Tell me about them, would you? … Prime Minister, would you, uh, would you tell me your thoughts on parliamentary democracy?" Later, as Smallwood paces around carrying his notebook and ruminating, Rubbo, in narration, comments, "Joey has enough questions to fill a small book."

While Smallwood thinks up questions, Stirling relaxes and philosophizes. He is a capitalist but a new-age one. He likes to sun himself in a skin-colored Speedo. He enjoys standing on his head because, he says, it opens up the organs, relaxing them. He alludes to Jonathan Livingston Seagull. He wonders if the psychiatrists at the mental hospital have tried LSD therapy. He wears heavy gold chains and shirts open to his belly button. Often he seems bored, while Smallwood is consumed with excitement at the prospect of interviewing Castro.

Despite their tense exchanges, we begin to sense that at some level Smallwood and Stirling like each other. We learn that they have known each other for more than twenty years, and although they were on opposite sides of the debate over whether Newfoundland should join Canada, they respect and even admire each other.

Rubbo helps us to like them both. He films an engaging scene on a beach with the two men, in a wide two-shot, discussing the impact of changes in the price of gold. The film team's imperturbable Cuban interpreter is looking on and listening. "Every time gold goes up ten

dollars an ounce, we make a million dollars," Stirling says. "So," Small-wood asks, "you've made a million in the last week?"

"Yeah."

"I think you should present *every nickel* of that to Cuba."

"You do?"

"Yeah."

Stirling needles Smallwood back, saying that if he presents it to anybody, he'll give it to his corporation to expand television through-out Newfoundland.

Smallwood can be tiresome, but we learn from Rubbo that he carries within him a painful political memory. He had instituted rad-ical, populist educational reforms, and was once loved by students and others for them. "But he lost the support of the Newfoundland youth," Rubbo explains, "and at the '69 [Liberal Party] leadership convention, the students gave him the Nazi salute and shouted 'Fascist!' And that hurt." Although Rubbo doesn't show footage of the incident, there are glimpses of students giving the Nazi salute in an earlier NFB documen-tary on Smallwood, *A Little Fellow from Bambo* (1970), directed by Jul-ian Biggs. (Rubbo's remark that the incident was hurtful to Smallwood is perhaps corroborated by Smallwood making no mention of it—that I could find—in his exhaustive autobiography, *I Chose Canada*.[3])

And it's hard not to be touched when, nearing the end of their stay in Cuba, when there still has been no interview, Rubbo asks Small-wood if he feels frustrated. Smallwood answers, "I still have faith. I have faith in Fidel. In fact, doesn't 'Fidel' mean—faith?"

Rubbo: "That's right."

Smallwood: "I must ask him what the name Fidel means, when I'm done asking him about his religious faith."

Stirling (facetiously): "That's a new question."

Smallwood: "Huh?"

Stirling: "That's a new question."

Smallwood: "Hmm. Yeah. I'm prepared to understand. I'm pre-pared to make all kinds of reasons, even excuses, because ... *I* had a job ... once ... *something* like his job. A *bit* like it. I had a cabinet, he has a cabinet. I had ministers, he has ministers ... *and* responsibilities, *and* cares, *and* concerns ... and, uh—"

A phone call interrupts. Smallwood has been invited to a reception Castro is holding for the head of East Germany, Erich Honecker. Smallwood is delighted, but he is told he needs to wear a dark suit. He didn't bring a dark suit with him to Cuba. Fortunately, the assistant cameraman has one. It doesn't fit Smallwood well but will serve the purpose. When Stirling laughingly observes, "Fits you like a glove, Joey. Too bad it doesn't fit you like a suit," we sense his affection for his ideological opposite.

The angriest and most memorable exchange in the film is not between Stirling and Smallwood but between Stirling and Rubbo. "Relations between Geoff and myself are deteriorating," Rubbo informs us over a shot of a tape recorder on which Stirling has been leaving messages for him. "Stirling is worried about his financial stake in this film." Stirling (on tape) disagrees with Rubbo's position that some things are worth doing whether they make money or not. Rubbo wants the argument to continue on camera, and so it does. After several exchanges along that line, their voices getting shriller, Stirling finally explodes: "I happen to be the guy that's paying for *that* tape that's running, and *that*"—Stirling points to the camera—"film that's running. And I'm telling you that [this project] was set up as an experiment to see if we could bring in a film that was good enough for release on NBC, and if you go over—as I know, I've had too many camera crews, and my instructions are three-to-one in color, five-to-one in black and white."

Now Rubbo, who a moment earlier had denied having heard of this experiment, explodes: "Why did you come to the *Film Board*? You *know* we do twenty-to-one!"

"Not with *me*, you don't!"

"Why didn't you say that?"

"It's your problem."

"Why didn't you say that in those meetings?"

"Because it never entered my head you'd try to shoot twenty-to-one!"

"Well, I'm *sorry*."

Stirling becomes apoplectic: "When you shoot—Mike, try to tell me—no, just a minute, Mike, maybe you're going to spend the rest of your life—"

Rubbo, muttering: "It's going to be twenty-*five*-to-one."

"—as a good, *graying, fat* guy who has never done anything under twenty-five-to-one, but if it *is*, Mike, you are so far *out* it, man, as a producer, that you're just a (BLEEP) joke!"

"Look, you think it's somehow—"

"(BLEEP) twenty-five-to-one, Mike, for the love of (BLEEP), man, you've got to be *kidding* me."

"I—"

"Twenty-five-to-one to put a film on?"

"Yes."

"How much (BLEEP, BLEEP) talent have you got, if you can't shoot better than that?"

"It's not a question of talent."

"If you've got a script together, man, and you know what you're gonna put together, you need three-to-one on the outside—"

"Bull-(BLEEP)!"

"Who the hell are you kidding?"

"Bull-(BLEEP)!"

"Well, come and meet a few *professional* directors! They'd—they'd *laugh* at you! If I told them twenty-five—wait till they *see* this film! They'll say, 'My God, *who* was that *guy*? ... On *what grounds* did he call himself a filmmaker?'"

The film cuts to the three men at dinner, subdued. It is in this scene that Smallwood is invited to the reception. When he returns from it, he is jubilant. "What a *night*! There're eight hundred *people* there, diplomats from all around the *world*, and here was Fidel and Honecker, from Germany, lined up [receiving people]." Smallwood beams with pleasure bordering on joy as he tells Stirling and Rubbo that he got a hug from Castro.

Smallwood says he told Castro about the film crew waiting for the promised interview, and that Castro assured him the interview would take place. But the interview does not occur, and days later a dejected Smallwood and Stirling take leave. They are gracious. Smallwood tells their interpreter, "I was very pleased to meet him. Will you tell him that?" Stirling expresses his thanks to the Cuban government for the exceptional hospitality it has showed them. Rubbo is staying behind to shoot some more footage, for a second film. Over credits, we see, from the point of view of onlookers, Castro giving a public speech.

6.4 "Twenty-five-to-one to put a *film on?*" Screen grab. *Waiting for Fidel* (1974). The National Film Board of Canada.

The film's mood in this scene is awestruck, wistful, and just this side of worshipful.

As the film neared completion, the largest concern at the Film Board was the expletive-laden argument between Stirling and Rubbo about shooting ratios and the purposes of film. Was it self-indulgent in an institutional sense? Would audiences care about the issues in the argument? Rubbo and producer Tom Daly wanted to keep the scene but bleep out the cuss words. Fortunately the executive producer, Colin Low, and the Film Board's upper management supported them.

Rubbo and Daly had another hurdle to clear before the film could be released: they had to show a finished cut of the film to Smallwood and Stirling for their approval. After the screening, Rubbo remembers, "Joey paced in front of the now-darkened screen and mused, 'If we hadn't been on our high horses, we would have got that interview.'" Smallwood thought that their freewheeling arguments about Castro's

Cuba might have been reported to the authorities and scared them off. Stirling was furious at how he was portrayed, but he

> relented when some courageous member of his entourage piped up and said, "That's you, Geoff." At this point, Geoff laughed, and said, "We'll do a deal with you. I'll sign a release if you give me all the outtakes, and I'll make the film that *should* be made, the *good* film." This was a most unusual offer, but since I knew there was no better film in the rushes, I urged Tom to accept the deal. We did, and the material all went to Stirling, who did nothing with it as far as I know except rant about the whole affair on his Newfoundland TV station, after midnight, sometimes with Joey there to tease him.

The film fared less well with the Canadian Broadcasting Corporation. A 21 October 1974 letter from a CBC executive to the Film Board reported that the CBC's director of information programs thought the film "self-indulgent and precious." In a letter dated 29 November 1974, another CBC executive, from whom the NFB sought a second opinion, reported to the board's administration that he too found various problems with the film. The argument between Stirling and Rubbo struck him "as being a very 'in' thing" and unlikely to interest most of CBC's typical audience. And the narration "had a distinctly pro-Castro Cuba orientation" which, he says, may have disturbed the director of information programs, whose position on the film he seconded. In addition, as Jeannette Sloniowski has suggested in an insightful scholarly essay on the film, broadcasters were uncomfortable with Rubbo's style because it undermined the assumed authority of the typical television documentary: "Is it any wonder that the CBC balked at showing *Waiting for Fidel*, a film that mocks that serious, and frequently stodgy, enterprise: the documentary film?"[4]

While the Film Board pressed the CBC, in vain, to broadcast the film, its own distribution wing apparently did not make an all-out effort to get the film before audiences. In 1975, I told David Denby, whom I had known from our graduate school days and who was now living and working in New York as a freelance film critic (and later

staff film critic first for *New York* magazine, and then the *New Yorker*), how terrific I thought *Waiting for Fidel* and *Wet Earth and Warm People* were. Denby had seen and loved *Sad Song of Yellow Skin,* so he arranged for a screening of the two films at the Film Board's New York office. He liked them so much that he introduced them to the Film Forum, which subsequently programmed them for a short run in November. Afterwards, he wrote me (8 December 1976) about the Film Forum run and his experience at the Film Board's New York office:

> The Rubbo caper seems to have gone off very well. I include the press coverage, which is really quite decent. ... I don't expect the Film Board to do anything [to promote the film]. They are the most lazy and indifferent people (in New York, that is) I have ever met in the film business. *I* set up the screening of Rubbo's films at their office—they didn't give a damn—and dragged some other critics along. ... When we got there ... no one seemed to know what was going on or why we should care about these films. The projectionist put the Indonesia film on first because it was "the better of the two." I had to remind him that he was supposed to be promoting this stuff, and he shrugged his shoulders. He then told us we might not be able to see both films because "a Canadian M.P. is coming along and we need this room." (This turned out to be a false alarm.) The final absurdity: when one film was finished he switched on the second without the slightest pause, as if it were an ordinary reel change. Now I understand why nobody outside of film schools gets to see NFB work around here. As far as these guys are concerned, it's just a *film*—it could be [about] anything, the Alberta Falls, or a travelogue on the Northwest country. I finally blew up at them and went into a long rant about Rubbo going halfway around the world and knocking himself out, and you guys don't care if anybody sees it, etc., etc. Sometimes Canadians are a little too low-key. Anyway, everything worked out fine and the Film Forum did the best business in their five-year history.

When I asked Denby, in 2014, for permission to quote from his letter, he wrote back, "Yes, of course quote from it. My anger came back when I read it again." Richard Eder praised both films in his *New York Times* review (14 November 1975)—they were "fresh and funny"—and offered a perceptive observation: "Mr. Rubbo likes the Cuban Revolution, but he does not anchor the film to his liking. Perplexity is his instrument for measuring the world, and he never lets go of it." In his own review (also in the *New York Times*, on 16 November 1975), Denby called *Waiting for Fidel* "a highly inventive and at times excruciatingly funny documentary about self-deception and the limitations of curiosity," adding that Rubbo was "attacking the complacency of conventional 'observers' as a way of reasserting the right to observe." *Waiting for Fidel* became a hit on the festival and art-house circuits. It was shown on American public television.

After these successes in the United States, the Film Board again approached the CBC about broadcasting the film. On 30 March 1976, in a memo to Rubbo, who had inquired about distribution efforts, NFB executive Barbara Janes wrote that she had reopened the subject with the head of current affairs programming at the CBC. That person, Janes reported,

> said that he too had seen the reviews and that they had interested him. He had therefore sounded out [his boss] on how he felt about "Fidel." [His boss's] reaction was so overwhelmingly negative that [he] felt it was pointless to pursue the issue. Therefore, the film seems a lost cause as far as Information Programming at CBC is concurred [*sic*; probably "concerned"].

Janes wrote that she has approached still another CBC executive for an opinion and would report back to Rubbo when she heard from him. Presumably the response was negative. The film was not shown on the CBC.

The film gradually achieved wider fame among the fans of documentary. The scene that the CBC and some at the Film Board thought was too much like shoptalk delighted audiences. The public was becoming savvier about film, and interested in its workings. The issue

of shooting ratios, which broadcasters considered of little interest to non-filmmakers, is not just a budgetary matter—it's also a matter of empirical method. The constraints that a three-to-one shooting ratio impose on what a film can explore and reveal are far more stringent that those imposed by a twenty-five-to-one ratio. The difference is not just quantitative: the lower the ratio, the more a director has to rely on preconceptions and the less open he can be to experience. And Rubbo's on-camera direction, responding to the unforeseen, inspired documentary filmmakers in the way Jean-Luc Godard's disruption of traditional dramatic narrative provoked new experimentation by directors of drama. As Trish FitzSimmons and her coauthors put it in *Australian Documentary: History, Practices, and Genres*, the film became "an influential model of a documentary whose narrative emerges during production."[5]

The CBC's objection to the film's pro-Cuba, pro-Castro slant was not wholly unfounded. Stirling is outnumbered two-to-one. Rubbo's narration is sympathetic to Cuba and Castro. Smallwood is effusive. His adoration of Castro is disconcerting, as is his embrace of the murderous Honecker. The concluding scene of Castro delivering a speech to the masses is uncomfortably reverent. Nevertheless, the criticism, when elevated to a reason not to distribute the film, seems overblown. The film's ideological slant is mild and not insistent. And there are subtle suggestions, intended or not, that maybe Cuba is not a workers' paradise. The responses of the student leader at the technical school sound programmed. The mental patient who captivated Rubbo looks sad, defeated. During one scene at night just outside the mansion, Rubbo cuts away to a shot of ants carrying pieces of leaves down a tree. What's fascinating about the film is the clear and hilarious way it demonstrates how one's preconceptions shape perceptions. Stirling, Smallwood, and Rubbo see in Cuba mostly what they came prepared to see. And Rubbo's film shows that. This lifts the shouting match between Stirling and Rubbo far above just a filmmaker's extended in-joke. Rubbo lays bare his own values and possible shortcomings in the scene, and he allows it to conclude with Stirling ridiculing him. Thus the film not only shows how preconceptions shape perceptions, it shows how it shows it.

And Rubbo accomplishes this through *drama*—that is, with characters in conflict, characters with flaws and strong points. He does

not demonize opponents. Each character is treated with dignity, and the closest Rubbo comes to denigrating one of them is in the argument with Stirling, which concludes with Stirling's denunciation of Rubbo himself. Conflict between persons is not at all uncommon in reality-based documentary, but conflict between *characters*—persons depicted in the round—is rare. A director showing himself to get the worst of an argument is rarer still. Rubbo easily could have edited the argument so as to give himself the last word.

As the film was shown, and written about positively by major critics and commentators, Stirling began to change his mind about it. In March 1976, he sent a telegram (stamped 23 March 1976 in the Film Board archives) to Daly. His message was brief: "CONGRATULATIONS ON THE MAGNIFICENT REACTION TO WAITING FOR FIDEL AND THE ASTUTENESS OF YOUR DECISION TO SELECT RUBBO. I BELIEVE YOU HAVE A WINNER ON YOUR HANDS. NAMASTE. GEOFFSTIRLING." Whether Stirling had forgotten that he had asked for Rubbo to be assigned to direct the film or was generously crediting Daly for the choice, he was conceding that Rubbo was right about the film.

After putting Smallwood and Stirling on the plane back to Canada, Rubbo and his crew remained in Cuba for another few weeks to shoot additional footage. From this new footage and some outtakes from scenes used in *Waiting for Fidel*, Rubbo edited a second television-hour film, *I Am An Old Tree* (1975).

The film is stylistically remote from that of *Waiting for Fidel*. Rubbo makes only one (very brief) visual appearance, and that is near the end, when he steps in front of the camera to shake hands with and say goodbye to two Cubans he had filmed. It is an inconsequential appearance. He is heard asking questions off camera from time to time. And yet, in some ways the film seems more personal than *Waiting for Fidel*. It expresses just *his* point of view, not those of three opposing observers of whom he was one. Without Stirling and Smallwood sharing the stage, his narration reflects only his own thoughts. And it is denser—i.e., there's more of it—in this film than in the ones he had made so far. He seeks to answer a question, posed over opening shots of happy toddlers in a day-care playground: "I stood at the gate, watching the kids in the playground, and wondering what this collective life ...

is really about." He visits several different locations or events, including the day-care center, a parade honoring visiting North Vietnam leader Pham Van Dong, a hospital where a woman gives birth, a boarding school, a meeting of a neighborhood Committee to Defend the Revolution, and a small farming village in a remote province.

Rubbo marvels at the love Cubans show for their children. He is impressed that all families can now eat meat and fish regularly and that they feel a sense of economic security. There is rationing, he acknowledges, but says it ensures that everyone gets a fair share. He seems to approve of Cuba's honoring of Van Dong, seeing parallels between what the United States did in Vietnam and what Cubans suspect the United States may have wanted to do in Cuba. He admires the Cubans' ability to improvise, the way they cannibalize parts from old machines, including cars, elevators, and air conditioners, to make some of them work. He is charmed by the children and impressed by how they are socialized into a sharing attitude. He expresses ambivalence about both the mass meetings presided over by Castro and the small meetings of the neighborhood committees, but he admires the neighborliness he observes in various gatherings. He is awed by the quiet beauty of the small farming village—not just its picturesque setting and quaint appearance, but also its simple, open, hardworking, apparently contented residents. At one point, he muses, "When I see people, fairly happy, making do with ... so little, I start thinking ... about ... *balance*. Is it inevitable that the human animal will always want more food, more power, more affection, than it needs? What will happen if we can't have more ... without depriving others? Will we accept a smaller measure, or will we go to war, to protect our affluence?"

The film is clearly sympathetic to Cuba, but Rubbo harbors ambivalence. He finds the committee meetings doctrinaire; the mass rally is exciting but intimidating. He observes that some factories have a problem of absenteeism, which results from basic needs being met already by low rent, free health, and cheap food. One Doctor Grande, who recurs in the film, is of particular interest to Rubbo. Dr. Grande had moved to the United States in the pre-Castro 1950s in order to make more money than he could in Batista's Cuba. He did well there, but he says that while he had a good account in his bank, he wanted a good account in his conscience. In 1963, after the failed US-backed

invasion at the Bay of Pigs, he returned to Cuba. He says he is happy with his decision even if the adjustment has not been easy. Rubbo asks Dr. Grande how well he has adapted to collective life. An old tree, Dr. Grande answers, is already shaped. I am an old tree. I have bad habits, he says. A young tree, you can shape, make it what you want.

Near the film's end, as Castro is mesmerizing the massed crowd (as well as people listening on the radio or watching on television), Rubbo says the speech reminded him of "another moving speech, almost as old as the revolution. Perhaps there's some connection." Then, over a scene from the village, we hear a recording of John F. Kennedy's famous exhortation, "Ask not what your country can do for you. Ask what you can do for your country." Rubbo then rephrases Kennedy: "Ask not what you can do for yourself. Ask what you can do for others. It's hard. I think that I too … am an old tree." Then the credits roll over images of "young trees," the children at the day-care center.

I Am an Old Tree is a meditative film. It is not a story. It reflects primarily Rubbo's thoughts about what he shows us. But Rubbo is a keener witness than his informal style of narration might suggest. His observation about the flagging work ethic is prescient: Western welfare states are now experiencing a similar phenomenon. His question about our willingness to share our affluence is now the subject of discussion on college campuses, in Western legislatures, and in the United Nations. And his pairing of Castro's inspirational (to Cubans) speech with Kennedy's call to put country first is a clever warning leading to a deft rejoinder. Kennedy gave his speech less than two years before the massive build-up of troops in Vietnam and their subsequent long stay, a venture Rubbo despised then and now. Thus Rubbo is cautioning admirers of Cuba that such idealism can go wrong, as it has so often in the past. His recasting of Kennedy's words into a universal message of altruism dampens the original's chauvinistic undertone.

Rubbo's closing admission that he is an old tree is another example of the personal honesty and lack of self-righteousness in his on-screen persona. It also reflects maturation in his political outlook. Documentary filmmaker and scholar Alan Rosenthal, in his 1980 anthology of interviews with filmmakers, *The Documentary Conscience: A Casebook in Filmmaking*, asked Rubbo about using film to advance a political agenda. Rubbo responded that he is

not a true believer, and am becoming less of one every day. I distrust more and more those who say they have the answers. The idealists and the utopians. I tend to want to be a weakener of strong positions where blind strength and dogmatism go together. I want to sabotage the sloganistic response to life. I am more skeptical than I was of societies that say they are trying to create the new man, like Cuba. I think these things appear in most of my films and will probably go on appearing in them in the future.[6]

Where the Action Isn't

Log House; *The Walls Come Tumbling Down*;
I Hate to Lose; *Tigers and Teddy Bears*

After his Cuban documentaries, Rubbo made two short films, both codirected. In terms of style, *Log House* (1976), directed with Andreas Poulsson, the film's cameraman, is diametrically opposed to the approach he used leading up to and culminating in *Waiting for Fidel*. A television half-hour, the film is completely devoid of narration and contains only bits of dialogue in un-subtitled French. It observes the construction of a log cabin in a nearly pristine mountain forest north of Montreal. Four Quebecois men build the cabin over several seasons, which they use to their advantage, cutting and trimming cedars in summer and fall, hauling them to the building site in winter when they can be dragged over the snow, and leaving them there until the spring thaw makes digging and building possible. The builders are led by Lionel Bélisle, whose name we learn only in the credits. Three young men, who apparently are brothers, assist him.

Log House is a sensual film, rife with tight shots of construction activity, location sounds, and pleasing wide and following shots of the men working. It is informative: for example, we see the meticulous, time-consuming process of cramming dried moss between logs for insulation. It is also a tacit comment on changing technology. The men

use a combination of primitive tools and modern machinery. Bélisle's knowledge is considerable. He seems to know how to do every step required for building the cabin. No specialists are brought in, and he teaches his young crew how to do a range of tasks.

The one quality of the film that is familiar from Rubbo's best work up to that point is its affection for its main character. But it does not require much artistry to make us like Lionel Bélisle. He takes pride in his work, manages his work crew casually and collaboratively, knows how to relax, and is almost always singing. He performs a brief jig while carrying a window frame. After cutting out a square in a solid log wall from the inside, which is filmed from the outside so we don't see him until the square is opened, he looks at the camera, says hello, and doffs his cap. He plays the fiddle at a celebratory party when the cabin is finished. He is an exuberant person, and Rubbo and Poulsson allow us to enjoy and appreciate him.

While *Log House* depicts a dwelling going up in a near-wilderness, *The Walls Come Tumbling Down* (1976) is about city homes—some are beautiful mansions, others comfortable and affordable family dwellings—being torn down to accommodate high-rise apartments and office towers. Rubbo had two codirectors, William Weintraub and Pierre Lasry, and he wrote and spoke the narration. The film decries the destruction of charming Montreal architecture, ranging from immense mansions that could be put to public use to working-class neighborhoods that are good places to live. The film takes the side of protestors who show up at the sites where houses are being demolished. One of them is a woman in her fifties who seems somewhat pixilated, who can't shut up, but is on the filmmakers' side of the issue. A few young activists have attempted to persuade city officials, politicians, and developers to stop the destruction of the older sites, but to no avail.

The film is both a lament and a call to action. Violin music early in the film sounds like a dirge. And the construction of ugly buildings "nobody seems to want" appears bound to go on and on. But eventually, community activists manage to get eighteen anti-development representatives elected to the city government. The film includes a cautionary interview with a Polish architect. He relates how in Poland, when the government's central planners were committed to equality, charming and livable neighborhoods were torn down and high-rise

apartment buildings erected in their place. The apartments differed only slightly, and according to needs, such as family size, rather than income. But the price of equality was architectural monotony. (The film shows a tract in Poland with several such high-rises; not only do they look monotonous, they are eerily like the dispiriting housing complex that is the setting for Polish director's Krzysztof Kieslowski's ten-film series *Decalogue*, completed years later, in 1989.) Near the film's end, we see an area of several blocks where over two hundred and fifty flats have been razed, and the sites readied for development. "Such irresponsibility," Rubbo intones, "really invites the Polish solution. So watch out, you greedy ones. And," Rubbo adds as we return to the vociferous lady at a protest, "we need *you*, dear lady, to keep giving them hell."

Rubbo's next hour-long documentary, *I Hate to Lose* (1977), is about one small, politically insignificant corner of the 1976 Quebec parliamentary elections: the race in the riding of Westmount, a prosperous, primarily Anglophone district in predominantly Francophone Montreal, in overwhelmingly French-speaking Quebec. The province's premier, Robert Bourassa, of the Quebec branch of the Liberal Party, has called the election two years before his mandate is set to expire. He wanted confirmation of his commitment to keep Quebec in its relationship with the rest of Canada, as a province like other provinces. His main challenger is René Lévesque's Parti Quebecois. The contest is essentially between French Canadians in Quebec who were more or less happy with the province's relationship to the federal government (and thereby to the rest of Canada) and those that weren't.

Lévesque had left the Quebec Liberal Party and formed the PQ in 1968. He was, or wanted to be, a moderating influence on French-Canadian nationalism, whose most passionate representatives wanted complete separation from Canada. In his *An Option for Quebec*, essentially an extended political pamphlet, he laid out a case for Quebec as sovereign but not completely separate from the rest of Canada. In the forward, signed by himself and ten others, they say that they left the Liberal Party looking for a solution that "was capable of reconciling the reality of interdependence with the exigencies of political sovereignty essential to the development of modern nations." They wanted a "sovereign Quebec which would be associated with Canada in a new union."[1]

How this association between a free Quebec and Canada would work remained vague: a monetary union, a common market of some sort, and coordination of fiscal policies. The sovereignty part was by contrast decisive and urgent: we "must rid ourselves completely of a completely obsolete federal regime. And begin anew ... Quebec must become sovereign as soon as possible."[2]

French Canada had always believed that it was short-changed in its economic dealings with the federal government, but cultural anxiety was perhaps the main emotion propelling sovereignty. In his biography of Lévesque, Daniel Poliquin writes that their status in Canada had made Quebecers insecure. They worried about the decline of French Canada. Immigration was a major issue. Immigrants settling in Quebec would assimilate into Canadian, not Quebec, society. They preferred learning English to French and sending their children to English-language schools. As Poliquin put it,

> Many felt something had to be done about immigration. And it was not just a matter of countering assimilation [to English Canada]; it was also a case of a majority that had always thought of itself as a minority suddenly realizing its strength and wanting for the first time in its history to assert itself. The message was clear: this is our place, always has been, and from now on, we will manage our own affairs in accordance with our aspirations.[3]

The PQ had competed in two recent provincial elections. In 1970, the Liberals won a sweeping victory, taking 71 of 108 seats. English Canada was euphoric. The PQ took just 7 seats, but they won 24 percent of the popular vote. In 1973, the Liberals took 102 of 108 seats. The PQ's share of the popular vote increased to 33 percent, but it suffered a net loss of one seat. Compounding their frustrations was a perception that the Liberal Party had become complacent and corrupt in Quebec. And a language bill introduced by Bourassa angered all sides. It restricted access to English-language schools, made French compulsory in some professions, and allowed any immigrant or French-speaking citizen to attend English-language schools if they passed a test. There was a

perception that the Liberals hadn't protected the French language in Ottawa or Quebec.[4]

But despite their steady gains in the share of the popular vote and the general dissatisfaction with Bourassa, the PQ was given little chance of winning the election. A vote for them was seen as a vote for eventual separation, something a majority of the French-Canadian population was thought to be wary of. Nevertheless, those in Quebec who were not nationalists were nervous about the election. There was also a specific proposal backed by the PQ that scared Anglophones and immigrants: Bill 101, which would make French the official language of government, the courts, and the workplace. All signage would be in French, and immigrants would be channeled into French schools. For most of Westmount's English-speaking voters, the main goal was to keep Bourassa and the Liberal Party in power, if only because the alternative was frightening.

The film focuses on Westmount's three Anglophone candidates: George Springate, candidate for the Liberal Party; Harold "Shorty" Whitehead, representing the Union Nationale, a once-powerful party that was trounced in the last election but is making a comeback; and Nick Auf der Maur, a former muckraking journalist and a member of Montreal's city council for the past two years, and who has launched a new political party, the Democratic Alliance. The PQ has fielded a candidate, but he hasn't a chance of being elected in this well-to-do English-Canadian stronghold. Rubbo's film ignores him.

The biggest thing at stake is the bill that would make French the official language of Quebec, although the outcome of the Westmount race is unlikely to affect the overall result. However, looming in the background is the possibility that, if the PQ wins, the new provincial government under René Lévesque will lead Quebec to separate from Canada and establish itself as an independent nation.

Little of this background is made explicit in the film except at the very end. The film is a congenial demonstration of Canadian electoral politics, which in Westmount at least, is admirably civil by today's international standards. We follow the three English-speaking candidates and see, for the most part, that they engage in essentially identical activities. They stand on the sidewalk and introduce themselves to passersby; they go from door to door in the hopes of finding someone

of voter age who is willing to listen to them; they enjoy appearing at electoral coffee parties, where they discuss their views with groups of ten to thirty people; and they strategize with their tiny core of trusted advisors about how to get their message out persuasively and inspire people to vote for them.

Given his sensitivity to character, it is not surprising that Rubbo manages to distinguish the three personalities by more than their party affiliation. Whitehead is soft-spoken, earnest, and not aggressive. He had been a tail gunner in World War II and is now a successful businessman. Springate once played professional football for the Montreal Allouettes and is a former cop. He is boisterous, loud, and irrepressible. Auf der Maur is reticent, soft-spoken (when he does speak), and circumspect. The three respond to the demands of electioneering according to their respective personalities. When rebuffed by people he approaches on the street, Fairhead reacts calmly but sheepishly; rejection embarrasses him. Springate bounds from house to house, never getting discouraged. An older Russian immigrant objects to Auf der Maur's position on the French language issue. "I don't like you," he tells Auf der Maur as he stalks away. Auf der Maur appears unfazed. Rubbo makes no bones about whom he favors in this election: "I was attracted to Nick," he says over the start of a coffee-party meeting for Auf der Maur, "because he's something of a leftist who's actually willing to get into government."

Robert Bourassa had kicked Springate out of the Liberal caucus for breaking ranks on the language issue. It was partly because the Liberal Party had no candidate for Westmount in this election that Auf der Maur entered the race in an attempt to pick up the disenchanted Liberal vote. Although Auf der Maur is unhappy that Springate has entered the race, he believes Springate has been so discredited for being critical of Bourassa while remaining a Liberal that he poses less of a challenge than Fairhead. But Springate is gaining support: many voters view him as the only candidate who, if elected, could have any influence on provincial government policy.

The film's most entertaining scene occurs in a radio studio where the three candidates square off against each other for a debate. Or, more accurately, Fairhead and Auf der Maur take turns at bashing frontrunner Springate. Fairhead charges Springate with hypocrisy. Auf

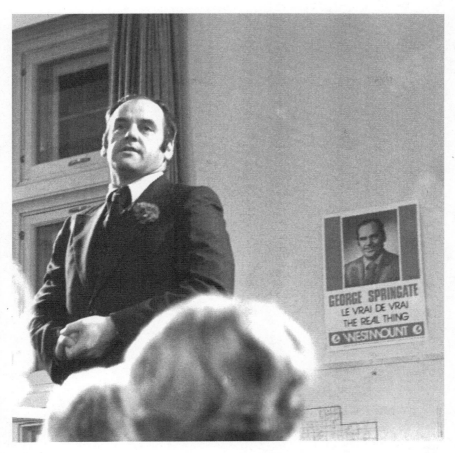

7.1 George Springate. Production photo. *I Hate to Lose* (1977). The National Film Board of Canada.

der Maur accuses him of asking voters to ignore his record. Springate squirms uncomfortably and impatiently under the attacks. When his turn comes, he lashes back at Fairhead for not fighting the language issue when he could have. Now Fairhead squirms. Springate says there's little point in Auf der Maur's candidacy, but Auf der Maur calmly maintains that minority opposition has a constructive role. It can raise questions and suggest alternatives, he says.

Auf der Maur's candidacy has stalled. His advisors are frustrated by his phlegmatic campaigning. At a polite coffee party, a man asks him

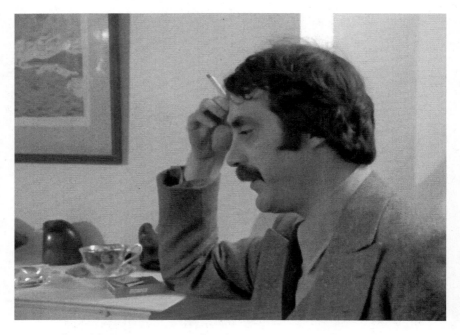

7.2 Nick Auf der Maur. Screen grab. *I Hate to Lose* (1977). The National Film
Board of Canada.

what he has accomplished in his two years as a city councilor. All Auf
der Maur says in response is, "A few minor things, like we've reduced
bus fares for senior citizens." The one scene in which Auf der Maur
appears forceful is at a well-attended rally for him late in the cam-
paign, where he is greeted by enthusiastic applause. "None of the other
candidates have had rallies," Rubbo reports, "perhaps fearing that a
poor turnout would reveal their weaknesses." Auf der Maur begins his
speech with a few remarks in French, then says, "We *choose* to live in
Quebec, we *chose* to learn French, long before any law told us we had to
learn French." Auf der Maur states that he, his party, and like-minded
English-speaking citizens don't want to be isolated from the majority
of citizens in the province, are happy to live among them, and want to
work with them. But the rally proves to be the high point of his cam-
paign. When a voter later complains he is still not clear what Auf der
Maur stands for, he replies that his party welcomes different points of

view. At a coffee party whose attendees are visibly unenthusiastic, he is asked what he can deliver if elected. He responds that he can't promise to deliver anything except his effort. "But a campaign without promises," Rubbo sighs in the narration, "is like a party without booze."

The growing fear of a separate Quebec should the PQ win the election has helped Springate surge into a comfortable lead. He is cocky, confidant, and in good humor, because, Rubbo says, "the papers are carrying reports that Bourassa is *furious* with him, and nothing could be better, right now, than a kick in the pants from the Liberal leader." Springate relishes his position as the likely representative from Westmount. He tells Rubbo that having been expelled from the party and then brought back in, he can now say with impunity the things that got him expelled.

Although the *Westmount Examiner*, which hadn't backed a candidate in a local election in forty years, endorses Auf der Maur, he admits that his own campaign manager has told him privately that he will lose. On election night, Rubbo cuts back and forth among the three campaign offices, television coverage of the election, and Westmount's election headquarters. When the anxiously awaited results from a key district, where Auf der Maur's support was thought to be strong, show him losing by a margin of three to one, his defeat is certain. Springate is declared the winner. Fairhead comes in second, Auf der Maur a distant third. At the election headquarters, Springate walks around, accepting congratulations and hugging supporters.

But "Suddenly," Rubbo announces, "our attention shifts from this riding, and we realize that elsewhere in the city something in ... incredible is happening." On television, throngs of Quebecers are cheering deliriously. In an upset, René Lévesque and the PQ have won the provincial election.

As the film cuts back and forth between the television coverage of Lévesque's victory and the activities in Westmount, the contrast in both enthusiasm and import between Springate's modest little victory celebration and the tumultuous one across town becomes astounding. Springate's supporters number about thirty or forty people. Occasionally, Westmounters gape at the television as tens of thousands of Quebecers cheer Lévesque, yet their attention still focuses on the results in Westmount. But the electoral drama we have followed in that riding

now seems laughable. "Rubbo," Piers Handling observed in his 1977 essay, "shows us a riding that, like an island, is lost in an ocean that it doesn't understand."[5]

We see Lévesque on television giving his victory speech. The spectacle scares many of Quebec's English-speaking residents. A commentator on an English-language television program tries to reassure his shaken on-air colleague, and perhaps himself: "It was quite a moderate speech, really, Stan, quite moderate—don't you think?" The mood is even more subdued in the Fairhead and Auf der Maur headquarters. Fairhead is good-natured about his defeat, but it has clearly stung him. Auf der Maur's advisors drown their defeat in raucous, alcohol-assisted laughter. His idealistic young volunteers are utterly dejected. The film's near-final image is an extended long shot of volunteers taking down a large Nick Auf der Maur banner while in the foreground a stunned young woman, nearly catatonic, stares blankly at something—or nothing—off camera.

Rubbo is not nearly as prominent in this film as he had been in his full-length television documentaries after *Sad Song of Yellow Skin*, but for the first time he overtly declares his political leanings and preference. He likes Auf der Maur because he's a leftist who is willing to participate in government. But Rubbo also seems attracted by the quixotic, underdog nature of Auf der Maur's quest, just as he was by his uncle Francis's sewage diversion plan. Auf der Maur's self-effacement is similarly reminiscent of Francis. At the same time, the film is gracious to those Rubbo doesn't like as much. He is amused by their foibles. Springate, whose brashness recalls Blaker from *Persistent and Finagling*, is treated generously. While Fairhead is prone to trade on his wartime combat role, Springate does not brag about his professional football experience. In a brief conversation with a teenager, Springate notes that the young man seems athletic and asks him if he plays football, and yet he says nothing about his own impressive athletic background (or if he did, Rubbo does not include it in the film). At a strategy meeting, Springate discourages his advisors from using the tactic of associating a vote for either of the other candidates as a vote for separatism. In his victory speech, however, he impugns Auf der Maur's motives, accusing him of entering the Westmount race in order to split the vote. Coming at the moment of his victory, and in Auf der Maur's absence (he hasn't

7.3 Devastated campaign worker. Screen grab. *I Hate to Lose* (1977). The National Film Board of Canada.

arrived at election headquarters yet), the public aspersion seems small of Springate.

I Hate to Lose affirms a tendency in Rubbo's work that in retrospect is noticeable in much of his earlier films: a sense that the real action is elsewhere. In *Waiting for Fidel*, after Stirling and Smallwood have departed, the awestruck final sequence of the huge Castro rally foreshadows the contrast in import between the Westmount election and the PQ's astonishing provincial victory. It's happening in the same city, across town, but Rubbo is not there; he—and we—watch it on television, as if it is happening in a foreign land. But there was also a hint of the same feeling in *Sad Song of Yellow Skin* when, over the final credits and the shots of thick forests, we hear small-arms gunfire, reminding us of the shooting war taking place around Saigon. In *Wet Earth and Warm People*, Rubbo senses the nearness of mysteries he nevertheless cannot access. Even his first film, *The True Source of*

Knowledge These Days, had a touch of this feeling of not being where the real action is. The only truly moving sequence in that film is the pair of stories related through voice-over by the two students who had gone to Mississippi—roughly two thousand miles from Stanford—to support voting rights. Rubbo may be present in his films, but his films themselves are not always present at the center of the action.

It would be easy to dismiss *I Hate to Lose* on the grounds of the irrelevancy of its subject. The Westmount vote was inconsequential, and Rubbo himself regarded the film as a failure. However, just as being off-center, so to speak, in *Sad Song of Yellow Skin* and *Waiting for Fidel* yielded emotions and insights that probably could not have emerged had the films been done as initially intended, *I Hate to Lose* accomplishes something unusual and astonishing: it shows a minority but long-dominant culture—represented by the well-to-do Westmount Anglophones—suddenly discovering what it feels like to be outsiders in one's own city. The scenes of joyous celebration coming over the television as the privileged Westmounters watch—when they can bear to—in awe and shock convey starkly this feeling of sudden outsider status. Empathic viewers of the film can put themselves in the Westmounters' position and experience, vicariously, that feeling of suddenly being an outsider. And conversely, even though the film views the election through the point of view of this once complacent, dominant minority, it conveys a sense of what the other side must have felt in the years leading up to the election. For Piers Handling, in his 1984 revision of his earlier essay on Rubbo, the election night sequence

> contains some of the finest work that Rubbo has done. … Even though the Parti Québécois victory is happening all around them, it is something they cannot bring themselves to see. It is an event that is happening "out there somewhere." Television sets in the background reveal the extent of the PQ victory, but … their attention is concentrated on the immediate fate of their riding. [Springate's] unforgiving and vindictive victory speech is intercut with Lévesque's highly emotional appearance in the Paul Sauvé arena, again shown only on television sets, as if one step removed from reality. Yet the English "reality," symbolized

for generations by the name Westmount, is sad, confused, and lost, detached from the society to which it belongs.[6]

And that it comes at the end of the film, after nearly an hour of watching the low-key, coffee-klatch, minimally impassioned campaign among the Anglophones lends the scene a frisson that it might not otherwise have had.

Graham Fraser corroborates the impression of a shocked English Canada conveyed in the film:

> In Montreal, a long night of celebration began. In English Canada, a sense of shock set in, as if there had been an earthquake, or a hostage-taking. An adventure was about to begin, and no-one, least of all René Lévesque, was sure where it would lead.[7]

But this was to be the high point for Lévesque and the PQ. Daniel Poliquin points out that there was an irony in Lévesque's victory:

> More and more Québécois felt increasingly secure about the future of their language. And with the weakening of age-old nativist insecurity, the need for an independent Quebec became less acute. All his life, René Lévesque had wanted Quebecers to feel confident about themselves; now they felt so confident they no longer felt the urge to separate: a classic case of the law of unintended consequences at work."[8]

While pondering his next major project, Rubbo agreed to direct a short follow-up to *I Hate to Lose*. On *Tigers and Teddy Bears* (1978), Rubbo is credited as sole director, writer, and editor, but of all the films Rubbo had made since *Sad Song of Yellow Skin*, *Tigers and Teddy Bears* is the least Rubbo-like. The film is built on interviews with the three Anglophone candidates from *I Hate to Lose*, along with the Quebecois candidate, who says he ran for symbolic purposes what he knew was a hopeless campaign, and a wonkish political science professor from McGill University. An unidentified person narrates the film. Rubbo

is heard asking only a few of the questions, and they seem rehearsed, or read.

The film is a debriefing of sorts, shot a few months after the election. Although not particularly interesting as a film, it yields some insight into the characters when the candidates are asked why they fared as they did. Springate's response is forceful. Repeatedly jabbing his forefinger at the off-camera interviewer, he says he won because "I *stick* to my *word*. And that is essential in politics. If I tell someone I'm going to do something, I *do it*. Right or wrong, against my party or not, if I give my word, it's *gold*. And that's what hit home more than anything else." A bit later, now pushing his palms forward instead of jabbing his forefinger, he paraphrases: "I don't waffle. Here's where I stand. That's leadership. Straightforward." Fairhead is low-key. He admits to being a weak campaigner—dogged but easily discouraged. When asked how important he thinks charisma is in an election, Fairhead says, "Very important—I wish I had more of it." Auf der Maur expresses doubt about the political system and laments voters' tendency to base opinions on impressions rather than facts. Politics, he observes with distaste, "is like selling soap." The candidates' reflections reveal much about their own characters. Rubbo corroborates their observations with amusing scenes from their campaigns: blustering Springate, who seems to enjoy collaring voters; diffident Fairhead, side-stepped by the people he approaches as if he were some kind of street pervert; and mild-mannered Auf der Maur, yelled at by the Russian immigrant for whom he is too left wing. It is Auf der Maur who gives the film its title. In politics, he muses, "some people are tigers, and some people ... are teddy bears."

Something's Happening

Solzhenitsyn's Children ... Are Making a Lot of Noise in Paris

Cuba had impressed Rubbo. He admired the sharing mentality that he thought he saw there. His warmth toward the Cuban experiment was evident in the two films he made there, especially *I Am an Old Tree*, which, despite its several caveats, is an affectionate account of Cuban society. Although he acknowledged that he felt himself too old—he was about thirty-six—to change, his film approved of the goals Cuba was pursuing and, for the most part, the steps it was taking towards those goals.

But Cuba upset him when, in 1975, it sent its military to Angola. The exodus of the "boat people" who took enormous risks to escape Vietnam after the triumph by the North took him by surprise. Reports of the Khmer Rouge's murderous rampage in Cambodia horrified him. And so, while he remained leftist in his sympathies, he feared he might have been too soft on Cuba's Marxist experiment.

Rubbo's doubts were exacerbated by Alexander Solzhenitsyn's *Gulag Archipelago*, the English translation of which appeared in 1973. Solzhenitsyn described in relentless detail the establishment of prison camps across the USSR, and especially in Siberia. Millions of inmates were forced into labor; thousands were brutalized or killed. Solzhenitsyn himself had been interned for years. Perhaps two aspects of *The*

Gulag Archipelago were most disturbing to its Marxist readers as well as less ideological leftists. One was the sheer nightmarish quality of the Gulag: no due process, whimsical decisions, lack of communication. Even more devastating was Solzhenitsyn's argument that the Gulag could not be blamed solely on Stalin. The Soviet Union's dark side could be traced back to its founding under Lenin, and to its core ideology. It was, for Solzhenitsyn, rooted in the nature of the Bolshevik Revolution and its Marxist-Leninist ideology. It was not an aberration but an inevitable outcome.

Following the book's publication, Rubbo became aware of an even stronger reaction in France, where several prominent young Marxist intellectuals, most of them avid participants in or supporters of the radically leftist May 1968 uprisings in Paris (subsequently known as May '68), had renounced Marxism, written tracts attacking the Soviet Union and Communism, and become media sensations. A vocal group of them were becoming known as the "New Philosophers." The term in French, *nouveaux philosophes*, had a connotation that was often lost in translation. The original *philosophes*, such as Diderot, Voltaire, Rousseau, and Montesquieu, were men of the Enlightenment. But, as explained in the introduction to a special 1981 issue on the New Philosophers in *The Chicago Review*,

> unlike the irreligious controversialists who are thought to have presaged the French Revolution, the *nouveaux philosophes* fix a backward gaze upon their own failed mini-revolution, the famous "events" of May 1968 and the general strike which followed. Once student activists, they have learned over the course of the intervening years to mistrust a narrow Marxist ideology. ... For inspiration [they] have turned to such modern heroes of resistance as Solzhenitsyn and Camus, or to the doubting Socrates, or to the church fathers and the Old Testament. But though they deny the expected Enlightenment touchstones, the century of the rights of man is not hard to discover in their work: in their skeptical vigour the new philosophers recall the disaffected critics of the ancient regime.[1]

Because Solzhenitsyn seemed to be the strongest influence on the New Philosophers, Rubbo decided that for his next project he would attempt to persuade Solzhenitsyn, who was now residing in the United States, to participate in a film about his book and the reactions to it by these young French writers who were once on the left. It so happened that the film would likely be shot on roughly the tenth anniversary of the Paris uprisings.

Rubbo's idea for the film was to assemble several of the New Philosophers at a Russian restaurant in New York, where they would have dinner and a discussion with Solzhenitsyn. The event would be an encounter and would be intercut with relevant archival footage. It would likely be contentious at times. Rubbo proposed the idea to Solzhenitsyn in a letter sent to him at the Hoover Institute, a conservative research facility and think tank housed at Stanford University, and where Solzhenitsyn held an appointment. As he remembers the now-lost letter, Rubbo confessed his leftist sympathies but assured Solzhenitsyn that he would be treated fairly. He described the National Film Board's reputation for fairness and his own somewhat dialectical method. He argued that a film with such an approach might extend Solzhenitsyn's persuasive reach to audiences inclined to disagree with him.

It is hard to imagine the reclusive, doleful Solzhenitsyn seriously entertaining this proposal. Rubbo did not get a reply. He has no evidence that Solzhenitsyn even received the proposal. Perhaps Solzhenitsyn had screeners at the Hoover Institute.

With Solzhenitsyn out of the picture, Rubbo shifted his focus to the New Philosophers themselves. He would take a crew to Paris, where he would team up with a Quebecois journalist based there, Louis-Bernard Robitaille, whom he had met in Montreal through their mutual friend Nick Auf der Maur, the leftist candidate featured in *I Hate to Lose*. Robitaille would help Rubbo make contacts, help him get around Paris, and interpret for him. Rubbo intended to interview a number of New Philosophers and some of their critics and predecessors. And now, in addition to coinciding roughly with the tenth anniversary of May '68, the film would be shot during the French national elections.

The film opens with a tracking shot of Rubbo on the back of a motorcycle (Robitaille's, we later learn) speeding alongside the Seine. Pop music plays on the soundtrack. Dashing through Paris in a car, on

a motorbike, or on foot will become a leitmotif in the film. After this brief intro, the film cuts to a Communist Party rally occurring just before the March 1978 general elections. The atmosphere resembles that of a fair. Young vendors hawk trinkets—small white figurines of Karl Marx; lapel pins showing the hammer and sickle—and various newspapers and journals. Soon we see Rubbo squeezing his way through the crowd, looking for Robitaille, who for the moment remains unidentified. Rubbo introduces himself. (This is a contrivance, as they had already met, and one that seems gratuitous in that it adds little if anything to the film.) "You know Nick auf der Maur?" Rubbo asks. "Yeah," the young man responds, looking quizzically at Rubbo.

"He—he told me when I got to Paris that I, yeah, that I should, uh, find you, because, uh, I'm doing a film—"

"How'd you get in here?"

Rubbo mentions his Film Board press pass, then says he wants to talk with Robitaille later. Rubbo notices a tape with the Soviet national anthem on it. "My contact," Rubbo narrates, "Bernard Robitaille, says it will be *amazing* if they play it."

After lingering to hear Communist Party candidate Georges Marchais rail about wealth disparities in France and promise to make the rich pay, and then the crowd sing "The Internationale," the film cuts to a shot of Rubbo and Robitaille, now looking like old pals, dashing across a busy intersection to a kiosk that sells newspapers and journals. Robitaille gives Rubbo a brief rundown on several dailies. *Le Parisien* is right wing, "a bit racist," with a "very big circulation." *L'Humanité* is "Communist, one hundred fifty thousand." *Le Figaro*, "respectable … of the right." *Libération*, "very interesting … May '68. The children read that." *L'AURORE*, "the 'old man' newspaper … right wing." *Le quotidian du pueple*, "the smallest … very orthodox Maoist," with a circulation of perhaps three thousand. *Le Matin*, one of the newest, is "pro-Socialist. And *Le Monde* "is something special … the conscience of the state, and of the nation."

In his apartment, Robitaille shows Rubbo stories he has published for *La Presse* on prominent intellectuals—not all of them New Philosophers—whom they may want to interview. "And here's Sartre," Rubbo sighs. We won't get *him*, for sure." "No, impossible to get him," Robitaille confirms. Rubbo, smoking a pipe, follows cigarette-smoking

Robitaille around, probing, asking questions about why he left Montreal, and not getting expansive answers. Then, over a montage of shots depicting Robitaille's typical morning, Rubbo says in narration, "It's not going to be easy to work with Bernard. The mornings are virtually lost. He rises about ten, goes to his favorite pastry shop, where he buys a *pain au chocolat*. This he takes to his favorite café, where he has one or two *double espres bien serré*—double espressos, well squeezed. Then he reads newspapers until about twelve … or did, before I met him." At this point, Rubbo meets up with him in a coffee shop. Robitaille groans that "it's too early in the morning." Such interplay between Rubbo and Robitaille, with Rubbo occasionally complaining about Robitaille's work habits, Robitaille teasing Rubbo about his intellectual deficiencies, and the two of them debriefing after an interview, recurs throughout the film. It functions as both comic relief and something like a chorus. The interaction is enjoyable and often, when in reaction to a recent encounter with an interviewee, revealing.

Speeding around Paris on Robitaille's motorbike again, Rubbo pleads with Robitaille, who has poor eyesight, to slow down: "It's quite terrifying on the back of here!" They briefly stop by the futuristic, forbidding headquarters of the Communist Party. Robitaille says he respects the Communists because they live by their principles. Racing past Notre Dame de Grace, Rubbo asks Robitaille why he takes so little notice of the Socialists. Robitaille says they're wishy-washy. Then the two find themselves with a Communist candidate for Paris's eleventh arrondissement, Douceline Bonvalet, a well-educated forty-year-old. A worker is pasting her large campaign posters over those of other candidates. Robitaille describes her as practical, close to the problems of the people she wants to represent. Cut to an elegant dinner, where Rubbo, sipping wine and turning on his charm, questions another woman, Marie-Pierre Carretier. Carretier is a journalist colleague of Bernard's. She won't vote Communist. "Communism is for nuclear power," she explains. "Communism is for the army, Communism is for centralism. It's … a reactionary party."

These two interviews serve as warm-ups for more substantial ones to come. But first there is a brief scene in which two men, one in a Mitterand mask and the other in a Marchais mask (the leaders, respectively, of the Socialist and Communist parties), pantomime a

8.1 Rubbo (r) with Jean-Louis Robitaille. Production photo. *Solzhenitsyn's Children … Are Making a Lot of Noise in Paris* (1978). The National Film Board of Canada.

fight to some street music. It's not very clear that the two men are Rubbo and Robitaille. Perhaps the scene is meant to suggest that they view the election as something of an empty ritual. There follows a scene of Mitterand delivering a formal speech to a large, well-behaved crowd. He drones on about how it is natural for men to seek power, which is why his Socialists not only seek power for themselves, but

"counter-powers"—limited, no doubt—for the opposition. Now in a car, Robitaille explains some of the election process to Rubbo (and to us). It starts with two rounds. The first round narrows candidates down for the second.

As hinted at by the mock fight, we soon learn that neither of the two men—who are now functioning something like a tag team—is very interested in the election itself. It's a pretext for the film, something of a MacGuffin. What intrigues them are the changes taking place on the French Left. In a bookstore, they examine works on Marxism. Cut into the discussion are brief shots of the books and inserts of the authors. "I think we can say that it started with Solzhenitsyn," Robitaille says over a shot of a paperback copy of *l'archipel du goulag*, followed by footage of Solzhenitsyn as they discuss him. Rubbo notes that at first Solzhenitsyn was ignored because he seemed so reactionary. As the pair examine more books, Robitaille says there was a second wave, so to speak, of former leftists, major figures from May '68, like André Glucksmann "who was ... first a Communist and then, uh, a Maoist ... and who wrote a book, *La cuisiniere et let mangeur d'hommes* ... Cook and the man-eater ." Rubbo says, "Yeah, I read—I read this one. He's more or less saying that, uh, that Marxism is as bad as, uh, as, uh, Nazism." Robitaille then picks up a copy of *la barbarie à visage humain*, and says, "Well, the big star is Bernard-Henri Lévy," who, Robitaille explains, was an early publisher of the New Philosophers and then became one himself with his book, *Barbarism with a Human Face*. Rubbo asks whom they should try to interview. Robitaille suggests several names, then adds, "But if you insist to have a star, we can see Lévy. I know you like that." The next shot shows them admiring a ceiling-high rack of books. "You're very impressed," Robitaille remarks, digging at Rubbo. "You've never seen so many books. Maybe you make films but you don't read a lot." Pleased with his jibe, Robitaille takes a drag on his cigarette, then doubles down: "If you're illiterate, don't—don't think everybody, uh, all your public is the same." Rubbo takes no apparent offense; in a close-up gazing at the rack of books, he just says, "Amazing."

Robitaille takes Rubbo on a tour—"a little history lesson ... which would be very good for you." A visit to a monument to the Paris Commune of 1871 leads to the next interview. The Commune is important,

8.2 "Maybe you make films but don't read a lot." Screen grab. *Solzhenitsyn's Children … Are Making a Lot of Noise in Paris* (1978). The National Film Board of Canada.

Rubbo narrates, because "according to Socialist historian and writer Jean-Pierre Faye, the fall of the Commune greatly influenced the first Soviet leaders." In his office, Faye says that at first the party was committed to democratic openness, but Lenin believed the Paris Commune failed because it was too soft, and that all dissent should be suppressed. The Czechoslovakian uprising of 1968, which the Soviets brutally suppressed, was, says Faye, an attempt to restore such freedoms as that of the press and of association. The film cuts to Rubbo-narrated footage of the Soviet Army's occupation of Prague. "So this is Prague, exactly ten years ago. … And it makes me very—it makes me very *mad* to think that those tanks are still there today … just like it used to make me mad to see Americans in Vietnam. It's *wrong.*" Faye says that the invasion also angered Communists in Europe. Over footage of a frightened young Soviet tank driver besieged by microphone-wielding reporters, Rubbo summarizes the exchange: "Always they say the same thing: 'Why are you here? *Speak* to us. You're *Communists*, aren't you? What are you *doing* here? There's no counter-revolution here.'"

At Robitaille's suggestion, they visit an old Czech exile, Artur London, now living in Paris. In 1952, he had been accused of betraying the revolution; he was convicted and sentenced to life in prison. In his apartment, his wife shows us microscopic messages written on cigarette paper he had smuggled out of prison, telling her that he would confess but not to believe it. He wrote a book about how he was made to confess. Fourteen people were convicted; eleven were executed. Intercut is footage of one of the accused, Rudolf Slánský, confessing that he "acted as an enemy, defending the interests of the Anglo-American imperialists, and I betrayed Czechoslovakia." When Robitaille asks why, after the show trials that had occurred earlier in Hungary and the Soviet Union, he maintained his faith in the Soviet Union, London explains that faced with Hitler, Mussolini, and Franco, Communists like him did not notice that the Soviet Union was becoming a police state. "Everybody defended the Soviet Union. Everybody defended Stalin." He admires Solzhenitsyn—"magnificent writing"—but disapproves of his endorsement of the Vietnam War and his claim that he had never felt so free as in Franco's Spain. London says he has retained a life-long commitment to what he calls "Eurocommunism," or "Socialism with a human face."

After London mentions that there were some protests in Moscow's Red Square against the Russian occupation of Czechoslovakia, and that one of the protesters, a worker named Viktor Fainberg, is living in Paris, the film cuts to Fainberg standing with Rubbo and Robitaille in a large, mostly empty public square. Fainberg says that his circle in the Soviet Union sympathized with the Czechs' efforts to liberalize Communism. Because Fainberg struggles to express himself in English, Rubbo provides a voice-over summary: "Seven demonstrators met together on Red Square. They had [printed] slogans, hidden in a pram, under a baby. So they got into position, and then suddenly the slogans just appeared in their hands, from under the baby. What did they say, the slogans? 'Hands off Czechoslovakia.'" The protesters were beaten, and Fainberg lost his front teeth and was sent to a psychiatric hospital for five years. He says it was a good experience, because he saw not only the depths of depravity that human beings were capable of but also their capacity for dignity and courage. He is convinced that because of the human rights movement, the Soviet Union is doomed.

In what Rubbo identifies as "the elegant office of René Andrieu, the editor of *L'Humanité*," Robitaille asks Andrieu, a guarded, stiff man who looks like he could be an oil executive or a college president, what form he thinks Socialism should take in France. For us, Andrieu says, Socialism and democracy are synonymous. He seems to hedge, and then obfuscate a bit, when Robitaille asks him if he thinks they are synonymous in the Soviet Union, but he concludes emphatically, declaring, "I'm *totally* for democratic control, I'm *totally* against arbitrary power, against the centralized state, against the one-party system. *That I don't want.*"

"Finally," says Rubbo in voice-over, "I got up the courage to ask him a question ... in my rotten French." Andrieu had debated one of the New Philosophers on television the night before; what, Rubbo asks, does he think of their comprehensive attack on Marxism? "It amuses me somewhat," Andrieu replies. Marx's followers stretch across the globe, Andrieu continues, a reality whether one likes it or not. "No philosopher in history has left such a legacy—neither Plato nor Descartes, Kant—none have made such an impact on the course of history."

The next morning, in a coffee shop, Rubbo upbraids Robitaille for oversleeping, causing them to miss "an extremely important interview with Jean Elleinstein, the most progressive thinker in the Communist Party." Instead they attend what Robitaille describes as "a very Parisian event," a book launch, the book in this case being about its author's expulsion from the Italian Communist Party. At the cocktail reception that follows, they speak with one of the panelists, novelist Philippe Sollers, whom Robitaille describes as "the pope of the avant-garde." Rubbo's voice-over translates and summarizes their exchange. Robitaille, whose manner seems to betray that he thinks Sollers is something of a charlatan, says to him, "You've had a rather zig-zagged career during the last few years. You supported the Communists, you were *very* close to the Chinese ... then suddenly you *break* with China."

"Yes, I'm ... always swinging against the tide, you know. I do things that are ... out of fashion. A bit of zig, and a bit of zag."

"But you believed in China pretty completely, no?"

Sollers has been chewing on an olive and now removes the pit from his mouth; he looks like he is searching for a clever response. "Oh, you

should look at that [as] essentially Dadaist, because I'm fundamentally a Dadaist. You know, people don't always see the … *humor* in political postures. They make a *religion* of it, and they're *shocked* by sudden changes of positions, like mine. … You don't seem … very convinced."

At a large indoor rally, Jacques Chirac is delivering what Robitaille says is Chirac's stock anti-Communism speech to his mostly middle-class audience. The Communists will try to trick you, Chirac says, but they have the capacity and the will to paralyze you, paralyze France. He speaks at a podium, on a stage, his image projected on a giant screen behind him. It looks Big Brotherish. After his speech, a woman leads the crowd in singing *La Marseillaise*. For them, Rubbo says, the Communist Party hasn't changed. As the song is ending, we see several shots of older, stereotypically bourgeois men on the street. One of them sports a bowler hat. A two-shot features two of them walking toward the camera, one with a cane, the other with an umbrella that he uses as a cane.

They've been given a second chance to interview Jean Elleinstein, Rubbo tells us, "if Bernard will hurry up." Apparently he does. Rubbo translates and paraphrases Elleinstein, who, like René Andrieu earlier, looks guarded and official behind his desk. European Communism recognizes, Elleinstein says, that Socialism must be achieved democratically. The Soviet Union's experience is not applicable here; it is an *anti*-model. When asked why he would want to keep using the name "Communism" when it has been so discredited, Elleinstein responds with what, in Rubbo's translation, seems like mumbo-jumbo: if in the West we can't solve our problems, it is not because of how Socialism developed in the Soviet Union, but because capitalism is dominated by the profit motive and is thus incapable of solving these problems. We have to find new roads neither social democratic, which failed, nor Stalinism, which is irrelevant. A new road has to be found. "That's what Eurocommunism is all about."

In a café, over wine and beer, Rubbo and Robitaille discuss labels such as "Communism" and "democracy." Simplistic uses of the words irritate Robitaille. Where, he asks, is the democracy in the Republican or Democratic parties in the United States? Afterwards, with Rubbo driving a car and Robitaille giving directions, they head for their next interview. "André Glucksmann," Rubbo narrates over violent footage

of the riots of May '68, "the man we're about to see, was in the streets of Paris in 1968 when they looked like this." As a consequence of the riots, Glucksmann joined an extreme Marxist group, Rubbo says. "We'll see how he feels today."

Glucksmann says that the resistance in the Soviet Union is what turned the young Marxists around. Rubbo translates in voice-over. Having been dissidents here, we understood the Russian dissidents, Glucksmann explains. People like him felt "an underlying rapport that exists when the illusion is stripped away." For example, the Vietnam War, "a dirty war on the Western side, we imagined it was a clean war on the Vietnamese side. That was false. Obviously false."

Robitaille suggests that it might be Glucksmann who has changed, not Communism. Glucksmann says,

> there was a willingness not to see. A willingness to be blind. Yes, I've changed. And no, I haven't changed. We were right to protest against the concentration camps in South Vietnam, for instance. And the proof that we were right is that Cambodia, which was perfectly peaceful, an island of peace before the American intervention, became the scene of terrible massacres ... where American bombers have been replaced by the machine guns of the Khmer Rouge. So in a sense we *didn't* change, because we were against *all* massacres, and still are, by all states. In another sense, we've changed because ... we had that willingness not to see. We believed that one side had to be good if the other side was bad.

When Robitaille observes that Glucksmann seems to equate the Soviet Union with the French Communist Party, Glucksmann assails him for having written an article on Glucksmann and the other New Philosophers that argued that, because they criticized the Left, they were therefore of the Right. That's "the logic of the Cold War ... the logic of camps, in every sense of the word." If we can't say, he goes on, that there are lies from the Left or the Right without being accused of being enemy agents, then "I say it's not me that's sick, but you."

Rubbo mentions that he had made two films in Cuba in 1974 and was quite impressed by the idealism of the young people he met there. We see clips from the films. The student body president from *Waiting for Fidel* is included in the clips. "What fascinates *you*," Glucksmann asks Rubbo, "about that young Cuban? Why didn't you ask him, one, about the concentration camps, two, about the way they treat homosexuals … three, about, uh, what Cubans are doing in Africa, why they're playing GIs for the Soviet Union? *You*. What fascinates *you*? The young Cuban, I don't know—but *you*?"

In Robitaille's apartment, Rubbo and Robitaille, slumped on sofas, look dismayed and tired. And perhaps tired of each other. "Well," Rubbo says, "it wasn't a very good interview that you just did there."

"Oh, come on."

"Well, where do *you* stand, Bernie boy? Where do you stand in this debate?"

Robitaille responds reflectively: "It's very easy to draw … very, very simple conclusions like that [i.e., Glucksmann's]. You say, 'That was so bad, so let's not do it again. Let's just stay as we are, now. Let's not try anything.'" The scene shifts to the two men riding an elevated train, their conversation continuing in voice-over. Robitaille elaborates, "'Because there are problems, and because the experiences were not very good, let's not change anything any*more*.' I think that's—that's a bit *easy*. It's not stupid, it's easy. It is very easy. And I think that's the problem of the New Philosophers."

The men continue on the train for a while, cool to each other. In one shot, they avoid each other by burying into their respective newspapers (Rubbo, *L'Humanité*; Robitaille, *Le Matin*), held up before their faces as if to discourage any attempt at communication or interaction. Over this sequence, Rubbo, in narration, editorializes: "*I* don't think Glucksmann makes it too simple. It's not too simple to say that one was blind. It *is* simple to think that the truth about something all comes from one or two great minds, and that all virtue resides in one or two social experiments. It's not simple to admit that the world is more complex than that."

Over a scene in a café, Rubbo introduces in voice-over the next interviewee, "Jean Daniel, editor of the left-wing *Nouvel Observateur* [who] supports the New Philosophers, but with some … interesting

reservations." In the interview, in which Robitaille asks all the questions, and which Rubbo translates in voice-over, Daniel says that the New Philosophers are important but warns against slipping into resignation. Man is capable of remaking Socialism "while at the same time denouncing the use of that word ... by the Cubans, the Chinese, and the Albanians. ... We don't say that Christianity is bad [just] because there are bad Christians. ... But the word 'Socialism' *has* been wrongly expropriated, and the New Philosophers have made us conscious of that takeover."

Prodding, Robitaille opines that ten years earlier it would have been much harder to say that the Soviet Union or China were not Socialist countries. "Well," Daniel responds, "there's always the question of degree. In the case of the Soviet Union, you are *wrong*. It was *quite* possible to say that ten years ago. But since mankind is always looking for a mecca, or Vatican ... we have moved our dreams from Algeria to Cuba. China has been one of the most enduring examples of our desire to anchor our dreams to some existing model. You're right: it would have been hard ten years ago to say China wasn't Socialist. The real difficulty is to resign oneself to the lack of models."

As they stroll through a park, Robitaille, in voice-over, again needles Rubbo: "You know, this time you were very good, hardly no Australian accent in your questions. Very precise, very good."

"That's because I didn't ask any questions."

"Very good, very good."

But, as Rubbo points out in his narration, "some people still believe in the models." We are now at a large rally staged by a Marxist-Leninist group that "is faithful not only to the China of Mao, but to the teaching of Lenin and Stalin as well." Asked if there are some countries he still considers Socialist, a bearded young Maoist mentions China, Albania, North Korea, Cambodia, and Vietnam—"with variations, of course." Robitaille asks him how he feels about Cambodia: "The news that's reaching us now is a bit ... *upsetting*, isn't it?" "Yes," the young Marxist replies, "it's *very difficult* for us, because we supported *both* Vietnam *and* Cambodia in their national liberation struggles. It's very unfortunate what's happening, and we just hope that it'll be settled ... peacefully."

In a bookstore again, Robitaille gives Rubbo a quick rundown on several older and recent books about China. Until a few years ago, all the books about China, from both the Left and the Right, were very positive. Now, they are mostly negative. The last book Robitaille shows Rubbo, *la moitié du ciel*, is very positive on China, unconditionally pro-Mao, Robitaille says. But recently its author, Claudie Broyelle, with her husband Jacques and a third author, have published a very critical book on China, *Deuxieme retour de Chine*.

Rubbo and Robitaille interview the Broyelles in their home. In Rubbo's voice-over translation, Claudie Broyelle says, "It's a bit embarrassing for me to take responsibility for my first book, because I have to admit I was wrong ... and it's not ... pleasant to have to say that." After she elaborates, Robitaille exclaims that the Broyelles have gone from one extreme to the other; first, China was all white, now it's all black: "It's a bit like leaving the church."

"No," she protests. "It's *not* like that. Firstly, it's not completely black, the picture of China that we paint. And anyway, we just reported what we saw." Jacques Broyelle: "We thought that it was a dictatorship on the enemy, but we quickly found out that the dictatorship was on the people, too, like in all Socialist countries." Claudie Broyelle: "If you want to get married, you have to ask permission of the committee. If you want to have a child, ask the committee. You're given a number. ... *You* [pointing her finger] can have a kid in '75, *you* can have one in '76, *you* in '77. If you don't get on with your husband, ask the committee for permission to divorce. In *every domain*, the party reigns supreme. You can say that from the cradle to the grave, the Chinese are controlled in all that they do ... by the party."

"There are now some twenty-five Socialist experiments in the world," Jacques Broyelle observes. "Each time an experiment fails, we remake our investment somewhere else, redefining our concept of Socialism."

Claudie Broyelle says that she now believes "there *is* no other democracy than the ... respect for forms ... the written codification of laws that people can *refer* to. ... Today, anybody can publish a newspaper. We ourselves, our little Maoist group, published a newspaper for *years*, even with very meager resources ... with a circulation of some five thousand. And we had *printers* who were willing to print our paper, because they were covered by the *bank* ... but if the banks were

nationalized, the printers would no longer do it. They'd have … precise goals … democratically decided by the union, the government, and the people—democracy in inverted commas."

Jacques Broyelle recalls that "when Solzhenitsyn's book came out [in France] in 1974, somebody asked Marchais if Solzhenitsyn could have been published in a Socialist France. He replied, 'Certainly—if he could find a publisher.'" Claudie Broyelle adds that during the Cultural Revolution, when the Communist leadership decided that the proliferation of Red Guard and underground publications was getting out of hand, they simply cut off the supply of paper.

Walking along the Seine, Rubbo and Robitaille debrief. Rubbo: "Do you think that maybe our opinions are so weak, we're convinced by everybody? Everybody I talk to—everybody I talk to, I find convincing." He laughs.

Robitaille: "I agree. Yeah … because they're very convincing, what they say."

Rubbo: "Jesus, it's confusing."

Robitaille: "Well, maybe at the end, you'll just … abandon the whole thing, and just go to the countryside."

A fat, jowly man in a blue sweater is preparing a meal for several people in his apartment. Rubbo narrates that "we were impressed by the Broyelles, but Daniel Anselme is not impressed by *us*. This is depressing, because Daniel Anselme is an experienced and knowledgeable man when it comes to our subject, the Left. He used to be a Communist, and now is a writer-activist for *Autogestion*. He doesn't like our celebrities, our lack of contact with workers, and nor does he like being filmed. Disappointing as we may be, we still get a … good meal: veal escalope." Rubbo translates the ensuing conversation in voice-over.

A woman in the room—although not identified as such, she is Marilu Mallet, Rubbo's wife at the time (and herself a filmmaker); their young son Nicholas is in the scene, too—asks Daniel what he thinks of "this film Michael is making?" His mouth full, Anselme answers—Rubbo's voice-over translates not just his words but also his sarcastic, mocking tone—"Sounds to me like a piece on high fashion. Well, for a foreign newspaper one does an article on the fashion world of France, and you pick certain young designers who are up and coming, and who would like to become more famous. Ah! [cutaway to Robitaille lighting

a cigar] He's got a long cigar. Very elegant. Yes, he's a Canadian, but he's acclimatized ... Parisian ... a *dandy* of the boulevards. A century ago he would have had a *cane*, and yellow *gloves*. Sure! Yellow gloves and a cane. And you would have had your *table*, at the Café *Madrid*. And now look at the terrible life you lead in this false capital."

"Daniel knows, perhaps more than anyone else, about the 1968 uprising in Paris," Rubbo says, "but getting him to say something serious about it is another matter." Robitaille thinks Anselme may be speaking metaphorically when he says, "Okay, so you take a slice of veal, making sure it's not too thick ... you make this dish thinner ... slice of ham." Robitaille asks, "So that's the recipe for escalope '68?"

"No."

"No connection?"

"No."

An intense young man is walking down a narrow Parisian street. Rubbo is "still trying to catch Bernard-Henri Lévy. He's the most *outrageous*, and the most *marketed*, of the New Philosophers. He has a way with words that makes him a sort of philosophical pop star ... [Lévy is now sitting among an audience in a small room] a Mick Jagger of the brainy bunch. But we intend to stand our ground." Over these last words, Lévy glances over at the camera as if to say, "Not a chance."

But they get their chance, and as they climb the steps to Lévy's apartment, the two prepare for the interview. Rubbo: "You can ask the hard questions ... and I'll be the nice guy." Robitaille: "You'll be the— you'll be [laughing]—you'll be the nice dummy boy, North American, asking nice questions."

"And you can ask the tough ones, right?"

"Okay, I'll be the bad boy."

The interview opens on Lévy—pacing, gesturing, intense, humorless, self-important, incredibly young-looking, shirt open at the top. His apartment is all white or slightly off-white: the walls, the woodwork, the door, the furniture, even the floor. In Rubbo's voice-over translation, Lévy delivers an oracular mini-lecture: "Marxists have always said that it doesn't matter about the theory. Judge the practice. Judge materialistically. Thus they have rubbed our noses in the fact that the theory of liberty, equality, and fraternity leads to the Vietnam War, and to the massacres in Algeria. So, apply the same criteria to

Marxism. ... It's a philosophy which preaches *against* the state, but which has had the concrete effect of *strengthening* the state. So I simply ask that they apply to Marxism the same rigorous judgment that they demand *we* apply to liberal thought. And surely it's even more justified in the case of Marxism, which is a philosophy that claims to lead to a new, improved society."

Robitaille seems at least mildly intimidated by Lévy's dazzling erudition. He is having trouble playing the role of the bad boy. He asks if Marx would approve of what's happening in the Soviet Union today. "I have no idea," Lévy replies. "The question's meaningless—just as meaningless as it would be to ask if de Tocqueville would be happy with what's happened in Vietnam. Anyway, Brezhnev is not mistaken when he thinks that he is inspired by Marx. And when you see, over the gates of Kolyma, the enormous Soviet concentration camp, a quotation by Marx, I say it's not misplaced."

"But," Rubbo asks, "all this evidence of oppression has existed for a long time—the trials of the '30s, the ... crushing of the Prague Spring. How come people like you have just woken up?"

> One reason, and I never tire of repeating it, is the appearance of that monumental work, the writings of Solzhenitsyn. In essence, he says the same things as Kravchenko, and others, with the difference that Solzhenitsyn is an *artist*, and not a reporter. *The Gulag Archipelago* is as important to our times as the *Divine Comedy* was important to Dante's era, as *King Lear* to the Shakespearean age, as important as Picasso's *Guernica* was for the Spanish Civil War. [Here Lévy puts his hand on Robitaille's shoulder; it looks patronizing, and Robitaille seems taken aback] In brief, for me, he proves the thesis that *only* the artist, and *not* the theoretician, can stop the flow of blood. ... [Another] reason that the Western intelligentsia was *deaf* to Kravchenko, *deaf* to Koestler, was because the brains of the Left were fuddled with Marxism. ... Marxism made us *deaf*, Marxism made us *blind*, we had to purge ourselves of Marxism. So if the Communists come to power in France, it will be very dangerous. More than dangerous, it will be *catastrophic*. The

8.3 Bernard-Henri Lévy holding forth. Screen grab. *Solzhenitsyn's Children ... Are Making a Lot of Noise in Paris* (1978). The National Film Board of Canada.

day the Communists come to power, I swear to you, I will be the first French writer to change his nationality."

Robitaille asks if Lévy really thinks there's a danger of totalitarianism. Lévy: "I'm *telling* you, I would be the first French writer to shame the honor of his government by changing his nationality. With the Communists in power, with René Andrieu holding the reins of power, there would be a risk of totalitarianism—smiling, good-fellow totalitarianism, but still totalitarianism. And there are signs today which don't lie."

Later, in Robitaille's apartment, Rubbo, looking defeated, fiddles with what could be a neck chain. "We were ... too impressed," he sighs. Off camera, Robitaille says, "We were taken by ... *speed*."

"I wanted to ... talk about my Cuban experiences, because *really*, it was ... quite good in Cuba." As Rubbo says this, Robitaille's body language suggests he is tired of hearing about Rubbo's experiences in Cuba.

In a lengthy tracking shot on a bridge over the Seine, the two men, facing the camera in a medium two-shot, continue their discussion about Lévy. Robitaille: "And I think pessimism ... is something very natural. And that's a force, because it's very—at the same time, it's very *easy* to be pessimistic, and it seems very natural."

Rubbo disagrees: "I think you were quite impressed by his arguments, actually."

Robitaille: "Yeah, he has ... some personal force, I agree with that."

The tracking shot lasts about twenty seconds, until a jump-cut gets them over the bridge and then to a shot of the river, at which point Rubbo's narration resumes: "Bernard is really worried that we are giving in to an easy and comfortable cynicism." Cut to a man in black pants and black turtleneck standing in front of a bookshelf in an apartment almost as universally white as Lévy's. "So he takes me to see another author, Gerard Chaliand, who has lived what he writes, and writes prolifically," says Rubbo.

Chaliand, who speaks fluent English with a slight accent, says he's written "oh, about ten, twelve" books, then takes one book after another from the shelf and tosses each to the floor as he identifies it. "That's—that's one on Algeria ... another one on Algeria. ... That's about arms trouble in Africa. ... That's the same one in English. ... That's about the peasants of North Vietnam. ... Palestinian resistance ... resistance again. ... That's been also in English." After mentioning a title in French, he shifts back to English: "We call that in English, 'Revolution in the Third World.' ... That's about Portuguese Guinea, that's about the Kurds, that's a translation of a book in Arabic ... in Turkish ... in, uh, Spanish ... Swedish." In the middle of this demonstration, the camera tilts to the floor to show the growing pile of books and that Chaliand is standing on a footstool.

Later, away from the pile of books, Robitaille asks Chaliand, "So you're an expert on the Third World, but that doesn't mean that you've become, through disillusionment, a 'New Philosopher,' huh?". Rubbo translates Chaliand in voice-over:

> Not at all. ... It's a very Parisian phenomenon. [Rubbo intercuts the headline of a story in *Libération* titled "MISERE DE LA NOUVELLE PHILOSOPHIE."] Very French, in

8.4 "It's very easy to be pessimistic." Screen grab. *Solzhenitsyn's Children ... Are Making a Lot of Noise in Paris* (1978). The National Film Board of Canada.

fact ... because in France we change fashions very fast. Fashions are discarded like ... old clothes. We've had the Structuralists, the Lacanians. ... We've been disciples of Sartre ... and now they're putting the New Philosophers on the market. Two years from now, nobody will read them, or will be spitting on them. But actually it's *good* that they are de*mystify*ing things, for a generation which was really behind the times, the generation of '68, who didn't know about the camps before reading Solzhenitsyn. So it's time that they discovered that the world isn't black and white [cut to a newspaper story headlined "ENTRETIEN AVEC BERNARD-HENRI LEVY"], and that's a *good* thing.

Switching to English, Chaliand says, "So, I think that, uh, it's not a philosophical question, it's a political one, really. I think that institutions, uh, should be as strong and democratic as possible ... uh, that pluralism is a lot better than one party."

The ballots for the first round of the election are being cast, collected, and tallied. Rubbo explains: "So the democratic ritual, that ... Claudie Broyelle now trusts, for want of something better, is underway." In a polling station, a gaunt man with a Lincolnesque beard presides over the counting. Robitaille reports the percentages to Rubbo, indicating that a split vote makes a leftist victory very unlikely for now. On television, a dejected Georges Marchais spins it positively: "Dear comrades and friends. The results of the first round show that there is a favorable climate for the victory of the Left, if they are united on the second round."

At this point Rubbo inserts a scene from a cab ride the day before, when, Rubbo says, it had "looked good for the Left." The driver hopes for a victory by the Left. Couldn't it turn out badly if they won? Robitaille asks. "How could it go bad? There's no reason for it to go bad. You have the Socialists, as a rotation of power. It's not the Communists *alone* who are going to take power, with a knife between their teeth." Robitaille: "What [if it were] the Communists alone?"

"No! That would scare me. That would scare any Frenchman who was not a died-in-the-wool Communist."

Anxious reporters are cramped in a small space waiting for something. "In the Socialist Party headquarters," Rubbo explains, "we well-paid journalists from all over the world scramble for a place from which to witness Mitterand admit that he's been beaten. Obliquely, sadly, he will blame the Communists ... first for the split, and for tonight's defeat."

Mitterand is bitter. "Ladies and Gentleman, our country chose the Union of the Left at the last provincial and municipal elections. It is clear today that the hope that that victory aroused was betrayed by the rupture of the Left on the twenty-second of September, 1977. History knows who bears responsibility for that rupture: those who never ceased in their attacks on us, attacks as violent and incessant as those of the Right. The results are there. France stays with the same parliamentary majority, and the same problems."

A high–angle tilt down on a hectic crowd on the floor of the Paris stock exchange initiates a credit sequence constructed of shots of cacophonous trading activity intercut with Rubbo and Robitaille racing through Paris. Robitaille remarks off camera, "So you see that, uh,

a few hours after the election, the stock exchange was quite happy." The first end credit is appropriately generous: "special collaboration— Louis-Bernard Robitaille."

At eighty-five minutes, *Solzhenitsyn's Children* was Rubbo's longest film to date, and from a textual perspective, it was—and remains—his richest. It integrates images of Paris, glimpses of its citizens, film clips, photos, and excerpts of interviews. It portrays a culture of intellectual disputation. It is about ideas but it is also about buildings, streets, cafés, and conversation. Its sounds—street noise, music, and philosophical pronouncements—are not separate from the work but integral to it. Besides its length, the film represents an embellishment of Rubbo's by-now established personal style. Like *Waiting for Fidel*, the motivating force is disappointingly absent, but in this case with Rubbo's foreknowledge. He references his films on Vietnam and Cuba—the former indirectly, the latter overtly. He uses an intermediary, but this time as an on-camera equal. (Rubbo controlled the editing, of course.) And if his interactions with Robitaille are sometimes testy, Rubbo is comfortable with that. Without Robitaille, and the interplay between him and Rubbo, the film likely would have been much weaker. It for sure would have been less fun.

One thing the film is not is an argument for any one of the philosophical positions expressed in it. Its philosophical content is but one color in Rubbo's palette. This is not to say that the film is unserious. Where else can one find on film such a display of New Philosophical positions, including the reasons behind them? But the implicit point is that an attitude of doubt and skepticism about any philosophical position, and even about doubt itself, is perhaps the most honest stance a thinking person can take.

But in the documentary world there is often little interest in doubt or skepticism. Rubbo screened a fine-cut of *Solzhenitsyn's Children* in double-system projection at the 1978 Grierson Seminar, a week-long event for filmmakers to show their work and discuss it with other filmmakers, as well as critics and scholars. Don McWilliams programmed the seminar that year. One of the themes guiding his choices was that of the filmmaker as central character—which, in the four years since *Waiting for Fidel*, had become a contentious issue. Thirty-six years later, in 2014, McWilliams couldn't recall details of the discussion of

Rubbo's film (which then had the working title *The Doubt*), but he remembers that Rubbo "was roundly attacked. The general tone can be summed up by a comment from someone that a more appropriate title for this film would be 'A Tour of the cafés of Paris with Michael Rubbo'—something like that." That comment, of course, echoed Daniel Anselme's marvelously withering put-down of Robitaille (and by association Rubbo) as "a dandy of the boulevards." The consensus was that the film was "meandering and self-indulgent with little of value." The audience didn't care much for the New Philosophers in the film, either. But McWilliams was impressed with Rubbo's "openness to debate." Rubbo was "very thick-skinned" and "gave as good as he got," he said; he was "a gentleman."

In a 1982 *Cinema Papers* interview with John Hughes, Rubbo remembered the film's assailants at the seminar as "a bunch of British Trotskyites":

> I wish I had a tape of their loathing; it might be healthy to listen to it occasionally. ... [They] didn't like the politics of the film because on the screen, treated with undue courtesy, are a bunch of French intellectuals, once on the left, who are now saying that Marxism leads to the Gulag. To make it worse, the subject is handled in a playful way. They saw it as heresy in very bad taste. I know what they mean, but I found them totally intolerant of anyone who did not defer to their opinions, and I really don't think it is my fault that the world does not act out their doctrinaire vision.[2]

When Hughes remarked on the scene in which Rubbo and Robitaille admit to each other and to us that they find everyone they've interviewed convincing, Rubbo responded that their indecisiveness was

> shocking because one is supposed to have made up one's mind before the camera rolls, and we obviously didn't. What we had decided was that doubt itself is valid and important. Doubt is the best enemy of fanaticism. We defend the right to doubt in the film, even when the bullets are flying.[3]

It was not always clear if it was the film that critics hated or the New Philosophers in it, especially Bernard-Henri Lévy. In any case, the antagonism was enduring. In 2007, Rubbo put the entire sequence with Lévy on YouTube. "It got about one hundred thousand hits, but so many of the comments were so vitriolic, so racist against Lévy, that I took the comment option away and I think at the same time lost the hit count."

Perhaps the film's harsh critics would have preferred something like the only other documentary that I know of by a major director that explores the disillusionment of the Left: Chris Marker's three-hour *A Grin Without a Cat* (1993), which was first released in 1976, then reedited and updated in 1993 for English-language distribution. Beyond the fact that he is a Marxist, Marker's own beliefs are often elusive, but his affections clearly reside with the idealism and hopes of those participating in the May '68 uprisings, and he is disappointed at the diminution of leftist hopes since that time. Marker is not an on-screen participant in live-action events; his film is primarily an assemblage of documentary footage. He is joined in his narration by several other voices. Despite the revelations about the Gulag, the fall of the Soviet Union, and other disillusioning events, he remains a Marxist. The New Philosophers are not mentioned at all. The title may refer to the disappearance of reliable contexts or models for revolutionary impulse. But like *Solzhenitsyn's Children*, *A Grin Without a Cat* had a negligible impact in North America.

Although American public television aired Rubbo's film, the CBC did not. The film did receive screenings in early 1979 at arguably the two highest-quality movie houses in the United States, the Film Forum in New York and the Pacific Film Archive in Berkeley, California. Three New York reviewers recognized the thrust of the film: it wasn't a film about Marxism or the New Philosophers per se but rather French intellectual life. Writing in the *Times* (11 January 1979), reviewer Janet Maslin saw that the quality of ideas expressed in the film "matters less than the climate of intelligent activity Mr. Rubbo's film conveys." J. Hoberman, in the *Village Voice* (15 January 1979), concluded that ultimately the film "is exactly what one subject [Anselme] calls it, 'a film on high fashion.' But why not?" Hoberman recognized that because the "high fashion" criticism came from a subject in the film,

Rubbo was perfectly aware of what the film was. And the film was, for Hoberman, a lot of fun. Robert Hatch, referring to both *Waiting for Fidel* and *Solzhenitsyn's Children* in the *Nation* (3 February 1979), called Rubbo "an inspired seizer of opportunity" whose "happy combination of talent and personality produces reportage of extraordinary dramatic excitement." *Solzhenitsyn's Children* "is a serious but high-spirited plunge into French political life." "Paris," he added, "is probably the world's most photographed city, but I cannot remember a film in which it seemed so inviting."

One New York review echoed the harsh response at the Grierson Seminar and seems animated by hardcore Marxism. Amy Taubin in the *Soho Weekly News* (11 December 1979) attacked what the film's supporters admire in it: "One could be easily fooled into thinking [the film] is an amusing, stylish documentary of the Paris of the French left at the time of the 1978 elections. I think something much more insidious is going on." Taubin likened Rubbo's technique to that "of any hack travelogue-maker," accuses him of condescension, assails him for focusing his questions on human rights while ignoring economic issues, and calls the film simple-minded. Everything that is intentionally self-deprecating in the film is turned against Rubbo, including Daniel Anselme's put-down. All Rubbo has done, she concludes, is "make a useful tool for reactionary politics all over the world today."

On the West Coast, Walter Addiego of the *San Francisco Examiner* (17 February 1979) called the film "fascinating but troubling." He judged Rubbo's presence intrusive and he claimed the questions Rubbo and Robitaille asked of the New Philosophers were not pointed enough. Judy Stone, who had liked *Waiting for Fidel*, wrote in the *San Francisco Chronicle* (17 February 1979) that *Solzhenitsyn's Children* is "not precisely a model of lucidity" about its subject. Rubbo's narration was "soporific." She would have preferred Rubbo to focus on just two of his subjects: Artur London and Bernard-Henry Lévy. By doing so, Rubbo "might have really illuminated his thesis: that doubt is an essential ingredient for a revolutionary, although it may result in paralysis."

The film may be experiencing a slow process of entry into the documentary canon. In 2005, filmmaker and scholar Jonathan Dawson, writing in the Australian online journal *Senses of Cinema*, called *Solzhenitsyn's Children* "a documentary of great charm and style that

also perfectly captures a unique time in European history."[4] Dawson identified as a key element of that charm precisely that which Anselme and the critics who echoed him detested: the *flaneur*-like roles of both Rubbo and Robitaille, amateurs in philosophy, perhaps, but intensely curious. And in 2010, New York's Museum of Modern Art held a special screening of the film.

Facial Expressions

Yes or No, Jean-Guy Moreau;
Daisy: Story of a Facelift;
Not Far from Bolgatanga

After probing the most public ideological crisis of his time in *Solzhenit-syn's Children*, Rubbo turned his attention to a tense but comparatively parochial political issue: Quebec separatism. Three years earlier, in the election that provided the context for Rubbo's *I Hate to Lose*, Réne Lévesque was elected premier of the province. He had promised that if victorious, the PQ would introduce a referendum calling for the establishment of an independent Quebec. Now he was keeping his promise. Rubbo had strong personal interest in the outcome. He was an Australian who had been living in Montreal for over ten years and had started a family there. If Quebec were to separate from Canada, what kind of future could he and his family look forward to? A majority of the province's Anglophones shared his anxiety, and they had little confidence in Lévesque's proposal of sovereignty with association.

For his film, Rubbo decided upon a portrait of Jean-Guy Moreau, a gifted impersonator whose most popular impersonation was of Réne Lévesque. Moreau was an inspired choice, and not only because of his talent: he was wildly popular in Quebec but unknown in English-speaking Canada. He thus exemplified a Canadian dilemma explored in *Two Solitudes*, a well-known (in Canada) 1945 novel by

9.1 Jean-Guy Moreau transforming himself into Réne Lévesque. Screen grab. *Yes or No, Jean-Guy Moreau* (1979). The National Film Board of Canada.

Hugh MacLennan about a man, Paul Tallard, who is torn between his conflicting English- and French-Canadian identities. Moreau himself isn't torn between two identities—he's French Canadian all the way—but the contrast between his fame in Quebec and his obscurity in English Canada reflected the gap between the two cultures. Additionally, Rubbo, the Anglophone, could be said to represent that half of the fictional Tallard.

Yes or No, Jean-Guy Moreau (1979), coproduced by the NFB and WGBH-TV in Boston, is built around several performances that Moreau gives to appreciative audiences in Quebec, as well as one in Toronto. Moreau is extremely good at what he does, and watching him is a pleasure. Rubbo shows how meticulously he rehearses his mimicry and transforms his appearance. For his Lévesque, Moreau uses a thin latex skin that he pulls over his face to suggest Lévesque's receding hairline and as a foundation for his makeup. Rubbo is showing us Moreau's process as an impersonator just as he shows us his own as a filmmaker. But it is not hard to make a reasonably entertaining film around an

entertaining or charismatic character. What makes *Yes or No* a serious film is its personalization and dramatization of what is potentially a highly charged issue. What makes it not just serious but engrossing is Rubbo's characteristic treatment of his subject.

For one thing, Rubbo's familiar demystification of the film's construction is more matter-of-fact than ever. Again and again, he tells us what he is doing and why. Over a series of shots of Moreau's different impressions, Rubbo explains that he "got these clips together to show you his range." Before a conversation in what appears to be Moreau's home, Rubbo offers a confession in voice-over: "Selfishly, I'd like to find out if there's a place for *me* here ... a transplanted Australian film-maker with a ... bilingual kid." Rubbo tells Moreau that although he speaks French and has lived in Montreal for twelve years, he always feels like an outsider. For instance, Moreau's performances include inside jokes that Rubbo doesn't get. And Rubbo introduces a passionate separatist, Guy Fournier, whom he is about to film in discussion with Moreau, as a colleague of his at the Film Board, someone Rubbo says he has had in mind for some time to use in a film.

In several instances Rubbo lets us know the contrived nature of a scene. It's because he is disappointed in Moreau's lack of militancy, Rubbo explains, that they are going to meet the separatist from the NFB. Before another scene, Rubbo informs us that he has "arranged a lunch with a Portuguese family." Rubbo also contrives an appearance at a posh English-Canadian garden party, where one woman remarks on the presence of "the two solitudes" and acknowledges to Moreau that she had never heard of him. And when Moreau decides to perform in Toronto, Rubbo helps plan and execute the event. (He may even have instigated it.) "The ads are in the Toronto papers," Rubbo says in narration. "There's no turning back now. And I've become an impresario." Driving down a Quebec highway with Moreau, Rubbo notices that Corvettes—a model popular in Quebec, so we had just learned—keep passing them. The camera pulls ahead of their car, and we see that it is flanked by a dozen Corvettes. In what amounts to a wink at the audience, Rubbo observes that it seems a little more than a coincidence. (In fact, he and Jean-Guy had encountered a group of Corvette owners heading to some sort of gathering. Seizing the moment, they

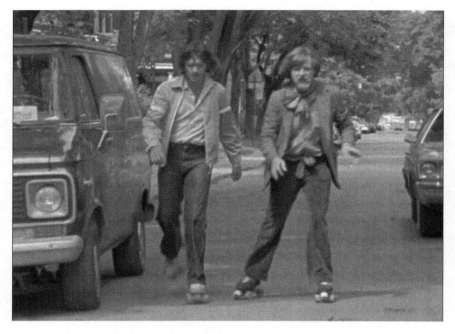

9.2 An easy relationship. Screen grab. *Yes or No, Jean-Guy Moreau* (1979). The National Film Board of Canada.

persuaded the Corvette owners to drive along with them for a short while in order to construct the scene.)

And Rubbo's on-screen appearances, although not more numerous than in several of his previous films, are more relaxed. His son, now three years old, appears in several scenes, sometimes making the film seem almost like a casual father-son outing rather than a major documentary production. His interactions with Moreau are more easygoing than those he had had with subjects in his earlier films. Moreau takes no evident umbrage at Rubbo's remark about his lack of militancy; he laughs it off. In one amusing interlude, transitioning to the interview with the Portuguese family, Rubbo and Moreau chat while roller skating down a tree-lined street—conveying as laid-back a feeling one is ever likely to encounter in a documentary on a political issue.

And there is a fleeting moment in which Rubbo allows himself to be mocked. At the lunch with the Portuguese family, Rubbo, standing

behind Moreau, who is sitting at the table, mentions to the group that his three-year-old son speaks French "better than I do, which I speak quite well." Apparently Rubbo believed his own French had improved considerably since *Solzhenitsyn's Children*, in which he had called his French "rotten." Moreau, whose face Rubbo couldn't see at the time of filming but couldn't miss in the editing, suppresses a laugh at Rubbo's self-assessment of his French.

The Toronto performance, the film's climactic scene, goes over fairly well despite—or because of—the fact that some audience members, seeming to take Moreau's Lévesque as Lévesque himself, begin arguing with him. By now one can see why this might occur: Moreau's impression of Lévesque—fidgety, nervous, shifting his glance left and right—seems both spot-on and representative of Lévesque's views. Moreau may even—so it appears—have convinced himself at some level that he has become Lévesque. But what does Moreau himself think politically? Throughout the film, he has insisted that he tries to remain aloof from politics in order to be more accurate and cutting in his impersonations, while Rubbo tries to provoke him to reveal how he will vote on the referendum. At the film's end, over credits, Rubbo asks, "So, Jean-Guy, how will you vote on this referendum?"

"It's going to be *yes*, Mike."

"Well, for me, I'm afraid, it's gotta be *no*."

"That's okay," Moreau replies, laughing gently.

The film lacks the bite of *I Hate to Lose*—Moreau exhibits passion only when he impersonates Lévesque—and it lacks the previous film's underlying tension as well. No one really expected the referendum to pass. And it didn't. French-speaking voters were split roughly down the middle on separation, and most other voters were against it.

In his next major film, *Daisy: The Story of a Facelift* (1982), Rubbo both advances and retreats from his personalization of documentary. His subject is a Film Board colleague and good friend of his, Daisy de Bellefeuille, an attractive, raspy-voiced daughter of the Austrian aristocracy in her mid-fifties who has decided to undergo a facelift operation. An early scene takes place in the Film Board cafeteria, where Daisy's colleagues discuss her decision. To underline the film's theme of "the face," Rubbo edits the scene such that we only occasionally see the person who is talking, and mostly the reaction of those listening.

But while the film includes a few scenes shot at the Film Board, its connection to the NFB is not made explicit. Given Rubbo's identification of Guy Fournier as a Film Board colleague in *Yes or No, Jean-Guy Moreau*, Rubbo's decision to downplay the substantial Film Board connection in *Daisy* seems odd. But this was not Rubbo's original intention. He had hoped to include a debate from the program committee over whether or not to fund the project. One complicating issue was that since Daisy was chair of the program committee, which had a key role in deciding which proposed films would be funded, she embodied a serious conflict of interest and recused herself from the committee's discussions about the film.

Some of Daisy and Rubbo's colleagues at the NFB thought that the subject was trivial. What need was there for such a film, some asked, given all the larger problems facing Canada and the world? And there probably was an unacknowledged objection to Daisy herself as the subject of the film: she was an outspoken lover of men and sex. At the Film Board, where political correctness had made early inroads, she was a living, breathing—and cheerful—rebuke to the institution's emerging gender ideology.

And while Rubbo himself is prominent in the film, it is mostly as a supportive friend who remains off camera except for occasional reaction shots and some interludes not involving Daisy. Perhaps Rubbo felt, consciously or not, that pulling back to a degree from his now familiar physical intrusion into the story would help him treat Daisy with affection and delicacy. She had agreed, after all, to put herself in an extremely vulnerable position by participating in the film. Intimate at times but mostly maintaining a respectful measure of emotional distance, Rubbo follows her from the days leading up to the operation, to the operation itself (mostly elided), and, occasionally, for several weeks after it.

Daisy is candid about her motivation. She wants to look better—for men. She acknowledges her romantic view of love, which in her case has led to serial relationships, including three failed marriages. She can laugh at herself: she says she seems to be good at getting married and getting divorced, but not so good at what comes in between. She notes the irony that while she has spent so much of her life with a man but no career, she now has an excellent career but no man. Part

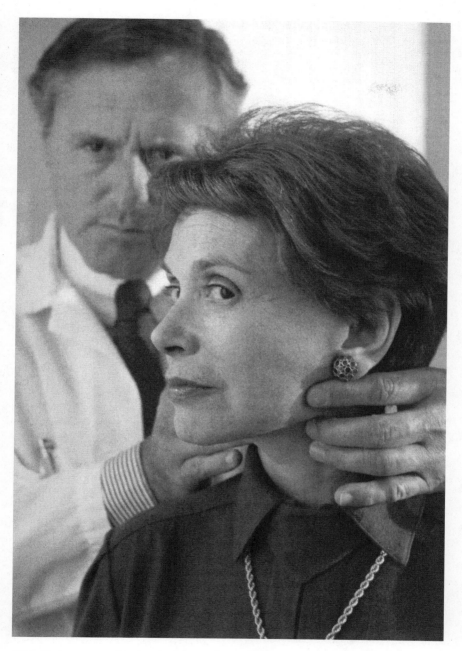

9.3 Daisy, pre-op. Production photo. *Daisy: The Story of a Facelift* (1982). The
National Film Board of Canada.

of her charm—although feminist viewers are prone to deride her for it—is that she is open and self-mocking about her sexual attitudes. She had served in the air force—Rubbo thinks it was the RAF, but it might have been the Royal Canadian Air Force—as a young woman. There was a poster, she recalls in a mischievous tone, that said, "'Join the air force and serve under the men that fly.' And that appealed to me somehow."

Rubbo constructs two substantial sequences in which he goes off alone, without Daisy, to look into the role the face has played in Western culture past and present. At the New York Public Library, he begins a brief informational excursion into physiognomy, which we learn was popular in the eighteenth century. He constructs an amusing sequence on physiognomy's main theorist, Johann Kaspar Lavater, who believed, in Rubbo's words, that one could infer a person's "inner character from the outer mask." Over portraits of various faces from Lavater's writings, Rubbo quotes Lavater saying such things as this person's nose indicates he is lustful, that person's lower lip suggests listlessness, and so forth. Rubbo also interviews a psychologist and a job counselor. The latter cites evidence that one's facial appearance affects employment prospects, opportunities for love, and even grades in school.

But while these sequences convey interesting information, the emerging portrait of Daisy is absorbing and moving. Cautiously and patiently Rubbo draws her out. We learn there are layers to Daisy that go deeper than her romantic views of love. A man's looks have never mattered to her, she says. No man ever appealed to her until he opened his mouth: "For me, sex starts in the head." She may be a romantic, but she's neither dependent nor a clinger—she's existential. And she is grateful to her parents for not burdening her with "Anglo-Saxon guilt." They taught her to accept that "marriages come and go, children come and go, money comes and goes, careers come and go. The only thing you're stuck with is yourself." While she is having her hair done at a salon, Rubbo asks her how she feels about getting old. "Terrified," is her answer. It's upsetting "when the past becomes more interesting than the future, and you don't know how to act anymore." When she says this, we realize that for her the facelift is an attempt to revive her interest in the future. At her home, as she is about to go to sleep, Rubbo, off camera, says, "You look depressed," to which Daisy replies:

"It's not an easy thing, aging." She says that the only reason she agreed to do the film is that lots of people are thinking about having plastic surgery because "it is a sort of … way … to … stave off … whatever horrid future one has to face."

The only time Rubbo enters obtrusively into Daisy's emotional space is in the plastic surgeon's waiting room. One other person is there, a man. With Daisy framed in a tight shot, reading *Vogue*, Rubbo (off camera) whispers in her ear, "Daisy … ask him what he's in here for." Without looking up from her magazine, she whispers back, "We can't do that, that's terribly rude."

"Well … just find some excuse."

"If someone did that to me," Daisy protests, "I'd smash his block off." Rubbo insists: "Do it." She does it, and a pleasant but brief and inconsequential interchange ensues.

The scene was contrived. "There is no way," Rubbo recalled decades later, "that I could have intruded without prior warning. That being so, I should not have used the whispering. I've never been called out on this, not to date." Yes, Rubbo could have said in narration that he invited this other patient to participate, and then showed the conversation. However, the conversation itself is not very interesting. By contrast, Rubbo's whispered prodding, and Daisy's initial resistance, are fun to watch and hear. And the prodding as well as the overture is improvised, not rehearsed. Daisy was a natural performer, and her initial discomfort rings true and appears to be in character.

The contrivance sets up, for later in the film, a fascinating if hard-to-watch sequence showing the face-lifting process—not Daisy's facelift, which is not filmed, but someone else's. Here Rubbo interacts not with his subjects—the surgeon, his assistants, or of course the anesthetized patient—but with his audience. "You remember Peter—the man who Daisy met in Dr. Schwartz's waiting room? Well, this is his facelift. I'll announce the bloody bits before they appear, so that those who want to can close their eyes." We watch skin below Peter's eyes being snipped, and some stitching around the eyes. "Not very bloody. Here comes the nasty part, so close your eyes." If we don't close our eyes, we see a glob of fat being lifted from a large slit in the skin below Peter's chin. "Take a quick peek, now. The skin is free, right down to the neck." (Although Rubbo doesn't say so, the stretched skin has an uncanny resemblance

9.4　"Here comes the pull." Screen grab. *Daisy: The Story of a Facelift* (1982). The National Film Board of Canada.

to the latex mask Jean-Guy Moreau pulled over his face to prepare to look like Rene Lévesque.) "You see? Our faces are really … masks. By now, you may be able to stay with us. I hope so, because here comes the pull, which makes the lift. Seeing this is worth a thousand words … and may … save you a few thousand dollars." Then, "some stitching, and one side of the face is done." The film then cuts to a long shot, signaling the end of the sequence. "I don't suppose you need to stay for the other side."

On the night before Daisy's surgery, she and her daughter, who has flown in from Boston, enjoy some laughs talking about men. Her daughter says she has given up trying to change men; she will let them stay screwed up. Daisy confesses laughingly that she herself has still not learned that. The next day, we see Daisy briefly being prepped for the surgery, then again afterwards. Her face is swollen and bruised. Two weeks later, she still has some bruises. A few weeks more, she is smartly

dressed and packing her bags. "It was six weeks before I saw her again," Rubbo says. "She was going away." Where are you going? he asks. To Vienna, she says, and to Salzburg, Zurich, and maybe London. She puts on a hat. She wants to go somewhere, she says, where people don't know her.

She's traveling alone. Rubbo asks if she hopes to meet someone at the airport. "I never like to be sure about these things," she laughs. "Let's see." Daisy goes to the airport in a hired car. In voice-over, Rubbo says, "I would have driven her to Mirabel, but she wanted to go in style. I was there anyway, watching from a distance. Daisy had withdrawn somewhat ... starting not a new life ... but a new chapter." Daisy herself says in voice-over, "I really don't think of it as a break with the past or a new beginning. It's just an incident in the continuation of life." Darkness has fallen when her plane taxis along the runway and takes off. "Later," Rubbo says, "I would get a card ... from Salzburg, I think it was. 'Having a wonderful time.'" Apparently, Daisy's future has proved interesting.

Over credits, we hear Willie Nelson, whose voice has been heard periodically during the film, sing several lines of "September Song":

> Oh the days dwindle down,
> To a precious few ...
> September ... November
> And these precious days,
> I'll spend with you.
> These precious days,
> I'll spend with you.

Different as they are, *Yes or No Jean-Guy Moreau* and *Daisy: The Story of a Facelift* share a fascination with appearances, especially the face. A visual "suture" even links the films: the pair of very similar shots of stretched skin. In *Yes or No*, it is the latex skin that Moreau pulls over his own face on the way to transforming himself into René Lévesque. For *Daisy*, it is the shot of Peter's facial skin being stretched several inches off its original surface to allow for the removal of fat before being itself trimmed for a tighter look. Both films involve choices: the impending referendum that lurks in the background of Moreau's

impersonations, Daisy's decision to undergo plastic surgery. Both films are about imagining an alternative way of being: for Moreau, inhabiting, for fun, the personae of others; for Daisy, a future for herself more interesting than her present.

Not surprisingly, *Daisy* provoked more complicated responses from women viewers. In "The Documentary of Displaced Persona: Michael Rubbo's *Daisy: The Story of a Facelift*," Joan Nicks writes that Rubbo "takes up the behaviors of patriarchal privilege to enter a feminine space afforded by Daisy and her facelift." He creates "a parody of male voyeurism in [his] obsession with what drives Daisy's pursuit of a more youthful face to recapture a romantic past."[1] Daisy, for Nicks, is a victim of an ideology that places too much value on a woman's appearance. Rubbo's film gives Daisy the kind of closure she desires—a new adventure full of romantic hope—but it is one "befitting a femininity defined by patriarchy and fantasy."[2] Nicks's feminist analysis is a rewarding read, but it misses the film's humor and downplays its empathy. Maybe the film is all that she says it is, but it is also warm and funny. It is honest and moving. Perhaps only a male could have made it. Occam's razor permits an interpretation that takes Daisy and Rubbo on their own terms. The film suggests—both Daisy and Rubbo voice it—that the ordeal and expense of a facelift is probably not worth the money or discomfort, but there is a self-awareness and a hopefulness in the venture that, for viewers like me, trump the critique.

While Nicks's analysis is solid and dispassionate, the dominant feminist reaction was disdainful. When a planned catalogue of NFB films on women's issues omitted the film, Daisy, with characteristic insouciance, wrote a memo (29 February 1984) to someone involved in the project:

> I understand that Studio D [a unit at the Film Board devoted to making films by and for women] has excluded "Daisy" as an entry.
>
> I consider this to be sexual discrimination. (I have NEVER suffered from male chauvinism ... and now I am confronted by female discrimination. An entirely new concept, don't you agree?)

I would like to point out that, even though this film might not be about the kind of woman decreed to fall into the perception of role model as they see it ... it is none the less a very popular film with a great many women across the continent. In fact, it has communicated with the majority of the female race. (Perhaps there are more women who feel like I do, as opposed to the other way.) It would be a great pity if it didn't appear in the catalogue.

... I thought you might find this twist amusing.

I wasn't able to find out what catalogue Daisy was referring to or whether the film was ultimately included in it or not. But the film was popular with Canadians. Although the CBC rejected it, the American Public Broadcasting Service aired it nationally on 28 March 1983, under the banner of *Frontline*, a major documentary series produced by WGBH-TV. Because most Canadians live in the southern band of Canada stretching from the Atlantic to the Pacific, they could receive PBS broadcasts. *Daisy* garnered almost uniformly rave reviews from critics in both countries. On 13 April 1983, Rubbo wrote a two-page letter to CBC's head of news and current affairs urging the broadcaster to reconsider its rejection:

It is a bizarre situation. We have a film which, on the strength of one PBS screening, has garnered at least 12 reviews across Canada and the U.S. Not a single one finds the film soft or uncompelling, as [a CBC executive] describes it. In fact, they are full of praise, as the enclosures show.

Coupled with this, we have been inundated with calls congratulating us on the film and asking when it will be aired again.

After citing evidence of the film's popularity, Rubbo then addressed what was probably the major objection—his personal style. He first relates that he has often been invited to give workshops at universities in Canada, Australia, and the United States; he had spent a year teaching at Harvard as a visiting filmmaker; he had taught at the Australian

Film and Television School and had been invited back to bolster the school's documentary side:

> I mention this because, in showing the classics in my cours-
> es, it was quite clear that none of them would be accepted
> by the CBC. The great documentaries that stand the test
> of time are often not, as I'm sure you're aware, journalism
> in the sense [i.e., objective and balanced] that [the CBC]
> means it. *Nanook* and *Man of Aran* are certainly not. Nor
> are *Drifters, Song of Ceylon, Night Mail, Triumph of the Will*
> and *Olympia*. There'd be no place for *Listen to Britain* ...
> nor for the free cinema films of Anderson and Richardson,
> films like *Momma Don't Allow, Oh Dreamland* and *Nice
> Time*. Even *Everyday Except Xmas* would be doubtful.
>
> Then from the contemporary classics *Grey Gardens,
> Gimme Shelter, Salesman, Harlan County* and *Hearts and
> Minds* would be excluded on the grounds of not being bal-
> anced journalism. I am simply trying to point out that the
> personal vision is an honourable tradition in the documen-
> tary and that many of the classics are just that.

During the period in which he made *Yes or No* and *Daisy*, Rubbo, along with Barrie Howells, codirected and narrated a remarkable documentary sponsored by the Canadian International Development Agency, *Not Far from Bolgatanga* (1982). The film's subject is a Canadian government project in Ghana. The people in hundreds of villages spread thinly across a large area around the town of Bolgatanga, in the north of Ghana, are suffering numerous health problems as a result of consuming, washing with, and swimming in water contaminated with various parasites. Their water supply is mainly puddles in the rainy season and mud holes in the dry season. CIDA's project entailed building about twenty-five hundred small, hand-pumped wells in the area. The film documents first the need for a solution to the problem of the contaminated water, and then the project's implementation.

For a sponsored film, *Not Far from Bolgatanga* is a remarkable work. It engages the viewer from the very beginning, panning from face to face of the Ghanaian villagers as they stare at the camera in

tight close-up, with sound emanating from a flock of birds swarming in a tree above. Rubbo, who wrote and speaks the commentary, explains (and shows on a map) where we are, and over images of village life he announces that the film is about water, "which means it's about life ... [and] about ... sickness and death." Then he returns to close-ups of the men. As in *Daisy*, Rubbo's narration draws in the viewer: "Did you notice," he asks as we scrutinize the faces, "that they're all ... blind?" The cause is a fly attracted to the water. We quickly learn of other dangers lurking in the contaminated water. One menace is a snail that carries bilharzia (also known as schistosomiasis), which eats away the liver and whose presence in the body is indicated by blood passing in the urine. Another is a worm that enters the body and can grow several inches long. And there's dysentery. A woman carrying a large jug of water on her head is limping, because her foot is infected. A group of boys swim in a water hole. Afterwards, when Rubbo asks them how many are passing blood, most raise their hands.

The main body of the film is about installing the wells and persuading people to use them. The film doesn't gloss over difficulties. Some wells, for example, are overworked. "We asked," Rubbo says at one point, "a dozen people at random, and found three of [the wells had] broken down." Parts are hard to come by. There is no expertise in the village to maintain the pumps. People don't realize that the clean water will soon be contaminated if it is carried in dirty containers or if waste is dumped nearby. Some fear that the well water is itself contaminated by corpses buried in the ground. There was, initially, too much reliance on foreigners, so now villagers are trained in maintenance and repair of the wells, and they are taught how contaminated water causes their various sicknesses. The only boosterish note in the commentary is Rubbo's characterization of the building of twenty-five hundred wells: "an incredible feat." The film ends on a hopeful note. The film crew, Rubbo reports, tracked down the woman with the infected foot. She had followed the crew's suggestion that she wash the foot each day in clean water from the well with some salt added, and she said that her foot "was 'almost better.' Could there be," Rubbo asks, "a better recommendation for the well?"

Although Rubbo does not appear on screen, and is heard asking a question only once, his commentary is delivered in his usual personal,

informal tone. He is understanding and affectionate, not patronizing. He respects his subjects' dignity yet conveys tidbits of information on even minor characters, giving us a sense of their personality and humanity. And just before the end, in a disarming flourish of reflexivity, Rubbo says, "Before we go, perhaps it would be nice for you to meet the film crew." Over a candid shot of each at work, Rubbo names them: "That's Fred Coleman, who photographed the film. That's Sam Boafo, who recorded sound. That's Matthew Adoteye, assistant cameraman. … That's John Garatchi, assistant director. And that's Barrie Howells, who is the executive producer and directed the dry-season material."

The film bears Rubbo's personal stamp in spite of objections from CIDA. While praising the film overall, the agency conveyed a number of complaints in a letter to the Film Board on 27 February 1981. Most of the complaints had to do with matters that would typically come up in NFB collaborations with other government agencies: the film should be more positive; more information should be conveyed; some footage is inappropriate. But the strongest objection had to do, unsurprisingly, with Rubbo's style. CIDA's impression was "that to too great an extent, Mike Rubel [*sic*] was allowed to 'do his own thing.'" The complaint is elaborated, and emphasized with repetition, by another official in an attachment to the letter:

> The film is patronizing from the Ghanian point of view. The commentary is quite offensive in some parts. … I personally would not approve of a narrative that was in the first person and represents a personal statement. The filmmaker is too prominent in the whole production. His enthusiasm and involvement are very positive factors but they should not be so evident as to detract from the film. … The script must be more objective, less a personal statement. … The narrative should not be done in the first person

The Film Board stood its ground, won over CIDA, and released a most engaging and provocative film.

Long Shots

Margaret Atwood: Once in August;
Atwood and Family

In 1984, Rubbo directed a documentary on Margaret Atwood as part of an NFB series on Canadian authors. The film, *Margaret Atwood: Once in August,* was completed that year and is a television hour in length. In 1985, he cut a shorter version, with some changes, called *Atwood and Family.* Their subject, Margaret Atwood, was—and still is—Canada's most celebrated author. Her most famous novel up to that point, *Surfacing* (1972), is narrated by a woman who feels alienated from a society that pressures her to assume traditional gender roles and a culture that is at risk of being dominated by American culture and media.

Margaret Atwood: Once in August begins with Rubbo typing a letter to Atwood asking for permission to film her for a series on Canadian authors initiated by the Film Board. In narration, Rubbo describes Atwood as the author of five novels, ten books of poetry, two books of criticism, and three collections of short stories. As well she is an advocate of various causes. "People become very excitable or ... nervous in her presence," he adds. While the letter-typing scene was staged after the fact, in his actual letter to Atwood, dated 5 May 1983, Rubbo acknowledged the CBC's aversion to his films, warned her of his "quirky and personal" filmmaking style, and made clear that he wasn't

interested in an approach that was reverential or even deferential. He proposed what amounts to an encounter between equals, and which comes close to expressing Rubbo's sense of documentary ethics:

> A writer has a very special relationship with his or her public. A documentary filmmaker of my sort also has a special relationship, a sort of unwritten contract, with his subject. There is an exchange of valuables. One gets close access in return for a subtle self-affirmation, self-referencing of the subject. Famous writers have no need of this, but famous writers could well be interested in the phenomenon. After all you do set your characters in interesting and well-researched life situations.

His request accepted, Rubbo tells us he will spend several days with Atwood and her family on the family island in a lake in Ontario. Her partner, Graeme Gibson (also an author), her parents, and her children are there. Rubbo and his crew will get there by canoe and camp out in a tent.

The central story line is Rubbo's attempt to discover an underlying, psychological motive, perhaps rooted in unhappy childhood experiences, that impels or at least informs Atwood's writing. He's convinced one exists. Time and again, he attempts to probe for it only to be repelled calmly, patiently, but firmly. Of Atwood's *Surfacing*, Rubbo tells her he can't help but wonder if it is autobiographical. Atwood replies that the book "is fiction, Michael." Rubbo suspects her childhood might have been repressive, but Atwood says that she grew up without a sense of limitation. Rubbo tells us, in narration, that he has been wanting to ask her "why her characters are often so cold, so trapped. ... I've *wanted* to ask her this, but ... haven't dared, for fear that it would sound ... more critical than I mean it to be." When he finally says to her that he finds lots of victims in her books, people who don't seem in control of their own lives, she calmly replies, "I don't happen to agree with you on that." Perhaps she had particularly in mind *Surfacing*, in which the main character rebels against victimhood; its most famous line is, "This above all, to refuse to be a victim." The woman who says that, the book's narrator, earlier says, "I had a good childhood."

(The same year that *Surfacing* appeared, Atwood published a survey of Canadian literature, *Survival*, which identified victimization—i.e. failure—as the major preoccupation of Canadian writers. She urged Canadian authors to confront and transcend it.) Atwood points out to Rubbo that most of her characters are women, and that women are more limited in Canadian society than men. But then why, Rubbo asks, doesn't she write occasionally about an *accomplished* woman, like herself? "Ah, that's the George Eliot question," Atwood replies, alluding to the fact that George Eliot never wrote about a successful female writer. Then why not, Rubbo rejoins, write about women in, say, the anti-nuclear movement, which Atwood supports? Because, she says, it is not, in a dramatic sense, a Canadian issue; a Canadian can't write about it except as an observer. But, Rubbo persists, her novels are peopled with "a bleak cast of characters, no?"

"Well, look at the statistics, Michael."

Dispersed among Rubbo's interrogations of Atwood are various scenes in which he pursues other avenues to the mystery he is certain lurks behind her writing, but they only reinforce Atwood's assertion of normality. The family seems to enjoy being together. Her father answers Rubbo's question about his parenting philosophy by saying the main principle was fairness. Her mother, while preparing a pie, remembers having praised her daughter's early creative efforts. While Rubbo is elsewhere, Atwood observes to his "collaborator"—Rubbo's term—Merrily Weisbord, who is also an author, that an eagerness to make an author's story specific to the author's life takes the reader, and society, off the hook. Here's a clue for Michael, Atwood tells Weisbord: her inspiration was the nineteenth-century novel, such as those by Dickens and Eliot. A novel is an interaction with society. It's as simple as that.

About two-thirds into the film, Rubbo does something surprising, unorthodox, daring, and somewhat challenging in the days of 16mm sync-sound shooting: "Admitting a certain defeat, we turn the film equipment over to the Atwoods. They can go ahead and make their own portrait." Rubbo's crew taught a member of the family how to work the equipment, then absented themselves for a while. The family improvises a simple scene around a table at night. The camera is locked down on a tripod, framing Atwood, who is flanked by family members. There appears to be just one light for illumination. In a single

continuous shot, Atwood analyzes Rubbo's approach. "Michael Rubbo's whole problem is that he ... thinks of me as *mysterious*, and a *problem* to be *solved*, and for that reason he spent a lot of the time so far trying to get the *clue*, trying to solve this *problem*. ... This afternoon, he was off on a tack that somehow my family had been 'repressively benevolent' [she laughs] and ... he's trying to find out why some of my work is somber in tone ... and he's trying for some simple explanation of that in *me*, or in my *life*, rather than in the society I'm portraying." This is a remarkably lucid, simple statement about her work. And on Rubbo's part, it was a stroke both self-effacing and brilliant, first to cede control of some of the filming to Atwood's family, and then to include in the film her withering rejection of his film's premise.

Nevertheless, Rubbo—or at least his on-screen persona—appears not to have understood, or perhaps to have understood but disagreed. As the film comes to a close and the crew leaves the island, Rubbo is dismayed that Atwood "had *eluded* us. Yet that is her right. Why should she reveal what haunts her, if anything does? Especially when she knows quite well that we like it much *better* when she remains private ... and mysterious. For me, she's an island on which no boats land. They circle. They peer after her. But no boats land. That's how I have seen her—through binoculars."

Rubbo may have seen Atwood "through binoculars," but what if that perspective reveals her accurately? Other than Rubbo's insinuations, there's nothing in the film that suggests Atwood is hiding something or that she wants to remain mysterious. The film contains no objective hint that Atwood the writer is other than what she says she is. She comes off as having a clear sense of herself and an ability to communicate it. A fair-minded viewer of the film would likely think Rubbo *has* revealed her, far more successfully than he realizes. If she seems mysterious, maybe that's part of her nature, a natural reserve, not the result of a deliberate intention. When the editing was in its final stages, Rubbo sent Atwood a VHS copy for her to review along with a covering letter (9 April 1984) in which he wrote, "You may be interested to know that the reaction here at the board is that you remain totally mysterious, but that somehow my failure to pin you down is itself richly revealing." No need for a microscope. Binoculars were fine.

10.1 Atwood pulls a paper bag over her face. Screen grab. *Margaret Atwood: Once in August* (1984). The National Film Board of Canada.

A striking moment in *Once in August* occurs when the Atwood family discusses Rubbo in his absence. Atwood pulls a paper bag over her face as if to mock Rubbo's insistence that there lurks something murky in her psyche. It's an irony on which Rubbo, in his narration, doesn't comment: his two most recent full-length documentaries, *Yes or No* and *Daisy*, had featured characters and their "masks." But in both films, Rubbo had respected the characters' right to their masks, and did not assume or imply something sinister or dark lurking underneath. He exhibited the same tolerance in films where the masks were metaphorical rather than literal, as with Stirling and Smallwood in *Waiting for Fidel* or Blaker in *Persistent and Finagling*. There are literal masks in *Wet Earth and Warm People* and figurative ones in *Sad Song of Yellow Skin*. He and Robitaille donned political masks for a brief scene in *Solzhenitsyn's Children*. *Once in August* is the only film in which Rubbo is not content to respect the persona his subject has chosen to project. Yet his vain attempt with Atwood yields a terrific portrait. Seeking to penetrate Atwood's depths, he renders her surfaces, and in so doing, renders her whole. His talent seems to lie in observation and

10.2 Sketching beside the lake. Screen grab. *Margaret Atwood: Once in August* (1984). The National Film Board of Canada.

reflection, not exposure. Perhaps he is best at revealing character and suggesting truth through the surfaces of things, like a painter.

There is a pleasant scene in the film where Rubbo and Atwood, sitting on a rock beside the lake, are each sketching something. Atwood asks Rubbo what he is drawing. "Something very difficult," Rubbo says. "I'm doing *you*. But I can't see you, you see." "Very symbolic, isn't it?" she answers. Atwood is probably referring merely to Rubbo's frustration that he is not getting to know the "real" or "inner" Atwood, but the scene could serve as a broader metaphor, not just for this film but for Rubbo's films in general. He sees things as a painter, not a psychiatrist, anatomist, or investigative reporter. Painters paint what they see; they paint surfaces.

Even so, there is more to the film than its ironic depiction of an author who maintains she has no secrets which, if disclosed, would illuminate her work. Rubbo's framing adds a storytelling aspect that helps him create a sense of mystery. His use of the island—the family's private island—as a metaphor lends his film an atmosphere reminiscent of many an adventure story in film and literature. He and his

crew approach the forested island silently in canoes. Rubbo explores the island, fails to penetrate its mysteries, and leaves. In his closing narration, he asks rhetorically why Atwood should "reveal what haunts her *if anything does?*" Those are my italics. Intentionally or not, Rubbo is acknowledging that there may be nothing hidden to reveal, no secret to discover. His quest, at least to some extent, is a construction, a way to turn his portrait into a story, one with mystery, thus enhancing the portrait. Carlotta Valdez (the portrait that purportedly haunts the woman Scottie Ferguson has been hired to keep tabs on in Hitchcock's *Vertigo*) it is not, but the purported mystery has kept us interested. And his concluding admission of at least partial failure is reminiscent of his acknowledgments of unfathomed secrets in several of his earlier documentaries, such as *Sad Song of Yellow Skin*, *Wet Earth and Warm People*, and *Solzhenitsyn's Children*.

In the shorter version, *Atwood and Family*, Rubbo is less intrusive than he is in the original version. He doesn't back away from his search for some hidden cause of the bleakness of much of Atwood's fiction, but, partly because the film is shorter, he comes off as less insistent. Most of the footage in *Atwood and Family* was seen in the original film, but the way Rubbo introduces some of it changes noticeably. He doesn't identify Merrily Weisbord as his collaborator, but simply says, before the first scene in which she, not Rubbo, interviews Atwood, "It was good having Merrily Weisbord. She would relate differently to Margaret." Before the scene in which the family films itself, he now says only that Atwood "was bothered by my rather narrow view of her work. This came out in some filming they did ... one evening when I wasn't there." And although he ends the shorter film with the same description of Atwood as like an island on which no boat lands, whom he has seen only through binoculars, this passage is preceded not by saying that "she had eluded us," and that she likes remaining private and mysterious, but rather by "I got to like her ... but not to know her." These changes make the shorter version feel more like a detached portrait of Atwood than an encounter between filmmaker and author. But while the result is a pleasant portrait, it lacks the impact of the longer version. In the shorter film, we haven't seen enough of Rubbo's interactions with Atwood for his comment that Weisbord "would relate differently to Margaret" to carry much meaning. Rubbo's new

introduction to the scene shot by the family in his absence suggests they took it upon themselves to shoot the footage, perhaps even without his permission, while in the original version we were told that the equipment was deliberately turned over to the Atwoods so that they could film without Rubbo and his crew around. And the new ending, with Rubbo saying that he got to like Atwood but not to know her, carries less impact than it might have in the longer film, with its numerous scenes suggesting that he and Atwood were not connecting well.

The two Atwood films would be the last documentaries Rubbo would direct for sixteen years. Had he felt there were no more methodological barriers to break? Or was he simply getting tired of documentaries? Neither was precisely the case. His attention does seem to have turned inward since *Solzhenitsyn's Children*. Reviewing Rubbo's major films up to but not including the Atwood films, which hadn't been released at the time of his writing, Piers Handling found Rubbo's recent work problematic. Handling detects in the later films a withdrawal from social and political concerns and "a detached, external and often amused point of view." He notes the ambivalence of *Solzhenitsyn's Children*. He regards Rubbo's admission in *Yes or No, Jean-Guy Moreau* that he's worried about his own future in a separate Quebec as a retreat into personal concerns. He wonders if *Daisy* is "a regressive portrait of women or a condemnation of society as a whole." He finds it hard to tell where Rubbo stands on the issues at the core of the three films. "There is," he writes, "a sense of suspended judgment to these films, as if Rubbo has shied away at the last moment from the full implications of his subjective treatment of the chosen material."[1] One would guess that, had he seen them, the Atwood films would represent for Handling an even further retreat from wider concerns.

And yet, in the very next paragraph, Handling writes:

> To my mind he is one of the most important documentary filmmakers in the world. His formal innovations and questionings, his intervention as a social actor on the image-track, and his acknowledgement of his role as instigator, creator and manipulator are central to the documentary debate, yet are questions being addressed by few filmmakers. If there is a radical element to Rubbo, it lies

with this desire to question and perhaps rupture the illusionism at the core of documentary.[2]

Handling's analysis strikes me as remarkably acute. He discerns in Rubbo a retreat from sociopolitical concerns but acknowledges his continuing innovations. Rubbo is less passionately engaged. But the quality of suspended judgment that Handling detects in Rubbo's later films is also present in the earlier ones, with their underlying mood of doubt. And I would quibble with Handling's tone of disapproval regarding Rubbo's apparent withdrawal from political issues. Given Rubbo's openness to experience and his predilection for doubt, it was probably inevitable that he would turn to situations less contentious and complex. But he certainly engaged with these situations. *Daisy* and *Margaret Atwood: Once in August* (which Handling hadn't seen) are beautiful, provocative films each in its own way. As for formal innovations, which Handling praises, Rubbo would resume his experimentation with them, sometimes radically, when he returned to documentary directing in 2000.

A Break from "Reality"

*The Peanut Butter Solution; Tommy Tricker
and the Stamp Traveller; Vincent and Me;
The Return of Tommy Tricker*

By 1985, Rubbo had been with the National Film Board for rough-
ly twenty years, and he had thrived there. In film after film, he had
chipped away at documentary conventions. He had mastered the form
and developed a distinctive personal style. He had become extremely
comfortable with his on-screen persona and in using it to find and
shape a story. The on-camera director in his later NFB films seems
as relaxed as one could imagine possible in a pressured situation like
shooting a documentary film for which he will be accountable.

Despite occasional instances of bureaucratic sluggishness or pock-
ets of indifference to its mission, the Film Board had been a very good
place for him. Ten years earlier, after he had made his two Cuban films,
he expressed to *Sightlines* interviewer Steve Dobi the special advantages
a job at the Film Board provided someone like him:

> Apart from the freedom to say what one wants (most of
> the time), there is the equally important freedom from
> financial worries. Most directors have to waste enormous
> amounts of energy financing their films and fitting their

film conceptions into financeable packages. Not so at the board, and that must have an effect on my work. I think that it means that the personal character of the filmmaker tends to come out in the films. It gets closer to being self-expression, closer to painting. In the world of commercially made films, and more controlled documentaries, the "personal" gets averaged out into something which will supposedly appeal to a greater number of people. ... There are no pressures on me to be like that, and so I have just gone my more natural way.[1]

And at the NFB he could go on his natural way with a comfortable salary, job security, first-class budgets, and terrific craftsmen involved at all levels of production. It was a dream situation, the envy of many a documentary filmmaker who was familiar with the Film Board. But he walked away from it.

Various factors contributed to his decision. For several years, he had enjoyed teaching stints at Harvard, which took him out of production. There he tried to get going on a pair of environmental films, but couldn't find support. His marriage was breaking up, and he was engaged in a stressful custody battle with his ex-wife about their son. The Film Board itself was entering a stage of gradual downsizing. His beloved mentor and favorite producer, Tom Daly, was retiring. The internal politics at the Film Board drained energy from filmmaking. Rubbo says he was "not popular because I took a position that we shouldn't have tenure, that there should be something at stake in our jobs, some security but not a guaranteed job for life. There were people there who just collected their salaries. My judgmental streak came to the fore."

Meanwhile, a new filmic interest was developing. Rubbo had always had an interest in stories for children. Six of his first seven NFB films were made either for or with children, or both. In 1967, he published an article on children's films in the Canadian film journal *Take One*, in which he called for children's films that were less protective than they typically were in the English-speaking world.[2] He had been involved at an early stage with a popular NFB feature film, *Christopher's Movie Matinee* (1970), directed by Mort Ransen but largely improvised by the

teenagers who act in the film and are its subject. In 1979, he proposed a coproduction with WGBH-TV Boston on the childhoods of famous people. In the 1980s, he unsuccessfully urged the Film Board to create a program of quality feature films for children. In an undated, unpublished interview in the 1980s—in it he mentions *E.T. the Extra-Terrestrial*, which was released in 1982—he suggested that engaging in honesty with children might be "worth a nightmare or two." The Film Board wasn't interested, but there was a movie producer in Montreal, Rock Demers, who had founded a company called La Fête devoted to making feature films for children. Rubbo happened to meet Demers when he visited the Film Board, and they hit it off. With Demers as producer, Rubbo, after leaving the NFB, wrote and directed four children's features: *The Peanut Butter Solution* (1985); *Tommy Tricker and the Stamp Traveller* (1988); *Vincent and Me* (1990); and *The Return of Tommy Tricker* (1994).

It is a common thing for documentary filmmakers to want to try their hand at fiction. But when documentarians venture into drama, they tend to be more comfortable with realism than with fantasy. Not Rubbo. The stories in all four of his features are utter fantasy. No one would have guessed that they were the work of an accomplished documentary film director.

Rubbo's first feature, *The Peanut Butter Solution*, contains a nightmare or two. Eleven-year-old Michael and a friend are taking a painting class under a tyrannical teacher, Sergio (called Signor), who insists that his students paint exactly what they see. They are not to use their imagination. When, later, Michael dares to enter an abandoned fire-damaged house, something frightens him. He falls down a chute used for cleaning out debris and is knocked unconscious. When he wakes up the next morning, he is bald. His classmates humiliate him with their teasing. One night he encounters some friendly ghosts in the family kitchen. They give him a recipe heavy on peanut butter but otherwise sounding like a witch's brew. They say it should restore his hair. It proves so effective that his hair not only grows back, it won't stop growing and must be constantly sheared. But Signor, recognizing an opportunity, kidnaps Michael and about twenty other children, employing the latter as slave labor to make magical paintbrushes from the never-ending supply of hair that Michael produces. Michael's friends

trace him to Signor's secret factory. With one of the brushes, Signor paints a huge canvas depicting the burnt house. After the painting morphs three-dimensionally, Signor enters it, suffers a fright similar to the one Michael had experienced, and turns bald himself. At that instant, Michael's hair stops growing because, we're told, his fright was passed to someone else. Michael enters the painting, goes back into the house, and sees only the friendly ghosts. Soon Signor is captured and the children are freed. As the story transitions back to comparative reality, Michael says in voice-over that what he discovered in that house was that the biggest part of a fright lies in your imagination.

The Peanut Butter Solution resembles a cross between a fairy tale and a dream. Waking up bald, then having hair that won't stop growing, a tyrannical authority figure, enslavement—these are the stuff of scary fairy tales. But they are put together in a surrealistic way that jumps from one situation to another more by free association than by conventional cause and effect.

Although the film didn't make much of a mark when it came out—Rubbo remembers the English-language reviews being dismissive—it had a haunting effect on many young children who saw it. When, in 2009, the film was posted on YouTube, almost all the commenters were pleased to have a chance to see it again. Several remembered it as being a dream, not a film, and are relieved to have the matter cleared up. The most common theme in the responses, however, is the scariness of the film. Someone self-identified as kirstleeh reported that "growing up in our house with four young children, we were all very scared [by] this movie." One JonL said that the movie "scared the crap out of me as a kid." Willie Brown remembered "seeing the trailer on HBO ... and waking up like 3AM to watch it before school. Big mistake [because] it freaked me out for weeks after that." "It scarred me as a kid," reported chrisjamesknapp, "I was so terrified." It was, for kimmyfreak 200, the "weirdest movie ever it gave me nightmares as a kid." Baby Jane, however, evidently somewhat logic-bound, exclaims, "I'm five minutes in wtf is going on."

Tommy Tricker and the Stamp Traveller shares *The Peanut Butter Solution*'s whacky causality. Ralph, who stutters, collects stamps. He is told by an eminent collector who is visiting Ralph's father, also a collector, that stamps have the power to lift a package and send it

anywhere in the world. Later, Tommy Tricker, a young hustler, persuades Ralph to trade his father's prized Bluenose stamp (depicting a schooner, it is considered Canada's most beautiful stamp) for some colorful but worthless stamps Ralph has coveted. Tommy then sells the Bluenose to a dealer for $300. Ralph's friend Nancy tracks it down, but the dealer won't sell it back for less than $600. To placate Nancy, he gives her an unopened package containing an album that he presumes to be worthless, which Nancy gives to Ralph. They discover a letter in it that says there is a valuable stamp album in Australia. The letter instructs the reader to use his imagination to shrink himself so small that he can fit onto a stamp and ride it to the letter's destination. After following the letter's specific instructions, which include chanting "I have no fear, I have no fear at all," Ralph becomes a two-dimensional being and shrinks onto the stamp. Through a series of misadventures, the stamp gets removed from its envelope and affixed to a letter addressed to China, where Ralph winds up. A boy who befriends him takes him on a boat ride on a lake where dragons are said to live. The boy falls overboard and Ralph dives in to save him, but the apparent accident turns out to have been merely a test of Ralph's courage. Ralph is now ready to be reshrunk onto another stamp on an envelope addressed to Australia. In a visually lyrical sequence, the envelope is caught up in the tail of a dragon kite, soars upward, comes loose, falls like a leaf into a postal worker's mail cart, and is sent to Australia. In Sydney, Ralph discovers that the valuable album had just been picked up by Charles Merriweather, a boy they had seen on the Bluenose stamp. The album is now in the hands of one Mad Mike, who after losing his prized menagerie of animals, became a crazy hermit. Mad Mike, they learn, has captured Tommy Tricker, who somehow learned of the album's whereabouts, travelled on a stamp to Australia, and tried to steal the album from Mad Mike. Ralph takes a koala bear to offer to the animal-loving Mad Mike in trade for the album. Tommy Tricker is forced to acknowledge that the album belongs to Ralph. The album now in his hands, Ralph's stuttering clears up. Somehow, Ralph gets shrunk onto a stamp on an envelope addressed to his home in Canada, a kangaroo mails it, and Ralph arrives back home with the album. It is full of valuable stamps, to the delight of his father, who also, somehow, has gotten the Bluenose back.

Like *The Peanut Butter Solution, Tommy Tricker and the Stamp Traveller* had a lasting effect on many of the young children who saw it, but in this case a comparatively benign one. Posted on YouTube in 2014, it has drawn a number of comments from grown-ups pleased that it had been made available. 90schick posted, "One of my favorite movies when I was 6-7. Thank you so much for uploading." "Thanks so much for posting this movie," writes SLDragon, "When I was younger, it was one of my favorites." Donald Dahl wrote, "I remember this movie and can't wait to watch it with my boys." Memories of the film were further triggered when Rubbo uploaded a song, "I'm Running," that Rufus Wainwright, later a famous singer-songwriter, had written and sung for *Tommy Tricker* when he was a teenager. Everpod "watched this movie every day when i was a kid." Laura H and her siblings "used to watch it at least once a week when we were growing up." For kevinstakes13, *Tommy Tricker* is "One of my all time favorite movies." And some of its once-young fans are now adult fans: "I am 25 years old and I still love it," writes sveccha15, "as does my 24 year old sister. We still watch it to this day." Says dj26000, "Great movie I saw it in 1989 when I was 5 on TV and still watch it today … they don't make movies like that anymore."

The film's sequel, *The Return of Tommy Tricker*, is similarly structured, with whatever causality Rubbo pulls out of a hat to carry the story quickly forward. Told by an old man that the name of the boy on the Bluenose stamp is Charles Merriweather and that he has been stuck there since 1930, Ralph and his stamp-collecting friends decide to free him by putting the stamp on a letter mailed to themselves. But once again, Tommy Tricker manages to steal the stamp. After a short-lived effort at establishing an island nation on a swampy spit of land, where he had intended to print his own stamps to sell to collectors, he mails the Bluenose to himself. He sells it, but the buyer has it snatched from him by Cass, who is a friend of both Tommy Tricker and the other kids, and who takes it to Nancy's house. The kids bar Tricker from the house. Somehow they free Charles Merriweather from the stamp, but he turns out to be a she—Molly, his sister. She explains that Charles had gotten sick, so she took his place. She is pretty, but when the mask she is wearing at a party is removed, we see that she has aged rapidly and is almost an old lady. Tricker, feeling partly responsible,

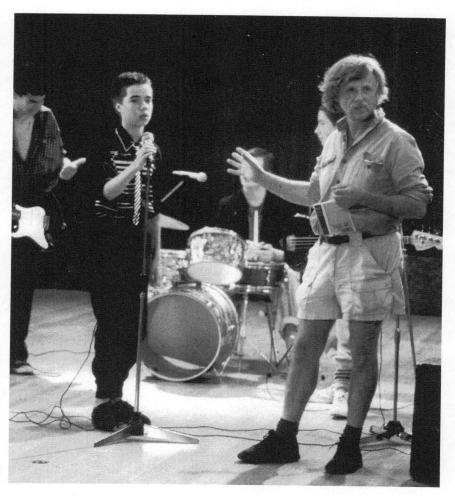

11.1 Rubbo directing Rufus Wainwright. *Tommy Tricker and the Stamp Traveller* (1988). Still photograph by Jean Demers, courtesy of Productions la Fête.

has found a letter explaining that a certain dart, which was in Molly's satchel, will take you, if thrown at a large map, to wherever it lands. The dart lands at London, which just happens to be where Molly lived in 1930. Tommy and Molly ride the dart through a galaxy of stamps, but instead of London they land on a tropical isle, one of the Cook Islands. They make friends with a native boy, who takes them for a

canoe ride on a lagoon. Molly falls in the water and the boys rescue her. Swimming underwater, Tommy notices a single-engine plane on the sea floor.

Molly falls ill and is taken to a traditional healer—who just happens to have a stamp collection. The healer tells the boys to go into the forest and get a certain plant that has special healing powers. At some risk, because the medicinal plant is surrounded by other plants deadly to the touch, Tommy uproots it and delivers it to the healer. Then, in a village square, he encounters a crowd of young stamp collectors engaged in showing and trading. They have more Bluenose stamps than any of them want; the stamp is common here, because missionaries used to get them on overseas mail. Tommy trades some cheesy modern dinosaur stamps for their Bluenoses, which he then hides. Molly, though, is not getting any better. The healer says the only cure is to cover her body with stamps. Tommy reluctantly turns over his Bluenoses. She is cured, and goes to watch a traditional marriage ceremony featuring much native dancing. One dancer, however, turns out to be Charles, her little brother. They embrace.

Tommy and his friends go to retrieve the plane. Tommy sits in the cockpit underwater as his friends start the boat to tow the plane to the surface. The tow-rope snaps. The kids on the boat chant, "He has no fear, he has no fear at all," and then the plane, its engine now running, rises, breaks the surface, and soars into the air. Tommy metamorphizes into a stamp on an envelope addressed to his house, and he returns home.

The Return of Tommy Tricker, although less compelling than the first Tommy Tricker film—largely because Tommy is played by a less-engaging actor—shares the attraction to fantasy and advocacy of imagination that permeate Rubbo's first two feature films, and it also has the same surreal or dreamlike continuity, the kind of sequencing that makes sense in a dream but seems absurd upon awakening. It also contains the same appeal to courage: have no fear. The one element that the two Tommy Tricker films share with Rubbo's documentary work is their attraction to foreign lands and cultures—the China sequence in the first Tommy Tricker film, and the Cook Islands sequence in the second. Both sequences convey an enchantment with the visited culture and affection for its people.

Vincent and Me, which Rubbo directed between the two Tommy Tricker films, may be a children's film but it stands apart from the other three. Jo, a talented small-town girl, is off to Montreal to attend a summer arts school. She loves the work of Vincent van Gogh and wants to paint like him. At the school, she is asked to design a backdrop for the school play. She designs a backdrop copied from Henri Rousseau's "The Dream," except that in place of the nude woman she paints her bespectacled friend Felix. The teacher chastises her for copying. Use your imagination, she exhorts, giving her no credit for the displacement of the nude woman by Felix.

When not in class, Jo likes to sketch people she sees around Montreal. A man notices her, follows her, and is intrigued by the sketch, which is in the style of van Gogh. He buys the sketch and asks her to bring to him any others she has. They meet at a Chinese restaurant. He buys the other sketches she has brought along. But when Felix, dressed as a waiter, takes a photo, the man raises one of the sketches to hide his face.

A few weeks later, when the school play proves to be a great success, Jo's teacher, aware of her love of van Gogh, shows her a magazine article about the recent discovery of early sketches by van Gogh, one of which was sold to a Japanese businessman for $1 million. Jo immediately recognizes the drawings as hers and the "discoverer" as the man who bought them from her. No one believes her. She is accused of lying and is about to be expelled from school when Felix appears with the photo he took at the restaurant. The sketch that the buyer had held up to hide his face is the sketch pictured in the magazine article.

Now with support, Jo and Felix will go to Amsterdam chaperoned by Tom, a journalist from Jo's hometown who is a friend of her father. Their visit to Amsterdam coincides with news of the recent theft of a valuable van Gogh painting. While the journalist pursues the story of the falsely attributed sketches, Jo and Felix become friends with a Dutch boy who lives on the smallest houseboat in Holland. Exploring an abandoned boat, they discover a secret belowdecks compartment in which a young artist is held hostage producing, under threat of bodily harm, copies of the stolen painting. He must finish by the next morning—or else. Jo helps him. They finish. Jo and Felix tell Tom about this and swear him to secrecy. But the next day, they see a television

11.2 Rubbo on break with "Vincent" (Tchéky Karyo). *Vincent and Me* (1990). Still photograph by Jean Demers, courtesy of Productions la Fête.

news report about the arrest of the art thieves and the retrieval of the painting. Tom has betrayed them and taken all the credit.

Asleep, Jo dreams of van Gogh. Her spirit leaves her body, soars toward the stars, and lands in a field in Arles, where van Gogh is painting. He is skeptical of Jo's claim that she is from the future, but she gradually convinces him. He is enormously gratified to learn that he, who can't sell any of his work, has become famous in the future. At his house, Jo gets him to write a disclaimer on the photo of the sketch in the magazine article. When he surprises Jo with a smile, she remarks

to him that he rarely smiled. "Every painter likes to be remembered," he explains.

Framing the story is a pair of scenes with an actual person, the 114-year-old Jeanne Louise Calment, who at the time the film was shot, in 1989, was the only living person who had once met van Gogh. At the beginning of the film, she merely says that he was rude to her. That's all she remembers about him. At the end of the film, after waking up from her dream, Jo takes the high-speed train to Arles to meet Calment. They talk briefly. Jo says van Gogh was nice to her. Calment, who repeats that she found him rude, can't believe that Jo could have met van Gogh, since she is only thirteen years old.

Except for Jo's dream sequence with van Gogh, the film's continuity is, compared to Rubbo's other three features, straightforward, if hardly more believable. Like the other films, it is constantly inventive, and like them, defies concise summary. It was shown on American television in 1992 and won an Emmy for Outstanding Children's Special. Adults can enjoy it, too.

The only obvious element of Rubbo's documentary style in this quartet of children's fantasies is the quasi-documentary set of bookends in *Vincent and Me*. Calment and the interview are real while Jo is a fictional character. The device recalls Rubbo's periodic use of imaginative contrivances in his documentaries. An echo of Rubbo's fascination with masks appears in *The Return of Tommy Tricker*, when Molly's mask is pulled off to reveal the face of an old woman. The two Tommy Tricker films reflect Rubbo's love of travel and fascination with other cultures.

Overall the features share another characteristic with Rubbo's documentaries: enormous energy. The films move fast, and they look like they were shot quickly—not that they appear carelessly shot, but that a lot of filming seems to have been compressed into long shooting days. There are numerous twists in the films, and they happen quickly, seemingly frenetically. Their plots sometimes race along faster than the viewer can keep up with them.

More intriguing is the question of how rooted these four children's features might be in Rubbo's own childhood or adult life. Stamp collecting plays an essential role in the Tommy Tricker films. In his childhood, Rubbo collected stamps. Their fascination lay in their evocation of faraway places. "I loved stamps as a kid, had an album and

daydreams pretty much like the kids in the movies. I noticed that each country had a particular style and that you could get a good idea of the country's geography and appearance from them." But by the time he left college, he had long abandoned stamp collecting for the real thing, having traveled abroad several times.

Both *The Peanut Butter Solution* and *Vincent and Me* feature painting. Rubbo is also a painter. He produced all the "van Gogh" pieces for *Vincent and Me*. We had seen him sketching with Margaret Atwood. Rubbo's mother was an accomplished painter. And Rubbo's Italian-born grandfather, Antonio Dattilo Rubbo, was a painter as well as a gifted and inspirational art teacher in Sydney for most of the first half of the twentieth century. In 2011, the Art Gallery of New South Wales put on an exhibit of his work. The exhibit catalogue, as of this writing available on the gallery's website, included twenty-four illustrations, a scholarly essay by Emma Collerton, and a family remembrance by Rubbo.[3] In the late 1980s, Rubbo combined his own love of painting with his memories of the allure of stamps. For sending letters to friends, he would create miniature oil paintings that he pasted on the back of envelopes. On the front, he'd put old mint stamps, ones he remembered from his childhood and which he now would buy from dealers. "I sent many such letters around the time of the Tommy Tricker films," he said. "It was a way of carrying on the sort of game of the movies in my own life. Like in the movies, the risk aspect intrigued me. Would one see an original oil painting and steal it, since it was not protected in any way? Or steal the stamps? Most got through. Later, I took some to an art fair in New York City and had a stall, selling a few."

But there could be a deeper connection between Rubbo's fascination with painting and the one theme the four films share: fear. The lead character in *The Peanut Butter Solution* is named Michael. The painting teacher is to some extent modeled after Rubbo's memory of his grandfather. Unlike the painter in the movie, Antonio Dattilo Rubbo exhorted his pupils to be creative. But like the movie character, "He was called 'the Signor' by his students," Rubbo says, "and he would walk around behind his students acting a bit like you see in the movie. I was scared of him as a kid. When he was an old man, he would tell me about the duels he fought [in Italy], and he would pull out of his pocket something brown and shriveled, and say in his heavily accented

11.3 Rubbo's letter art. Courtesy of Michael Rubbo.

voice that it was part of a human ear that he had nicked off in a duel. Looking back, I think it was actually a piece of dried apple." And no doubt Rubbo, like any kid, experienced various other episodes of fear that remained imbedded in his memory, consciously or not.

Fear and the necessity of overcoming it feature explicitly in the two Tommy Tricker films as well. But since fear is an emotional element in most children's films, there's nothing unusual in its role in Rubbo's first three features for children. And if Rubbo was a fearful child—I have no reason to think he was—he surely overcame it before he reached adulthood. He wasn't afraid to travel to and explore non-Western countries. His large Film Board budgets, for which he was accountable, didn't intimidate him. He would throw himself into projects and situations that many would shy away from. He could deal with uncertainty and reversals in the midst of shooting. He could withstand criticism of his

personal style. But for all that, employment at the Film Board paid decently and was secure. Perhaps fear and the need to overcome it were on his mind because of his attempt to make it as a freelance director.

Rubbo's long and deep fascination with the tormented van Gogh suggests another possibility. Does Rubbo, who was certain that some dark personal experience lay behind Margaret Atwood's bleak portrayal of Canadian society, himself suffer from deep anguish? There is no such suggestion in his documentaries. They are not bleak in tone but, for the most part, joyous, or at least buoyant. Except for minor annoyances like a stolen camera or being stared at, the concern he expresses in his documentaries is for others, not himself. The only utterance of his in any of his films that sounds at all like a *cri de couer* is his mildly tortured-sounding insistence, in *Solzhenitsyn's Children*, that "it's *wrong*," for large, powerful countries to invade smaller, weaker ones. This was a moral plaint, not an expression of personal hurt.

Or could Rubbo's identification with van Gogh lie in an artist's anxiety that he might not be remembered? Van Gogh received no public recognition in his lifetime. Rubbo's grandfather's art occupies only a minor place in art history, and he is all but unknown outside Australia. Could the anxiety of being forgotten lie behind Rubbo's exhortation to overcome fear in his children's features? After all, as Rubbo had van Gogh say in *Vincent and Me*, "Every painter likes to be remembered." Substitute "filmmaker" for "painter," and could not his van Gogh be speaking for Rubbo?

There are some other reasons for suspecting that this could be the case. In 1980 or 1981, the Film Board published an illustrated (and undated) booklet on him, titled *Michael Rubbo: The Man and His Films*.[4] Rubbo instigated the project, helped compile the material, and suggested the layout. For this act of self-promotion he was derided by some of his colleagues. But from his point of view he was simply taking an initiative to try to help the NFB distribute his films and perhaps provide a model for other NFB filmmakers amassing a body of work. Imagine his frustration that most of his best films—which he had to know were excellent and innovative—were refused by the CBC, the prime outlet for the Film Board's television-length documentaries, or indifferently promoted by the Film Board itself. How could he be remembered if his films couldn't even reach audiences?

As recently as 2007, the nearly seventy-year-old Rubbo posted on YouTube a two-part defense of Michael Moore against a film attacking him, *Manufacturing Dissent* (2007), by Canadians Debbie Melnyk and Rick Caine. One of the film's main charges was that Moore's *Roger & Me* (1989) was based on a lie. The premise of *Roger & Me* is Moore's unsuccessful quest for an interview with General Motors head Roger Smith, whom Moore blames for the economic troubles of his hometown of Flint, Michigan. Moore, the Canadian film claimed, was granted an interview but chose to pretend he never got it. Rubbo's defense of Moore seems ambivalent. He regards Moore's alleged lie as unacceptable if the allegation is true, but he doesn't outright condemn it. He is more annoyed at *Manufacturing Dissent*. He distrusts the filmmakers. He defends the right of a filmmaker like Moore to fiddle with the facts a bit in order to make an interesting story. One gets the impression that he doesn't approve of the alleged, major fudging in *Roger & Me* but he has an unacknowledged reason for not denouncing it outright. At the end of the second part of the YouTube presentation, Rubbo holds up a copy of the DVD of *Waiting for Fidel* and remarks that he has been told that *Roger & Me* was inspired by it.

New Tools of the Trade

*ABC; The Little Box That Sings; Much Ado
About Something; All About Olive*

In 1995, after nearly thirty years in Canada, Rubbo moved back to his native Australia to accept an invitation to head the Documentaries Department of the Australian Broadcasting Corporation. He had also been offered the headship of the Australian National Film School, but he preferred to be involved in production. And the ABC accepted as a condition of his employment that he be allowed to develop and produce a new ABC program inspired by a French-Canadian television series, *La Course Tour du Monde*, which had intrigued Rubbo when he saw it in Canada. ABC's version, called *Race Around the World*, lasted two years (1997–1998). Each year the program selected, on the basis of video submissions, eight young people to participate. After a brief course in documentary, each was given a newly released Sony digital hand-held camera with a side-opening viewer, an international itinerary, and a hundred days to produce ten four-minute documentaries. They had to plan and shoot the films, but their footage was sent back to Sydney to be edited according to their instructions. Four of the films were shown on each half-hour television broadcast. It was a competition: the films were judged, with points deducted for lateness.

For Rubbo, *Race Around the World* was a chance to offer young Australians the kind of travel-based storytelling he had loved doing as

a teenager and college student. In his day, of course, Rubbo had to rely on words, photographs, paintings, and occasional 8mm silent footage to tell his stories. Now, inexpensive, easy-to-use digital film equipment enabled the young travelers of *Race Around the World* to make films with soundtracks. But in Rubbo's view, the filmmaking—the documentation—was then and now secondary to a more fundamental experience. In an interview with Geoff Burton in 1999 about his days at the ABC, Rubbo said that he

> was just like many other Australians, a good traveller, very open and empathetic with people. Documenting my travels with whatever technology I had at hand was just a logical add-on to the rich emotional process of interacting with people. After all, documentary is all about getting access to people's lives and having those people willing to give you good stories under certain circumstances. It is an exchange of valuables, meaning they get something and you get something. *Race Around the World*, the process of travelling with tiny unobtrusive cameras, is perfect for that negotiation to happen.[1]

These remarks about *Race Around the World* reveal something essential about Rubbo's documentary aesthetic—its basis in his enjoyment of personal interaction, a sense of mutuality. The "exchange of valuables"—which he had invoked in his letter to Atwood—is not just a kind of free trade benefitting both parties; it is an ethical principle.

Rubbo created and hosted one other major ABC series, *Stranger Than Fiction*, which showed Australian documentaries, most of which he commissioned. He preferred chance-taking, observational documentaries to scripted or interview-based films. He encouraged filmmakers to experiment with the new digital technology. To help the students in *Race Around the World*, he had developed a set of six criteria for assessing proposed or completed films, and he applied these to the documentary series. A documentary film should have something at stake; have a story; have interesting characters; be emotionally touching; provide food for thought; and be strangely compelling. However, as he told Geoff Burton,

he ran into fierce opposition from some local film-makers who were accustomed to making a lot of essay type films and had no interest in the observational genre. They saw me as a threat because ... I was touted as someone who would not commission anything that was scripted or of the essay type.[2]

Rubbo nonetheless commissioned roughly thirty documentaries during his short reign and served as executive producer on several of them.

But the executive role did not suit Rubbo. As in any bureaucracy, there was infighting and intrigue, something he says he was never good at. There was ample bureaucracy at the NFB, but there his responsibility was confined to his own films. Wise executives like Tom Daly and Colin Low (who Rubbo once said "brings a certain serenity to filmmaking") negotiated the bureaucracy for him and other filmmakers. Unhappy as an executive, learning his contract would not be renewed, and itching to get back to making his own documentaries, Rubbo started working on a new documentary of his own using the new technology that he had been urging other documentary filmmakers to employ. With digital equipment, one could make a film by oneself. A director could do both his own photography and his own sound recording if he was reasonably proficient technically and not afraid to try the new tools.

Rubbo's new wife, Katherine Korolkevich, suggested the topic for his first project as a digital filmmaker, Australian violin makers, and she shares credit on the ultimate film. One of the key figures in the film would be Harry Vatiliotis, who immigrated to Australia from Cyprus in the 1950s. Vatiliotis is a skilled violin maker who rarely leaves his house, which also doubles as his workshop. Rubbo negotiated a departure deal with the ABC that allowed him, on the broadcaster's money, to start shooting the film while still working there. As Rubbo explains it,

I would duck out at lunchtime, drive to Harry's violin workshop and shoot a sequence on my ABC camera before rushing back to take care of meetings and correspondence for the rest of the afternoon. People found it very amusing

that the head of documentaries was shooting a documentary on his lunch break. I enjoyed it very much and I think I also enjoyed demonstrating a sort of bold competence that none of the others would try even as they marked me down for my bureaucratic performance.

Rubbo had to make some adjustments to his documentary style. Without a crew, he couldn't easily step in front of the camera and enter the action. He could participate, provoke, and contrive in real time, but only from behind the camera. But eliminating the intrusiveness of a film crew provided freedom of another kind. As both interlocutor and shooter, perhaps he could get even closer to his subjects than before.

The Little Box That Sings (2000) displays the new technology's advantages and limitations for a filmmaker as involved in his storytelling as Rubbo. As the film starts with a tilt up from a shadow of a violin player to the man playing, Rubbo extends an invitation to his audience: "I want to take you into the world of the violin makers. It's a strange backwater, where the little boxes they craft have not changed their basic shape in four hundred years. I'm guessing you don't know much about this world. And it's all strange to me, too, as this story starts."

But the world he takes us into is not quite the world. He's interested in *Australian* violin makers. In the course of the film, we meet several of them as well as a teacher, a dealer, some students, and a professional violinist succeeding in New York—all Australian. A few have a major presence in the film, their scenes interwoven and sometimes intersecting.

Charmian Gadd was a child prodigy who became a successful soloist and is now a teacher. She is buying a violin shop that will specialize in Australian-made violins. She says it is hard to get students to try one. They don't take the Australian violins seriously; they want Italian instruments. Commiserating, Rubbo says to her, "If you think 'violin,' you don't think Australia." But she is working on one of her best students, Nguen, to try a violin made by John Johnston, an Australian.

At Harry Vatiliotis's workshop, Asmira Woodward Page, the Australian doing well as a violinist in New York, is considering buying one

of his violins. But he has competition: she is also considering one made by Guadagnini more than two centuries ago.

As interludes in these developing stories, Rubbo's film takes us twice to Cremona, Italy, home of the famed luthier Antonio Stradivari and still the mecca for violin players, teachers, and makers. In the first sequence shot in Cremona, Rubbo introduces some Italian violin makers and students. He interviews Stradivari's last surviving descendant, Antonia Stradivari, who says her name is "a burden." She manages the Stradivari Museum, where we view a valuable Stradivari kept in a glass case and suspended therein on filaments of nylon. In the second Cremona sequence, we learn that most people think the secret of Stradivari's violins is in the varnish. His varnish recipe has not survived, but apparently Stradivari himself said the secret was love—that he made his violins with love.

Between the two Cremona sequences, we catch up on the main developing stories. Rubbo revisits Harry Vatiliotis, who is working on the violin for Asmira Woodward Page. Harry works fast, Rubbo observes. When the basic box is done, Rubbo says to Harry, "It looks as fragile as a model airplane." "It's like an eggshell," says Harry. When the violin is finished, he holds it up for Rubbo's visual inspection. "Even I," Rubbo says to us, "who have followed the process, am stunned by the beauty of what comes from his hands."

At her shop, Charmian Gadd is evaluating old violins people have brought to her for possible sale or just an assessment. Deception is rife in the history of violins, we learn, with ordinary ones passed off as rare and valuable. When Charmian remarks on the difficulty in evaluating them, Rubbo says in narration, "Perhaps they're treasure. Perhaps they're trash." An Australian expert, we're told, likes to joke that Stradivari made eleven hundred violins in his lifetime, and twenty-five hundred of them are in Australia. We also meet Graeme Caldersmith, a one-time aerospace scientist who now makes violins from Australian woods instead of the usual European maple or pine.

After the second Cremona interlude, we learn that Nguen, who had been lent an old, valuable Italian violin for use in a competition, had lost. Now, at Charmian's shop, he is considering an Australian one. He tries one by John Johnston and one by Graeme Caldersmith. "So," Rubbo says to him triumphantly, "we finally got you to test an

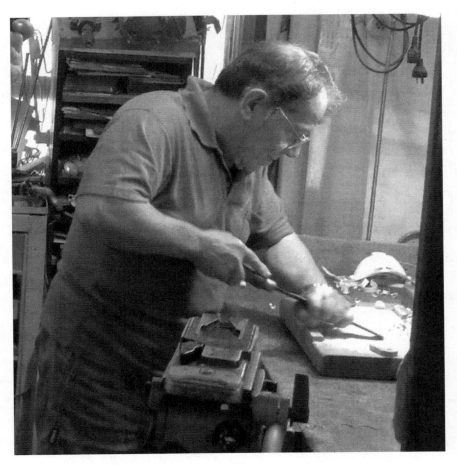

12.1 Harry Vatiliotis at work. Production photo. *The Little Box That Sings* (2000).
Courtesy of Michael Rubbo.

Australian violin!" Then Nguen tries an Italian one, which he likes better. "Looks like another victory for Italy," Rubbo sighs. Charmian admits defeat, for now, adding that there's "no point in bullshitting about it." But before the day is over, Nguen tries an Australian violin again and decides to take it on a trial basis. We learn that after a week or so, he returns it.

With a $50,000 violin, Suzie Park had lost a competition and was told by a judge that she needed a much better instrument. Now,

accompanied by her father, she is checking out a two-hundred-and-fifty-year-old Guadagnini someone is selling for $400,000. Her father is in the background, staring out a window. "The poor dad is desperate," Rubbo observes. "It's one thing to buy a $50,000 violin for your talented daughter, but another when she starts looking at one that costs $400,000." The father says he hopes to persuade a bank to buy it for his daughter.

Asmira Woodward Page, back from New York, tries out the violin Vatiliotis has made for her. "It sounds wonderful to me," Rubbo says, but Page finds things wrong with it. It looks like she will reject Harry's violin. In narration, Rubbo wonders, "Can there really be such a difference in sound? Or is it mostly snobbery?" To Harry, he says, "I think yours was right up there, Harry."

As the film nears its end, Rubbo tells us that "something rather nice happens." Harry has fixed up an old fiddle that has been brought to him. Just before returning to New York, Asmira tries it out. Ron, the owner, says it probably had not been played for seventy-five years. His eyes tear up as he watches and listens to Asmira playing it. Self-conscious, he asks Rubbo, "You don't want to see a grown man cry, do you?" "Why not?" Rubbo replies.

Considering that Rubbo did the shooting and sound recording himself, and that it was his first try at it, the technical excellence of *The Little Box That Sings* is impressive. The sound is crisp, and if there are musical shortcomings in the extensive passages of violin playing, only an expert could discern them. The image always has enough light. The handheld camera is steady and confident. There are fewer cutaways than typical of Rubbo's earlier films, and noticeable use of soft cuts and jump cuts, but the footage was adequate to allow for coherent scenes. The result is an absorbing film, with engaging characters, fascinating images of craftsmanship, interesting historical facts, beautiful instruments, and lovely music.

But while the crucial personal element in Rubbo's style is as strongly present here as in his other films—although from behind the camera only, not in front of it—it has a subtly different effect in *Little Box*. In his best work at the Film Board, when Rubbo is in front of the camera along with his main subjects, he engages with them as their dramatic equal. Often he enters in an at least mildly antagonistic relationship

with them: he baits them, provokes them, challenges them. But he also shares their vulnerability to the camera's gaze, and he makes sure, in the editing, to include scenes or moments that undermine his authority or expose his pretentions. But while he is always present on the soundtrack in *Little Box*, we glimpse him only rarely, for example as a reflection in a mirror. Yet he seems to form a more intimate relationship with his subjects than he did in the predigital films. Instead of challenging or goading his subjects, he gently cheers them on. He roots for Harry to sell Asmira Page his violin, encourages Nguen to try John Johnston's Australian violin, hopes for Charmian to succeed with her business. And with no film crew intruding on the scene, his subjects seem more relaxed than in his earlier films. They are more at ease with him. And he seems completely at ease with them.

There are some moments in the film that remind the viewer of Rubbo's earlier films but are discordant in this adjusted style. Driving from the airport to Cremona, he points out the presence of his wife and daughter in the back seat. There is no value added by this glimpse of his family. That could be said as well of moments in *Solzhenitsyn's Children*, say, or *Yes or No Jean-Guy Moreau*, where his son and then-wife also occasionally appear, but in those films, since Rubbo also appears (to a much greater extent, to be sure) in front of the camera, the inclusion of family seems a little less gratuitous. In those films, the presence of his family might have contributed to the relaxed atmosphere in the scenes in which they appear.

And because being behind the camera rather than in front of it takes the focus away from Rubbo and places it on his subjects, occasional lines of commentary that were apt in a film from his Film Board years seem incongruous here. Over the scene at the school in Cremona, for example, he tells us he is "filled with nostalgia for my own student days." Suddenly, for this brief moment, the film is about him. Self-references in his NFB films served variously to advance the story, illuminate character, reveal process, or reduce his own authority vis-à-vis his subject, but here it seems pointless.

Rubbo next took on a more ambitious digital documentary project. While visiting with Australian actress Diane Cilento and her husband Tony Schaffer in Queensland, Schaffer urged him to read *The Man Who Was "Shakespeare"*, a book by Calvin Hoffman claiming that

Christopher Marlowe was the true author of the plays attributed to Shakespeare. A few months later Rubbo got around to reading the book. For some time he had had a modicum of curiosity about the authorship question, and the book increased his interest. It appealed to his sense of mystery. He decided to make the authorship issue the subject of his next film.

As feature-length documentaries go, *Much Ado About Something* (2002)—which in its longest version runs a little over an hour and a half—didn't cost much to shoot. Funding from the Australian Film Finance Corporation and the Australian Film Commission paid for travel expenses and post-production. Additional funding came from the *Frontline* documentary series produced by WGBH-TV, which had been receptive to Rubbo's work. Rubbo had already reinvented himself as a cameraman-director and made an excellent film with digital equipment. So he decided, as he says in an interview on the *Frontline* website, to "go off to England and do the film. I prided myself on having no lights and no tripod, and I just went off to do it. My wife, Katerina Korolkevich, was my main helper, acting as assistant director. Daughter Ellen, then about 7, was in tow too."[3]

The film consists primarily of interwoven interactions—they're too informal to be called interviews—with proponents and skeptics of the theory that someone other than Shakespeare wrote the plays and poems. There is also some BBC footage of the now-dead Calvin Hoffman, a sojourn to Italy to visit archives, and excerpts from two movies, *Shakespeare in Love* (1998) and the Franco Zeffirelli version of *Romeo and Juliet* (1968). Although Rubbo gives what seems a fair allocation of time to those who believe Shakespeare was indeed the author, his sympathies lie with those who are convinced that Shakespeare could not have written the plays. He is, in his own word, "fascinated" by the possibility. Well into the film, Rubbo begins to develop his own theory. He believes, along with some of his subjects, including the dead Hoffman, that Christopher Marlowe, an established and already acclaimed playwright reported to have been killed in an argument at the age of twenty-nine, actually fled England in a cleverly conceived plot. He needed to fake his death and flee because he was about to be arrested and tortured, and perhaps killed, for alleged heresies he had uttered against the Catholic Church. From his refuge in northern

Italy—where several of Shakespeare's productions are set—he writes, and then sends to England, the plays that will appear under Shakespeare's name. Marlowe had the requisite education and learning for the literary quality and historical knowledge reflected in the plays. By contrast, there is no hard evidence that Shakespeare was well educated or even that he appreciated learning; there were no books in his house, and his daughters could not read or write. Rubbo's twist on the theory of Marlowe's authorship is that Marlowe was too refined and humorless to have been capable of writing the bawdy passages in the plays, so he must have sent the plays to Shakespeare, who added that element. Addressing the camera, Rubbo summarizes his theory thus: "I'm seeing Shakespeare, the country bumpkin, uneducated, and then busy theater professional, as a *junior partner* to this hidden Christopher Marlowe, who is living in Italy and writing these masterpieces. It sorta works for me—that is, *if* Christopher Marlowe is not dead in 1593."

The film is a lark. At times Rubbo piles on evidence for his theory so fast that there is no way someone not closely familiar with the issue can follow the details of his argument, but the film's energy, resourcefulness, and chutzpah carry it along. Rubbo resembles a Holmesian detective unraveling a mystery, brilliantly reasoning from seemingly minor facts to an unexpected conclusion. He advances a plausible theory that he hopes solves the case to the astonishment of everyone. Except that no one in his film seems astonished. They are merely unconvinced. Two of the pro-Shakespeare scholars become annoyed at his persistence. Even the "grande dame of the Marlovians," as Rubbo calls Dolly Walker-Wraight, gets irritated by Rubbo's argument for a collaboration between Marlowe and Shakespeare: "Oh, for goodness sake," she says to Rubbo, "how many probables are you going to add?"

Rubbo ends the film on a mildly equivocal note. After citing some instances in which historical evidence has turned up in the modern era—some papers in Italy possibly bearing on Marlowe's authorship; Marlowe's portrait found washed clean by rain in a pile of rubble in 1953—he says, "If it had not been raining that day [when the portrait was found], we would never have known the face of Marlowe. So in Italy, and everywhere else, let's keep on looking … till William Shakespeare clears his name." It just sort of works for Rubbo.

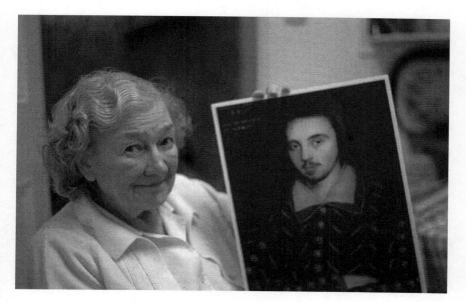

12.2 Dolly Walker-Wraight with portrait of Marlowe. Production photo. *Much Ado About Something* (2002). Image courtesy of Films Transit International.

It works for the audience, too, whether convinced or not. One reason the film is engaging is its structure, which was devised after a first attempt that failed badly. While producing *Race Around the World* for ABC, Rubbo required the young filmmakers to send in paper edits so that editing could begin while the filmmakers rushed from location to location:

> I would stress to them that their first take on the story was probably valuable, and if they did an edit on paper they would always have something clear to depart from and know why. I remembered the mess we got into in [the National Film Board] as we succumbed to the temptation to cherry-pick the bits we loved best about our rushes, and work on them rather than paper edit an entire film structure. This was often disastrous, because having worked very hard on favored sequences one can never let them go, even though they might have no real place in the film. By

doing a paper edit, and not being in love with some vérité moment here and there, one could get a strong story and then make it work. Sometimes very banal shots, which by cherry-picking one could completely miss, would turn out to be key story shots.

Following what he had taught his students, Rubbo did a paper edit showing how unbelievable it was that Shakespeare wrote the plays attributed to him. He gave the paper edit to his editor, Jane St. Vincent Welch, who executed it

> brilliantly in a couple of weeks. Well, we looked at it and we both felt sick. There was something horribly mean-spirited about it. How and why would you attack this great man like this, bring up all these petty points against him? We realized that, while in a way we were winning the battle, we were losing our audience emotionally. We seemed underhanded and unfair.

They restructured the film so as to develop the Marlovians, "celebrating their eccentricities, making the whole thing out to be a bit of fun." Then they built up the case for Marlowe as at least a precursor of Shakespeare and possibly a collaborator. It seems far less insistent than the first cut of the film apparently was. One can be utterly unconvinced that anyone but Shakespeare wrote the plays attributed to him and yet not find the film objectionable or annoying.

One further aspect of Rubbo's editing process, which applies to all his films, is that he writes the narration largely as he is editing. Normally for a film shot without a script, the narration is written after the picture and sound have been edited. Rubbo integrates the construction of the narration with the construction of the film. He finds that writing and speaking his narration as he is editing, and laying it in as a scratch track—he would refine the narration at a later stage—helps him discover whether a sequence is working. For *Much Ado*,

> I was forever popping out to the car in the alleyway, a quiet cul-de-sac, propping my camera on the dashboard, the car's

interior making a good sound booth somehow, and recording the narration, then dashing back inside for Jane to lay it in and try it. The funny thing is that some of the lines in the film that I speak come from those recordings in the car. I never bettered them.

As this was before the age of mobile phones, Rubbo remembers "the occasional mum with a baby stroller walking past and looking suspiciously at the man in the car talking to himself."

Despite Rubbo operating the camera himself, the film contains more self-reference and much more apparent contrivance than *The Little Box That Sings*. Perhaps Rubbo was more comfortable now with shooting the film himself. In the car, Rubbo films Dolly Walker-Wraight phoning a college for permission to film there. While exploring the authorship issue with Shakespearian actor Mark Rylance, who at the time was also the artistic director of the Shakespeare Globe Theatre, Rylance turns the question back on Rubbo, asking him why he is interested in it. In the graveyard where Marlowe supposedly was buried, Rubbo discovers the grave is unmarked: "I have no idea ... where to look. And small boys throw stones at me." The give-and-take between Rubbo and his subjects is often interesting. When Rubbo challenges Walker-Wraight with the stark differences between the plays attributed to Marlowe and those attributed to Shakespeare, she points out that artists evolve, and she cites Picasso and Chekhov as artists whose early work differed drastically from their later output.

Two imaginative, overt contrivances contribute to the film's overall argument. Fairly early on, Rubbo wants to explore the similarity between numerous passages from Marlowe and Shakespeare. "So I get two actors to help me do some testing," he says. Standing side by side, one actor reads a line from Shakespeare, then the other reads a similar line from Marlowe. They repeat this with several other pairs of lines. The first few times, the name of the author each actor represents is subtitled, but then the subtitles disappear. This deft move, compounded by similar clothing and even a physical similarity between the two actors, underlines the similarity in the respective pairs of lines. Later, to demonstrate problems Rubbo sees in the standard account of how Marlowe came to be killed, Rubbo hires four actors to "visualize

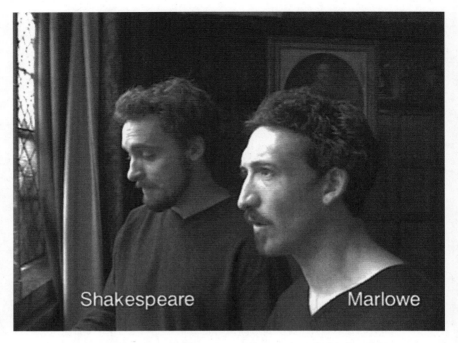

12.3 Shakespeare and Marlowe, identified. Screen grab. *Much Ado About Something* (2002). Image courtesy of Films Transit International.

how it's supposed to have happened." He runs through it twice, and makes a good if somewhat tortuous case that the standard account is problematic.

Fun though the film is, it prompts an uncomfortable question: Why should we care? Perhaps the question could also be asked of *The Little Box That Sings*. That film is charming, but its main thrust is an argument, or hope, that Australian-made violins are a lot better than they're given credit for. This matters far more to Australians than anyone else, and probably far more to the Australian violin community (and perhaps the foreign trade office and promoters of Australian crafts) than to Australians in general. But *Little Box* at least has a central character, Harry Vatiliotis, whose quest for recognition of his craftsmanship we can relate to and root for. With regard to *Much Ado*, the question was put to Rubbo himself in an extensive interview published on the *Frontline* website:

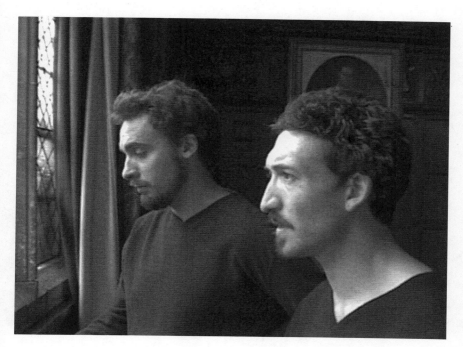

12.4 Shakespeare and Marlowe—which is which? Screen grab. *Much Ado About Something* (2002). Image courtesy of Films Transit International.

Frontline: But specifically, whether it was Marlowe, whether it was [The Earl of] Oxford—whoever it might have been—how do you answer the question of why it matters?

Rubbo: I find that question very strange. I mean, I don't know why anybody would ask that. Of course it matters.

Frontline: It's self-evident that it matters?

Rubbo: Yes, because in the sense that we ourselves have any creativity at all, we must be interested in the creative process. We must want to know about creative people. We must want to know how they did things. That's why! Not to want to know would somehow deny our own attempts at creativity. So I cannot understand it when people say it doesn't

matter. I think that's a pure cop-out. They don't want to deal with this tricky question. They don't want, perhaps, to be disloyal to a myth. Their attitude is, "A bard in the hand is worth two in the bush, and thanks very much."[4]

Rubbo gives two examples of how an awareness that Marlowe wrote the plays would affect how we interpret them. In *As You Like it*, Touchstone asks a character named William, "Art thou learned?" William answers, "No, sir." Then Touchstone compares William to a vessel that has been filled by emptying another (5. 1. 42–49). In *Measure for Measure*, the line "Death's a great disguiser" (4. 2. 186) in the context of a planned fake death could be an allusion to Marlowe's staged death. The *Frontline* website includes a forum addressing the question of why it matters, and it reports the results of a simple poll in which 43 percent of the 12,393 respondents (as of 28 January 2015) say it does matter, while 56 percent say it does not.

Rubbo's response to the question was unusually defensive. Had he forgotten two of the criteria he had posited and promoted for assessing a documentary's value—that there be something at stake and that the film be emotionally touching? Except to Shakespearean scholars and buffs—and perhaps to 43 percent of the respondents to the *Frontline* poll—what's at stake in *Much Ado* would seem pretty small compared to what's at stake in most of Rubbo's major documentaries—war, the environment, separatism, aging, Marxism, social responsibility, fairness, even success at one's craft of violin making. While knowing for sure that someone other than Shakespeare wrote the plays might enrich our interpretation of some passages, it is doubtful it would tell us much about the creative process, since we know next to nothing about how Shakespeare or any of the other alleged authors of the plays worked or felt when they wrote. And the film lacks the emotional element that even *Little Box* has.

But there's no need to flog Rubbo with his espoused criteria. In his interview with Geoff Burton, he admitted that he himself is "constantly forgetting to apply them."[5] *Much Ado* may prove nothing, and it may not make strong emotional connections, but an admirer of Shakespeare's plays would have to be in a dull mood to be bored by the film. It is a romp, and a highly entertaining, literate, and provocative one

at that. The authorship question made no difference to Stanley Kauff-mann in his review in the *New Republic*, but it also made no difference to his high opinion of the film: "Rubbo's intelligent questions, his sub-jects' enthusiasm, and their occasional anger make for a crackling nine-ty-four minutes."[6] Even if there is little at stake, the issue is, as Rubbo says at one point in the film, indeed "fascinating." That's enough.

But his next digitally made documentary, *All About Olive* (2005), satisfies those two self-imposed criteria on which *Much Ado*, excellent as it is, falls a tad short. There is something at stake and the film is emotionally satisfying. It begins in Rubboesque fashion. After a few shots of an old woman saying goodbye to her fellow residents in an old-age home, we see a photo of Rubbo and the woman. Over it, as well as some images of the woman being examined by doctors, Rubbo states the film's premise: "I've been friends with Olive for two years … and now, we're doing something risky together. At a hundred and five, she's going home. We've had her in for checkups, and nobody's said, 'Don't go.'"

"Home" is Broken Hill, the famous mining town where Olive Ri-ley (née Dangerfield) spent her childhood and early adult years. The risk of returning there is more than physical. Olive harbors regrets and resentments. She complains that she never got any affection from her mother or most of her siblings. She would like to have been a nurse. Instead, as a consequence of the breakup of a bad early marriage, she spent most of her working years as a barmaid. She regrets having had children: "They're lost to me, now. … I never see them. They're in another world." What memories will this trip stir up?

Some of the memories prove painful: a broken doll, which was never replaced by another; being teased for her last name, Dangerfield, and her red hair; her mother's strictness; after her marriage, catching her husband in the act with her best friend. Sometimes a memory makes her cry. But over the course of the film, sad memories and all, Olive becomes revitalized. She enjoys speaking to young students who attend the same school she did. She remembers sneaking off to go to the roller-skating rink and winning a contest there. She has affectionate memories of her father.

What contributes most to her emotional rehabilitation is Rubbo's decision not only to reenact some of the incidents seared in Olive's

12.5 The remembered fight. Production photo. *All About Olive* (2005). Courtesy of Michael Rubbo and Ronin Films.

memory but to involve her in staging them. Some of the reenactments are brief and essentially illustrative. For instance, a person is mentioned, and we see a brief version of that person. But several are well developed. The most moving ones are those Olive takes an active, assertive role in shaping. The experience is cathartic for her.

In a reenactment of a confrontation in which some girls teased Olive about her name and red hair, the young actress playing Olive gives her chief tormentor a hearty shove. Rubbo and the real Olive are watching; Olive is especially intent. She is pleased with the performance but not yet fully satisfied; it is not historically accurate as she remembers the incident. Referring to the actress playing her tormenter, Olive protests, "She didn't sprawl." Olive wants the actress to sprawl onto the ground, because she remembers pushing the girl to the ground, forcefully. Rubbo assures Olive, "We'll do that later." "You'll have to have something for her to sprawl onto," Olive says. "No," Rubbo responds, amused. "We won't really make her fall over."

Later, Olive directs a reenactment of her washing her father's back. The remembered scene occurred after her father had lost the lower part of an arm in a mining accident. To play the father, Rubbo found a man who had lost part of an arm. (Was it out of Rubbo's own sense of realism, or at the insistence of Olive, who seems to place a great value on historical accuracy?) Olive keeps giving the young actress directions, coaching her through the scene as a director of a silent movie might do. Stand up on that stool, Olive says. Wash with your right hand. With your left hand, pat him on the arm. Nice and gentle. Rinse the rag. Do it again. You got to show that you love your dad. Rubbo, trying to be helpful, feeds the young actress a thought: "Oh yeah, it's so dirty, Dad." Olive snaps at Rubbo, "No, he's not [dirty], she's doing a good job. Will you stop interfering?"

"What?!"

"She's doing a good job. Stop interfering."

"Who's directing—"

"You're telling her he's dirty. He's *not*."

Having put Rubbo in his place, Olive resumes her directing. Now wrap the towel around his shoulder, she says. "That's a girl, that's right. … Thanks very much for that, Love, you did a good job."

In another reenactment, Olive dances a waltz with a young man in a tuxedo. Olive is in her wheelchair, set atop a circular wheeled platform that another man is steering around the dance floor. But soon Olive wants to try it without the wheelchair. Rubbo is hesitant. "If he holds me, I'll be all right. He's strong." They dance a short while. "It was lovely," Olive says. "I told you I could do it!"

Back from Broken Hill, Rubbo tells us, "Olive is having a birthday party. She's hoping the three kids will come." Whether they will or not is in doubt. We've learned that after the breakup of her marriage, she was not always able to take care of the children herself. Two were sent to a children's home, and the third to Olive's grandmother. Two of them arrive at the party. Olive and her guests wait three hours for the third one, "but Bonnie never came." The guests light the candles and sing Happy Birthday to Olive. Driving back from the party, Rubbo says, "Ollie [as he calls her] was very upset, so later I went to see Bonnie and her husband Bill, hoping to get them to reconsider … but to no

12.6 "Will you stop interfering?" Screen grab. *All About Olive* (2005). Courtesy of Michael Rubbo and Ronin Films.

avail." Hearing of this, Olive exclaims, "I don't want nothing more to do with them," and cries.

We are in a hospital. "Her daughter may not want to see her," Rubbo says, "but life goes on … even if you're a hundred and five. … Ollie always wanted to be a nurse. A carer is not exactly a nurse. But it feels good to be comforting sick kids." The film ends with several brief scenes of Olive interacting with young patients. Rubbo's last words to her are "See you later, Ollie."

All About Olive is a remarkable film. Rubbo had used reenactments imaginatively in *Much Ado*, but their purpose was to support an argument. Here they have emotional impact, primarily in their effect on Olive. They are cathartic and empowering. Olive winds up taking charge. She never seems more alive than when she directs those scenes.

It is hard to imagine another director pursuing this tactic or, if he were to try it, doing it so well. The scenes are both relaxed and daring. The actors are having fun. And Rubbo, as he does so often, shows others to his own disadvantage. He's happy to let Olive take over and shunt him aside. (In the film's opening credits, he attributes the film

12.7 Rubbo with Olive Riley. Photo courtesy of Michael Rubbo.

to both of them.) With *All About Olive*, Rubbo has told a great story, with interesting characters, provocative of thought, compelling (if not strangely so), emotionally satisfying, and serious.

But in the project's early stages, Rubbo once again faced opposition to his documentary style. He chose Olive from about a dozen centenarians he had screen-tested, and he secured partial funding from the ABC. Rubbo sought supplemental funding from Film Australia. But Film Australia favored an essay approach about centenarians. "In any case," Rubbo recalls being told by an ABC administrator, by the time approval for the project worked its way through the Film Australia administration, "Olive would surely be dead." But for Rubbo, "Olive was such a standout character that, as in the case with Daisy, I decided the film belonged to her. She was a delightful rough diamond. No one had ever paid any attention to her during her life, and suddenly because she was old, she was deemed interesting. But I found her interesting for her story and her roughness and her big heart." The Australian Film

Finance Corporation contributed supplemental funding, Rubbo made the film his way, and ABC broadcast the finished product to much audience acclaim.

Rubbo made good on his ending line of narration, "See you later, Ollie." He helped her set up a blog, called "The Life of Riley." Olive died in 2008, and the site is now defunct. In an essay entitled "Problems of expertise and scalability in self-made media," which appears in the anthology *Digital Storytelling, Mediatized Stories*, John Hartley describes as a typical blog entry a "story of Olive going to have her portrait painted, an adventure that includes the trip to the studio, a parking ticket and a pie, recorded in transcribed dialogue and still photos by Rubbo."[7] Hartley reports that the site attracted worldwide attention; in the first month, it had 192,000 visits. Rubbo often contributed his own comments on the blog and would reply to almost all other comments. To one query about why more older people don't blog, Rubbo, who was seventy years old at the time, disclosed his own fear of the new medium, recommended getting help from people who understand it, and confessed that he knows only how to post photos and written comments. When he tries to go beyond that, he admits, "I'm lost again." He ends on an encouraging note: just keep trying and learning, and it gets easier. Rubbo tried to keep the site alive after Olive's death, but he couldn't afford the hosting fees and didn't know how to move it to a more economical site.

Plein Air Documentary

YouTube films; Bicycle Art;
Painting with Film

All About Olive is, so far, Rubbo's last full-length documentary. In subsequent years, he has spent most of his creative energy on two seemingly very different kinds of pursuits: short YouTube documentaries (usually between six and twelve minutes in length), and making what he calls bicycle art: sketches and prints depicting people riding bicycles. The intersection of these two pursuits yields an insight into Rubbo's documentary aesthetic that I've barely touched on so far.

Rubbo has posted hundreds of mini-films on YouTube. Quite a few of them are either excerpts from or follow-ups to his past documentaries. Several of these pursue the Shakespeare authorship question, although some of the Shakespeare entries simply express his appreciation of Shakespeare. He has excerpted *Waiting for Fidel* several times. There are follow-ups on some of his features for children, especially the two Tommy Tricker films. His favorite subject drawn from his previous work, however, has been Olive Riley. Besides excerpts—some slightly revised or enhanced—from *All About Olive*, he made numerous original films involving her. Some feature Olive reminiscing about something, such as looking for work in the 1930s, encountering a shark up close, or going bushwalking with a friend. There are several of Olive singing such popular old songs as "Bye Bye Blackbird," "Waltzing

Matilda," or "Smile, Smile, Smile." A few of the films emerge from interesting setups: listening and reacting to an opera Rubbo plays for her; watching an old Australian film; Rubbo's wife Katya showing her some Matryoshka dolls.

The subjects of Rubbo's original creations for YouTube are varied, but most of the films exhibit familiar Rubbo touches. A few, such as *An Artist of Malacca* (2013), are about people who happen to interest him. Tham Siew Inn sketches "all over the world, and just for the joy of sketching, apparently," Rubbo says, although Tham does sell books of his work. Tham's work is swirly and kinetic. Rubbo's narration is typically informal and personal. The film ends with Rubbo back home presenting one of Tham's books to his wife. She calls his work "very delicate."

"So you like my little present?"

While the camera is on the book, she thanks Rubbo. Then, facing the camera, she says, "And thank you, Tham Siew Inn. I really enjoy your work. It's beautiful."

Over a period of a few years, Rubbo filmed a person who had become a close friend, Pyotr Patrushev. The four-part portrait, *The Man Who Swam Away* (2010–2014), is mostly a head-on interview with Patrushev, who recounts how, as a young and superbly conditioned athlete, he swam from the Soviet Union to Turkey over part of the Black Sea. Patrushev's riveting account is enriched by family photos and other visual material. Once branded a traitor to Russia, Patrushev has become a successful translator for visiting Russian dignitaries.

Rubbo frequently makes YouTube films advocating causes he supports. *Maggie Chiou Here on Show* (2013) is about a visitor's desire to stay in Australia. Maggie works in the Tarragal Nursing Home, where she teaches Tai Chi to the residents, plays the piano, guitar, and ukulele for them, and leads them in song. Sue, the head nurse, tells Rubbo about one man with severe dementia whose face lights up when he sings along with Maggie. Rubbo concludes the film by saying to Sue, "So the whole point of this tape is to try to get the authorities to think about letting her stay. Do you think she would be a good inclusion for our country?" "I certainly do, I certainly do," replies Sue. "I think she'd be an asset to our country." We are not told the nature of Maggie's visa problem.

Another cause is the preservation of old, single-screen movie theaters in small towns such as the one in which he is now living, Avoca Beach, about an hour north of Sydney. *Avoca Beach Theatre: Our Little Treasure* (2012) is a paean to a single-screen theater that has been a community fixture since the late 1940s. People go there not just for the movies but also for events and parties. In recent years, however, it has been threatened with development. The owners, who had enjoyed popular support when it was assumed they wanted to preserve it in its original form, have schemed to expand it into a modern complex first with three screens, then five. To Rubbo and many others in the community, the proposed expansion seems wrong-headed on several counts. For one thing, the community seems too small to support five screens. For another, people went there as much for the social interaction as for the movies. The film ends with the issue unresolved but Rubbo and his like-minded fellow citizens still trying to "save our little treasure." Rubbo has made several follow-up films on the ongoing fight for the theater.

Of all the causes Rubbo has pursued on YouTube, his most passionate one is the promotion of bicycle riding. He favors bicycle lanes, amenities for people who use bicycles for such things as commuting, shopping, or recreation, and the freedom to ride without wearing a helmet. His *Councillor on a Bike* (2010) praises the work of a civic leader in Yarra City, a suburb of Melbourne. The film starts in a familiar fashion: "I'm off to Melbourne, on a train of course, because that allows me to take my bike. I'm going to make a film about a local politician, Jackie Fristacky, who's very pro-bike." Fristacky, who doesn't own a car, goes from meeting to meeting by bike, because it is quicker. Rubbo, on his bike, follows her around with his camera. She often stops on the street to confer with residents who have a problem or complaint. She spots graffiti on a monument in a park and reports it through her cell phone. Yarra spends $17 per resident on bicycle infrastructure, says Rubbo. "It's a hard act to follow, but I'm hoping other councils might think it's worth a try."

The legal requirement to wear a helmet while riding irks Rubbo. For *Bike Share and Helmets Don't Mix?* (2009), he attends a conference in Melbourne on the future of bikes. It becomes clear that strict helmet laws discourage bike sharing and bike riding. "The helmet is

a vexing problem," a bike-share proponent from the United States acknowledges. For Australia, Rubbo proposes that the helmet should be voluntary for adults riding sit-up bikes. It could change Australia's bike culture drastically and bring millions of new riders, he believes. Rubbo ends with a brief interview with a young woman who says she loves using a helmet. Taken aback at first, Rubbo realizes that ending on such a note could be reassuring to those who would still choose to use a helmet.

In *Sue Abbot Fights Bike Helmets* (2009), Rubbo goes to Scone, a small New South Wales country town, to report on the case of Sue Abbot, who is fighting the $52 fine she has received for riding her bike without a helmet. Her legal and associated costs for disputing the ticket have soared to about $2,500. Sue takes Rubbo to the spot where she was ticketed. She had been riding all her life around here without a helmet. Rubbo cuts to an interview with a man who observes that bike riding has nearly disappeared since the helmet law was enacted. Rubbo himself says, "Those countries that cycle the least, are fattest," over a series of shots of big butts. He ends the visit with a visual paean to helmetless bike riding: lovely shots of Sue riding her bike on a gravel road in the countryside, where "the greatest danger is ... swooping magpies," which she wards off "with jingle bells." He concludes the film by noting that wearing a helmet is a matter of choice in Europe, where bicycle lanes and other provisions contribute to safety.

For *No Helmet, Please!* (2009), Rubbo is in Scone again, this time for Sue Abbot's trial. While waiting for the hearing, he observes that people aren't required to wear a helmet when riding a horse. Rubbo himself often wears a helmet when biking, but "I don't want to be *told* to wear one." Pro-helmet people like to point out that while the helmet law has decreased bike riding, it has also decreased injuries, but Rubbo observes that the simple decrease in ridership, not the helmet requirement, is likely the cause. Rubbo is not allowed to film inside the courtroom. Sue's lawyer, Rubbo reports, had told her that she probably would be let off if she simply agreed to wear a helmet in the future, but she refuses. She says she will keep on riding her bike without wearing a helmet. Rubbo ends the film with an analogy: because about three hundred people a year drown while swimming, compared to about

13.1 Sue Abbot. Courtesy of Michael Rubbo.

forty killed on bikes, will the officials now demand that people must wear life jackets when they go swimming?

It dismays Rubbo that while bike-share programs flourish in cities around the world, they are not popular in Australia. In *Melbourne Bike Share in Trouble?* (2010), Rubbo investigates why bike share is hardly used in Melbourne even though at various convenient locations bikes are available for sharing. He identifies the helmet law as the main cause. He interviews several people on both sides of the issue, and with one pro-helmet woman he engages in a brief argument. Rubbo

amasses evidence that helmet laws do not increase safety; all things considered, they probably decrease it, he says, by giving wearers a false sense of security.

Message to Melbourne from Dublin Bikes (2010) was shot in Ireland by an assistant. Rubbo narrates. Andrew Montague, a Dublin city councilor, has achieved great success with a bike-share program. With Montague on camera, Rubbo interviews him from Australia via speakerphone. They don't require helmets, Montague reports, yet after a million trips they've still had no fatalities. The small risk of riding without a helmet, Montague says, should be weighed against the risks of heart attacks and so forth resulting from inactivity. He cites a study showing that people who ride bikes regularly live ten years longer than those who don't. Rubbo ends with an exhortation to the city of Melbourne. It can't allow bike share to fail, he says. Exemption from helmet laws "*is* the game changer."

It's not that Rubbo disregards safety concerns. His problem with helmets is with requiring them and the false sense of security that can give. His *No Bike Mirror ... Suicidal?* (2014) answers its title question in the affirmative. After surveying the variety of mirrors a cyclist can choose from, Rubbo shows two actual accidents involving mirrorless bicycles. The footage for one was filmed from a cyclist's head cam. The other was filmed from a car camera. *No Bike Mirror ... Suicidal?* is strong stuff.

Recognizing that people, especially older people, who live in hilly areas may be less inclined to bike, Rubbo touts power-assisted bikes in *Electric Bikes—The Great Electric Bike Comparison* (2009). An accomplice takes a 7-kilometer hill in the Dandenong Range outside Melbourne, first in a regular bike, then in a power-assisted bike (which one still has to pedal, but not so hard). He climbs the hill in twenty-plus minutes on the regular bike, a bit over fifteen minutes on the power-assisted one—and feels a lot less tired afterward. Then Rubbo himself ascends the hill on his own power-assisted bike, something he says he would not have tried before.

To varying degrees, most of Rubbo's YouTube work exhibits the traits that made his previous and more substantial documentaries distinctive. He is always personal, usually present at least as an off-camera (since he is working it) participant. The YouTube films let the audience

in on purposes, plans, and methods, including the occasional contrivances. He is at ease with his subjects and himself.

The films promoting bike riding lead to a rarely noticed aspect of Rubbo's documentary aesthetic—its painterliness. They express cinematically a love of bicycles that Rubbo often celebrates in drawing, etching, and painting. Most of Rubbo's paintings are in oil. They are characterized by bold strokes and strong, joyful colors. Often they depict scenes in Quebec. But around the beginning of the century he began producing images of people riding bikes. For the most part, he used four different techniques. One was a kind of rubbing, which involves rubbing away oil paint from special paper. Another, akin to Japanese woodblock printing, involved linear carving into linoleum tiles, which in turn are used as printing blocks. The third method was a kind of solar printing: drawing first on acetate, then briefly exposing the drawings to plates that are sensitive to ultraviolet light, then printing with those plates. The fourth was simple drawing. The prints made from all these methods are full of motion, about as kinetic as a still image can be. At the same time, they are not detailed, sharply drawn, or naturalistic. With their graceful curving lines, they depict the pleasure and perhaps even the joy of riding a bike, usually with others, and never with a helmet. Like the bicycle films, the bicycle art is casual and free-flowing.

When a film is described as painterly, the adjective is almost always meant to suggest that individual shots have a pictorial quality resembling painting, usually scenic painting. Almost invariably, a "painterly" shot is static. It is picturesque. Movement within the shot is usually slight. When there is camera movement, it is likely a slow pan or gentle tilt. The camera itself rarely moves very much in a shot described as painterly. Such shots are, if anything, anti-cinematic, and they are uncommon in Rubbo's work. There are beautiful images in his films, but their beauty depends largely on the context in which they appear.

The painterliness in Rubbo's work lies not in individual shots but in the whole film as it unfolds over time, including the sounds—dialogue, narration, music, location sounds. Given the kinetic intensity of a typical Rubbo documentary, and his comfort with spontaneity, there would rarely be time for anything more than a painterly shot or two in the usual sense of the word when applied to film. To fully

13.2 Drawing by Michael Rubbo. Courtesy of Michael Rubbo.

grasp the aesthetic of a Rubbo documentary, one has to be willing to consider the film *as a whole,* as in some ways like a painting—and a particular style of painting at that: plein air. The term literally refers to painting done outdoors, but it also connotes an improvised, dashed-off quality, where the effect lies in the overall impression and not in the details. Rubbo himself has referred to his style of painting, although not his filmmaking, as "plein air." The sketching we saw him do with Margaret Atwood was exactly that.

To appreciate the cinematic nature of this painterly quality in Rubbo's work, it may be helpful to consider the aesthetic influence of his

13.3 Lino cut by Michael Rubbo. Courtesy of Michael Rubbo.

mentor, Tom Daly, on the National Film Board of Canada. Daly had begun his Film Board career as an editor at the age of twenty-two, just after the Film Board was created in 1939. When World War II broke out, the Film Board became a propaganda arm for the British Commonwealth. Television was not yet a mass medium, and theaters typically showed a cartoon and a newsreel before the main feature. The Film Board's mainstay became two-reel compilation films made largely from war footage, both Allied and captured from the enemy, and churned out monthly for theatrical distribution. Having little to do with the filming, the Film Board's creative role lay mostly in editing. Their "directors" were mostly editors. They had to discover order in—or impose it on—disparate footage shot for various purposes. They did so brilliantly; an early compilation film, *Churchill's Island* (1941), won an Academy Award for best documentary short, the first of many Oscars for the Film Board. Stuart Legg, imported from England,

13.4 Tom Daly, circa 1993. Photo by Lois Siegel.

edited the film. Daly, his assistant, soon emerged as a skillful editor in his own right. By the 1950s, Daly was a producer known for his brilliant editing and his attention to detail. He would emphasize the importance of the precise frame at which a shot should begin or end. A difference of a frame or two could affect the emotional power of a cut. Daly's aesthetic permeated the Film Board, and if not everyone was a true believer, most were affected by it. Any accomplished editor during Rubbo's years at the Film Board, when Daly was regarded as an editing genius and a superb mentor of young filmmakers, would value attention to detail, the more meticulous the better.

But there was another crucial, equally important aspect to Daly's view of editing, one that might seem to contradict the first. He believed in and espoused a personal philosophy of what he called "wholeness," which applied to far more than filmmaking, but which had a definite aesthetic meaning. To illustrate what he meant, he would occasionally tell a story about having seen a beautiful copper beech tree one autumn. It was standing alone in a field, so its branches were large and full. It was so beautiful that he walked over to it in order to pick a leaf from it to keep as a memento. But the first leaf he looked

at had a wormhole in it. The second had another leaf stuck to it. The third had caterpillar damage. He could not find a leaf that didn't have a flaw. He had a sudden vision of "this perfect thing ... made up of all these imperfections."[1]

An accomplished editor at the Film Board once told me that he thought Rubbo was a sloppy filmmaker and, specifically, editor. (He later retracted that opinion.) That editor was influenced strongly by Daly's meticulous side. He saw the individual leaves in the copper beech tree. Whether Rubbo is conscious of it or not, he is a filmmaker more influenced by the second aspect of Daly's philosophy than the first: what matters most is the whole tree. There are various ways of achieving a sense of wholeness in one's work, but in Rubbo's case any of his best films resembles an impressionist painting unfolding over time. The individual shots are not always particularly meaningful in themselves, and not necessarily joined for precisely the smoothest cut or cleverest segue. But together they create a beautiful motion picture constructed from hundreds of shots and sounds of varying power and import and whose beauty can be grasped only from the entire experience of viewing the film.

If plein air paintings have a dashed-off look it is largely because they are usually, in fact, dashed off. In *Vincent and Me*, Rubbo depicted his idol, van Gogh, painting this way. Van Gogh probably could produce a hundred paintings for every one by, say, Vermeer, his fellow countryman. Taking into account the cost, technology, and logistics of documentary, *mutatis mutandis*, Rubbo makes films in a manner much like van Gogh painted. He often embarked on his major Film Board productions with little preparation, and they were typically shot over an intense period of just a few weeks. In his 1980 interview with Alan Rosenthal, Rubbo acknowledged as much:

> I've ... come to value my tendency to plunge in. And these days I even make a virtue of being unprepared. ... You go out with vague ideas about what you want and then just let things happen, trusting in your good instincts. I know it sounds dangerous, but life will inevitably serve up much better stories than you could ever think up beforehand. The trick is to get involved, to get in.[2]

Since that interview was conducted, Rubbo has become even more at ease with uncertain situations, changing circumstances, and intervening in them to provoke behavior. One reason he has been a prolific YouTube filmmaker is his ease in unstructured situations. Some of the YouTube films were shot and edited in a day. Yet they are coherent and fluid.

Because it is one of his longest films, and the one most directly dealing with political philosophy—a subject resistant to documentary film—*Solzhenitsyn's Children* is perhaps the most instructive example of the plein air quality of Rubbo's aesthetic. Like most of his documentaries, it was shot on the run: quickly, intensively, and of course without a script. Even the contrivances are allowed to play out as improvisation. Almost every visual sequence and almost every sound passage has the feel of a brushstroke executed somewhat spontaneously. Even the sequences with the individual philosophers and critics function impressionistically. While the philosophical content is not unimportant—there are provocative ideas, intriguing contradictions, and prophetic statements in abundance—a sense of the thinker as a personality is what comes across most strongly. The ideas, as articulated by the interviewees and edited by Rubbo, can be thought of, like most everything else in the film, as brushstrokes. They convey just snippets of meaning in themselves but contribute to an overall experience. The film has the feel of a plein air painting—dashed off and exuberant. And yet it is hard to imagine another film more effectively conveying a sense of intellectual Paris of that time—its vitality, intensity, seriousness, competitiveness, vacuity, and pomposity.

Superficiality was and is one of the complaints, open or implicit, against *Solzhenitsyn's Children* and some of Rubbo's other films, but it could be that "depth" is something that, in film and other media, is an illusion. Rubbo once thought of becoming an anthropologist, a discipline which expects its practitioners to spend years with their subjects in order to know them intimately and discover the truth about them. Rubbo spends a few weeks with his subjects, at most. Does that mean his depictions of them are superficial? Confessing to failure in one of his researches, the eminent ethnographer and theorist Clifford Geertz wrote

I do know that however long [I tried] I would not get anywhere near to the bottom of it. Nor have I ever gotten anywhere near to the bottom of anything I have ever written about.[3]

Ethnographic issues aside, the charge of superficiality misses the plein air aspect of Rubbo's aesthetic. There is a difference between superficiality and a respect for surfaces. The British philosopher Roger Scruton has observed that

the most important features of the human condition are emergent features, ones that inhabit the surface of the world and are invisible to those whose eyes are fixed on the depths. ... Human cultures are reflections on and in the surface of life, ways in which we understand the world of persons, and the moral framework in which persons live.[4]

Rubbo's peculiar genius includes a respect for surfaces and an ability to reveal emotional depth through capturing and arranging them. He films what he sees and records what he hears. Rubbo's narration may comment on the material, but more than that, it both contextualizes and enters into it. And the narration itself uses words like brushstrokes. It seems organic to the material, not detached from it, perhaps because he writes it as he edits, not after. He takes characters as they are, neither debunking them nor explaining them away. He lets them wear their masks. When once he did assume the existence of some deep secret— in Margaret Atwood's psyche—and doggedly sought to uncover it, his confidence and ease as a filmmaker, his ability to adapt to unforeseen contingencies, his willingness to confess failure, and his daring interventions turned his failed quest for a dark secret into a film far better than he thought it was. Like many an artists, Rubbo doesn't always recognize his successes.

Conclusion

Influence ... Comparisons ... Importance

Rubbo's most salient influence—not always acknowledged—on documentary filmmaking is his use of himself, most famously in *Waiting for Fidel*, as an on-camera protagonist who drives the action, adapts to unforeseen circumstances, discloses aspects of the filmmaking process, and sometimes stumbles. In various forms the basic elements of this once-daring approach have become commonplace in documentary, most notoriously in Michael Moore's work. In *Roger & Me* (1989), his funny and biting report on how automobile factory closings in his hometown of Flint, Michigan, have all but destroyed it, Moore adapts to his own goal and personality Rubbo's role as on-camera storyteller and provocateur. He assumes a shambling, regular-guy persona. He borrows *Waiting for Fidel's* structure of failing to secure an interview, in this case with the film's eponymous character, the chairman of General Motors, Roger Smith. Here, though, the structure is more a conceit than an adaptation to dashed expectations. Rubbo's crew was in Cuba not in pursuit of a reluctant Castro but rather at his invitation. The failure to interview Castro was an unexpected setback to which Rubbo had to adjust while on location. On camera, Moore gives us no evident reason to expect an interview with Roger Smith. And in fact, according to the 2007 documentary film *Manufacturing Dissent*, he may even have gotten one, filmed it, and concealed it from the audience. In any case, for Moore, Smith is an outright villain with no redeeming qualities,

the man responsible for the plant closings, the laying off of thousands of workers, and the decline of Flint. Moore's quest for an interview is an act of aggression. Roger Ebert called the film "a revenge comedy, in which the stinkers get their comeuppance at last,"[1] even though the only "stinker" who gets a comeuppance is a glib General Motors public relations flak who, we learn in the end credits, loses his job, too.

In his subsequent documentaries, such as *Bowling for Columbine* (2002) and *Fahrenheit 9/11* (2004), Moore has persisted with his aggressive version of Rubbo's method. In *Bowling for Columbine*, his treatment of subjects becomes more mocking and exploitative. He ambushes the entertainer Dick Clark to confront him about a restaurant Clark owns that Moore says exploits welfare mothers; Clark manages to escape in his chauffeured limousine van. Moore tricks Charlton Heston into a confrontational interview, in Heston's home, that is meant to make the octogenarian actor, who had been a prominent civil rights leader in the film industry—a fact Moore withholds—look cold-hearted and racist. In addition, he deploys acknowledged contrivances, such as taking some kids who were wounded in the Columbine High School shooting to the headquarters of K-Mart, which sells weapons. In a scene reminiscent of *Roger & Me*, the group attempts to meet with top management but are repulsed. They do manage, Moore says, to provoke K-Mart to announce, the following day, a commitment to stop selling ammunition. In *Fahrenheit 9/11* Moore's role as filmmaker-provocateur consists primarily in his acerbic commentary and satirical use of television footage. He appears on camera only a few times in this film, and when he does, it is only briefly. When he decides that congressmen ought to read a long bill they recently passed, he rents what looks like an ice cream truck and drives around Washington reading from the bill into a loudspeaker. The scene works mainly as a funny, throwaway line, as it lasts only a few seconds. His most extended on-camera intervention is a sequence in which he accosts congressmen and tells them they should ask their sons to enlist in the military and volunteer to serve in Iraq.

Nick Broomfield includes *Waiting for Fidel* in his list of five distinctively different documentaries "that broke the mould." The other four are *Housing Problems* (1935), by Arthur Elton, *Titicut Follies* (1967), by Frederick Wiseman, *Home from the Hills* (1981), by Molly

Dineen, and *Sisters in Law* (2005), by Kim Longinotto and Florence Ayise. Rubbo's film is the only one Broomfield cites for influencing his own work. "Fantastic," he calls it, "underappreciated—and the film that persuaded me to make myself a character in some of my own films."[2] Before discovering Rubbo's film, Broomfield had become adept at the traditional observational documentary format. *Soldier Girls* (1981), codirected with Joan Churchill, is a penetrating, sympathetic look at a company of American female army recruits undergoing basic training in Fort Gordon, Georgia. The feature-length film depicts the surprising rigor of the women's training, records in depth the struggles of two recruits trying to adapt, and reveals a thoughtful, tragic side to a male drill instructor who up to that moment had seemed merely harsh. There is only one, fleeting self-reference in the film, and it appears accidental: when one of the women who has washed out says goodbye to the friends she has made, she also says goodbye to the film crew. We see the microphone and a startled Broomfeld for a brief moment.

By the time Broomfield made *TThe Leader, His Driver and the Driver's Wife* (1991), he had adopted an intensely self-referential approach and the conceit of the elusive interview. "The Leader," as he is called, is Eugene Terre Blanche, head of an Afrikaner white supremacist party dedicated to the continuation of white rule in South Africa. The party seems Nazi-inspired: its black, red, and white flag features an arrangement of three *7*s vaguely resembling a swastika. Broomfield tries several times to get an interview with Terre Blanche, is repeatedly rebuffed, and tries confronting him on the street and at party gatherings. He finally secures an interview, which (as cut in the film) consists almost solely of Terre Blanche upbraiding Broomfield for his pushiness and lack of consideration. Terre Blanche comes off as a scary character but a bit of a fraud. His driver, with whom Broomfield spends considerable time on screen, is just as racist, but in Broomfield's treatment he becomes somewhat likeable and sympathetic nevertheless. Broomfield uses the same structure in *Tracking Down Maggie* (1994), wherein he chases the now retired, memoir-promoting Margaret Thatcher around London and across the United States in vain pursuit of an interview. He makes scores of unanswered inquiries to Thatcher's chief press liaison. He intrudes on book signings, speeches, and a reception, but is always rebuffed. In New York, his team manages to hack into Thatcher's

itinerary, enabling Broomfield to be waiting for her at each scheduled stop. At one point, Broomfield says his team feels intimidated; they fear they are being followed and that their phone calls are monitored. Broomfield has a singular talent for effrontery, and his films are amusing to watch and somewhat revealing, but they leave the impression that Broomfield does not really want the allegedly sought interview.

Broomfield and Moore are, for Jon Dovey, in his study of the triumph of first-person media in British television, emblematic of a documentary style Dovey calls "the film-maker as klutz, the film-maker who makes mistakes, forgets things, retraces his steps, and can't get the essential interview."[3] Dovey cites Ross McElwee's *Sherman's March* (1986) as another example. McElwee had received some funding for a film retracing General William Tecumseh Sherman's famous (infamous in the South) Civil War march through Atlanta to the Atlantic Ocean. However, as the film opens, we learn that McElwee has broken up with his girlfriend, which apparently discombobulates him enough that he shifts the film's focus from Sherman's historic march to his own inability to establish solid relationships with women. He does follow Sherman's route, roughly, visiting now and then a historic site to tell us a fact or two about Sherman, but he lingers for long periods with various women from his past or that he meets on his way. Some have been foisted on him by relatives or friends anxious about his bachelor status, and others are women that attract him. In every case, no lasting relationship is established, and the fault lies mainly with him, as he acknowledges—sometimes directly, sometimes through the comments of others. He is too diffident with women. McElwee narrates the film's progression à la Rubbo, and he often shows us what he is up to. A one-man crew, he frequently locks down his camera and speaks directly to it, in two cases at night, whispering, so that he won't be heard. We see his reflection in a mirror now and then. He gets kicked out of places by authorities. He runs out of sound tape twice. The film includes a failed attempt to gain access—in this case to Burt Reynolds, who is in town in connection with a film project that one of the women in McElwee's own film hopes to get a role in. McElwee's film persona is self-absorbed—in one scene, he tells us through his locked-down camera that the night is unbearably hot "so I thought I'd just film myself unable to sleep"—but, nevertheless, most of the women he interacts with come

off as strong, intriguing persons, and he even manages to convey an interesting impression of Sherman in the few minutes of factual information he dispenses along the way. And at times the film's reflexivity is insightfully self-aware. At one point he wonders if "I'm filming my life to have a life to film," worrying that it may be the only way he can comfortably relate to women.

In *Photographic Memory* (2011), McElwee, now a father of a twenty-two-year-old son, Adrian, whose seeming fecklessness worries him, intercuts footage of Adrian as a charming little boy with scenes of the adult Adrian. McElwee muses on his difficulty connecting with his son, and decides to revisit a place in France where as a young man he had begun to find his own self and purpose. McElwee weaves from this varied material a meditation on relationships, the passage of time, and generally the evanescence of just about everything in life. McElwee seems interested in people primarily for what he can learn about himself through them. He is the driver of the action and its object. He seems to welcome having his expectations dowsed and his attention shifted. In the quiet of editing, he makes sense out of his material.

Morgan Spurlock's *Supersize Me* (2004) is another popular documentary adopting aspects of Rubbo's method. The film's premise is Spurlock's decision to eat nothing but McDonald's meals for thirty days and to record the results. Thus the entire film, not just a scene here and there, is an acknowledged contrivance. Spurlock is on camera almost all the time, sometimes embarrassingly so. He has an exhibitionist streak: we see him undergoing a rectal exam, he talks about a weird feeling in his penis, he discusses his problems getting an erection, he throws up after forcing himself to eat an entire McDonald's meal. There is a sequence showing Spurlock making numerous phone calls trying to schedule an interview with a McDonald's official.

Spurlock's self-focus is exceeded by Jonathan Caouette in his *Tarnation* (2005). *Supersize Me* had a pretense of investigating a social issue; Caouette's film is ostensibly about his mother Renee's troubled life, but it is mostly about him, about how his difficult childhood has affected him. He tells us that his mother was raped in front of him when he was a baby. He was placed in foster homes, where he experienced "extreme emotional and physical abuse." He was sold some contaminated marijuana. He vandalized his own house. He is gay. He

fantasizes about a rock opera about his life. Much of his narration is printed rather than spoken, and he refers to himself in the third person. He includes lots of home movie footage and family photos. He interrogates his grandfather but hardly lets him finish a sentence. The film might seem exploitative when the camera lingers on Renee while she is acting bizarrely, but the sequence is poignant nevertheless.

Except for Michael Moore, filmmakers adopting a klutzy persona tend to make films that are not overtly political. But the personal approach pioneered by Rubbo has powered the narrative of many a political film in recent years. An intriguing pair of examples is Josh Fox's anti-fracking film *Gasland* (2010) and Phelim McAleer's rebuttal, *Fracknation* (2012). In *Gasland*, Fox appears on camera quite a bit, motivates the action, openly contrives scenes (such as a test of tap water for contaminants), and shows himself attempting to get interviews at Haliburton and with oil-and-gas magnate T. Boone Pickens. He tells us about his idyllic childhood and his family home in a beautiful stretch of Pennsylvania woods he says are threatened by fracking. Wearing a gas mask at a Wyoming drilling site, he plays the banjo for the camera. *Fracknation*, in scene after scene, debunks claims Fox had made in *Gasland*. McAleer carries openness about the production farther than perhaps any of the filmmakers who have adopted that aspect of Rubbo's style. He tells us briefly about his Irish background so that we know something about him. He reveals in detail the source of his funding (almost entirely from Kickstarter). He films confrontations between himself and Fox. An ex-director of a water basin commission abruptly ends an interview with him and, in a parking lot, threatens to confiscate his film. He confronts a subject from *Gasland* on a public road in front of her house; he wants to ask her some questions. She threatens to sue him, says she is armed, and calls the cops. McAleer even shows himself trying, persistently but unsuccessfully, to get an interview with Josh Fox. In the film's credits, he thanks Kickstarter and, by name, apparently every individual who contributed to the film, saying at the end, "This is their film."

The method has been adopted even in historical documentaries. John Walker's *Passage* (2008), an absorbing Canadian film produced by the NFB in collaboration with various other agencies, sets out to recreate the two expeditions by John Rae to try to discover what happened

to an earlier British expedition of 128 men, led by Sir John Franklin, in search of a route through the Arctic to Asia. That expedition had not been heard from for years. Rae eventually discovered with near certainty that Franklin's party became ice-bound, that they resorted to cannibalism, and that those who were not eaten froze to death. After he reported his findings to the British authorities who had commissioned his search, the results were leaked to the press. Rae was vilified. Charles Dickens wrote scathingly of Rae's report and argued that the Inuit were savages who probably slaughtered and ate Franklin and his men. But the film doesn't recreate Rae's search and the aftermath in the expected way. It uses actors, but we see more of the actors researching their parts and rehearsing scenes than we do of the ultimate formal reenactments themselves. Walker is often on camera, although not intrusively, and he also contrives situations that yield unscripted results. For example, at one of the recurring meetings among the actors and advisors, Walker has invited an unidentified guest. When the guest is revealed as a descendent of Charles Dickens, an Inuit advisor on Walker's film confronts him and asks him to apologize for his famous forebear's slander against his people.

Dear Zachary: A Letter to a Son About His Father (2008), director Kurt Kuenne's film about his murdered friend Andrew Bagby and Bagby's son, who was born after his father's murder, shifts gears during filming to respond to dramatic events. The killer was the friend's ex-girlfriend, who fled to Newfoundland after the murder, got free on bail, and had the baby, Zachary. Bagby's parents move to Newfoundland and try to get visitation rights. By the time he's a toddler, Zachary relates very well to the grandparents. The mother curtails his visits, then murders Zachary and commits suicide. By the end, the film has morphed into an argument for various reforms in Canadian law that might have prevented these tragic events. The film is a good example of adapting to unforeseen reversals during production, although in this case there was no pressure of a limited shooting schedule, as had been the case with *Waiting for Fidel*. Indeed, *Dear Zachary* was years in the making.

The Act of Killing (2012), directed by Joshua Oppenheimer, is built almost entirely on enabling, encouraging, and watching dramatized demonstrations, directed by their perpetrators, of mass killings from

nearly half a century earlier. The events depicted happened in Indonesia after the fall of Sukarno in 1965. The victims were of two classes: real or suspected Communists who were thought to have threatened the Islamic country's independence; and ethnic Chinese, resented for their prosperity. The mass slaughter was never disowned or condemned by post-Sukarno regimes; perhaps for that reason the perpetrators apparently lack shame about it. Without using any archival footage at all, Oppenheimer reports on the killings entirely through staged reenactments proudly and lovingly directed mainly by Anwar Congo, now an old man. Congo and some of his former colleagues play themselves with gusto. But by the film's concluding minutes, the process of reenactment, which he first embarked upon eagerly, ends up making Congo deeply (and literally) sick at what he had done.

It's impossible to determine with certainty how much these personally driven narratives, and the fact that they emerged largely during filming, owe to Rubbo's *Waiting for Fidel*. Broomfield may be the only practitioner who has publicly voiced his debt to *Waiting for Fidel*. Moore is said to have credited the film for his approach in *Roger & Me*, and the claim is printed on the case insert for a 2004 release of *Waiting for Fidel* offered by Facets Video. I haven't been able to confirm that Moore himself credited Rubbo's film, but its influence on him has generally been accepted. For instance, in his recent (2010) book *Documentary*, Dave Saunders states that *Waiting for Fidel* "has proved an undoubted and obvious narrative influence on the 'unfulfilled' quests of [Michael] Moore and Nick Broomfield."[4] As different as *Passage* may seem from Rubbo's work, Darrell Varga, in his book about the film, traces Walker's method to *Waiting for Fidel*.[5] Perhaps the strongest evidence for the film's influence is, first, that there seem to be no competitors for the distinction, and, second, that in histories of documentary written in the last two or three decades, *Waiting for Fidel* is usually the earliest film cited (if any are) for having used the method.

Waiting for Fidel's likely distinction as the prototype for reflexive documentaries in which the director is an on-camera protagonist establishes or at least overwhelmingly suggests Rubbo's importance in the history of documentary. Although most of the films so influenced share common elements that seem traceable to Rubbo's work, they diverge among themselves in style, tone, and aim. A Broomfield,

Moore, or McElwee film bears its director's personal stamp beyond the mere fact of the filmmaker's on-screen presence. Thus the influence of *Waiting for Fidel* has been fruitful, inspiring a variety of imaginative and distinctive adaptations, not mere copies. But what may be lost in recognizing the diversity of personal styles that *Waiting for Fidel* helped birth is that Rubbo's films, too, are quite distinct from the films that *Waiting for Fidel* inspired. And his body of work, not just *Waiting for Fidel*, deserves far more attention than it has received. *The Oxford Companion to Australian Film* (2002),[6] for instance, makes no mention of Rubbo. In Stella Bruzzi's *New Documentary* (2006),[7] Michael Moore and Nick Broomfield, the two filmmakers most clearly influenced by Rubbo, are mentioned or discussed on twenty-four and twenty-eight pages, respectively, but Rubbo not at all. Numerous filmmakers whose careers predated Rubbo's are mentioned, several of them often. Rubbo's appearance in the text of the aforementioned history of Australian documentary film, *Australian Documentary: History, Practices and Genres*, is limited to a single page and occasional mentions about his tenure at the ABC in the 1990s. The book does credit *Waiting for Fidel* for its influence on documentary, but it is the only Rubbo film included in its filmography of roughly two hundred Australian documentaries.

I believe there are two main reasons for the comparative obscurity of Rubbo's work. One is that, except for a few films, it has not been widely seen. A second, and related, reason is that the spectacular success of his on-camera presence in *Waiting for Fidel* has distracted attention from other qualities in his work. As I hope my account has demonstrated, there is much more to his films than simply his narrative presence. They have a distinctive character that lies not in that single common element but in a combination of several traits found in his best films, and only—in combination—in his films.

One of their most distinctive characteristics is the painterly quality most evident in *Sad Song of Yellow Skin* and *Solzhenitsyn's Children*. It contributes to aesthetic satisfaction. His films, although usually structured as stories, thus possess an expressive quality beyond the primarily indexical, chronological structure of most documentaries, even personal ones. Of the personal filmmakers who followed after Rubbo, only Ross McElwee's work has something analogous—in his case not a visual or cinematic richness but an expressive literary overlay that

adds to his films' enjoyment and without which his films might well seem inane.

A second Rubbo trait is a subordination of ego. Early on, Rubbo was criticized for inserting himself into his films. That he did. It took a strong ego to be the first one to do it, and to keep on doing it despite the difficulties it caused for him and for the distribution of his films. But now that the technique has become pervasive, he seems remarkably self-effacing compared to most filmmakers employing a version of the technique. He may place himself at his film's center as a motivator of events, but he is not the center of attention. Rubbo always shares his stage: with Stirling and Smallwood, with Louis Robitaille and the New Philosophers, with the three Anglophone candidates in Westmount, with Francis, Daisy, Moreau, Atwood, Olive, and his YouTube subjects. His on-camera antics are almost always intended to advance the action and our understanding. His interest in himself is minor compared to his interest in his subjects. He never puts them down without allowing them to respond in kind. In any on-camera confrontation, whether intense like the argument with Stirling, or friendly like the discussion with the Cuban mental health patient, or sexist like in *Persistent and Finagling*, the subject gets the last word. His films are not about him. While some of the filmmakers we have discussed allow themselves to look ridiculous now and then, most of them are the stars of their films: the cheeky, wisecracking muckraker (Moore), the intrepid, relentless investigator (Broomfield), the super-sensitive male (McElwee), the heroic guinea pig (Spurlock), the victim (Caourette), the crusader (Fox), the relentless fact-checker (McAleer). John Walker, of *Passage*, and Joshua Oppenheimer, of *The Act of Killing*, manage the role of protagonist in a more self-effacing way than Rubbo, but with less spontaneity and on-the-spot creativity.

Rubbo's respect for others goes deeper than simple courtesy. In his best films, his subjects are presented as characters in the round. If they are on the "right" side (i.e., Rubbo's), such as Smallwood or Auf de Maur, they have flaws. They're neither idealized nor idolized. If they represent the opposition, such as Stirling, Blaker, Springate, or the Shakespeare traditionalists, Rubbo can disagree with or even disapprove of them without disparaging them. Stirling seems to have a good heart, Blaker reliability, Springate a soft side. Rubbo and Jean-Guy

Moreau, on opposite sides of a contentious issue, seem to enjoy each other. Most of the various New Philosophers, despite their self-importance, evasiveness, insistence, or derisiveness, are in Rubbo's treatment people you might to like hear more from. It's hard not to like, at some level, Rubbo's opponents, villains, and popinjays.

Rubbo's openness to his human subjects finds a parallel in his openness to situations. He has acknowledged a predilection for thrusting himself into situations with only limited preparation, the better to remain open to what reality has to offer. He has changed the arc of several of his films just before or even during the shooting as a result of unforeseen events or discoveries. His willingness and ability to switch directions while on location served him well in *Sad Song of Yellow Skin*, and without such existential poise it is doubtful he could have come up with the marvelous character study in *Waiting for Fidel*.

But if reality doesn't present enough surprise, Rubbo, with his audience's knowledge, will contrive situations in order to generate it. Probably Rubbo's three most imaginative—and gutsy—contrivances were persuading Stirling to allow his argument with Rubbo to be filmed, leaving the camera with the Atwood family, and allowing Olive to direct the reenactment of a childhood incident that affected her deeply. Walker used the tactic effectively in *Passage* more than once, in each case with essentially the same group, his team of actors, writers, and experts—and a surprise guest. *The Act of Killing* is built almost entirely on reenactments enabled by the filmmakers and directed by the film's protagonist, the effect of which can't be foreseen.

The construction of situations in which subjects are placed may seem manipulative, but besides yielding lively, sometimes dramatic cinema, it is arguably a means of producing truth of character. It allows the documentary director to engage in something roughly analogous to what is known in dramatic filmmaking as mise-en-scène—of making things happen instead of waiting for things to happen. Of course all documentary filmmakers engage in manipulation. Even when time is limited, control of events scant, equipment Spartan, and preconceptions minimized, choices are continually made that contribute to something like mise-en-scène—but only at a primitive level. Rubbo figured out a way to shape actuality without essentially distorting it or disguising the construction. He is involved in his subjects' performances while

giving his characters free rein. The fun of the reenactments in *All About Olive* lies not in the events reenacted, but in watching Olive direct and respond to them. The constructed yet spontaneous "reality" is what's interesting—and real. In these ways, Rubbo shapes and reveals reality without violating the implicit contract a documentary filmmaker has with his audience not to deceive them.

The issue of ethics is a huge one in documentary theory and criticism. The first chapter in *Introduction to Documentary* by the influential theorist Bill Nichols asks, "Why are ethical issues central to documentary filmmaking?"[8] For most people who ponder such things, the issue of ethics for the documentary filmmaker points in two directions: to his audience and to his subjects. In the view of Brian Winston, the

> relationship between participants and documentarists is far more pregnant with ethical difficulties than is the connection of film-maker to audience. Unlike the audience, the vast majority of which remains usually unaffected (in measureable ways, at least) by any documentary it sees, participants are engaged in an exercise that could be life-changing.[9]

Most members of the documentary community would probably agree with Winston. For his livelihood, the documentary filmmaker depends on people whose trust he must gain (unless he is a muckraker or an attack documentarian) and whom he does not pay. He likely will affect their lives far more than they will affect his. He owes them not just fairness but concern. What do his subjects get out of it? Jean Rouch, codirector with Edgar Morin of *Chronicle of a Summer* (1961), one of the earliest and most influential self-reflexive films, remarked to James Blue that people

> behave very differently when being recorded, "but what has always seemed very strange to me is that, contrary to what one might think, when people are being recorded, the reactions that they have are always infinitely more sincere than those they have when they are not being recorded. The fact of being recorded gives these people a public."[10]

Rubbo's subjects get to present themselves to a public and never in a disparaging way. It is a form of public validation of their selves. This is the other half of the "exchange of valuables" that Rubbo says should take place in the filmmaking process. In his above-referenced interview with Geoff Burton, Rubbo added that documentary filmmaking "is all about encounters, sensing their meaning and their value to the project at hand, while at the same time being a feeling human being who likes people and wants to spend time with them for other reasons."[11] This attitude comes out in his films, in part because Rubbo uses that tool of ultimate control—editing—to help make his subjects likeable and perhaps people one would want to spend some time with.

One prominent filmmaker who may outdo Rubbo in generosity to her subjects is Molly Dineen. In *Home from the Hills* (1987), *Her African Farm* (1988), *Heart of the Angel* (1988), and *In the Company of Men* (1995), Dineen employs a primarily observational approach enriched by frequent off-camera questioning and occasional references by her subjects to her, her crew, or her film. She seems intensely interested in her characters, and her only agenda, apparently, is to show them in an honest but sympathetic light. *Her African Farm* is a warm portrait of a crotchety old landowner who has decided to sell her farm, at about a third of its value, to her servants, keeping only her house. While she is generous, accepting, and fatalistic, she is also somewhat imperious to her servants and their families. Her chief servant, by contrast, says that while his boss can be mean and stubborn, he will take care of her until she dies, because she is old and needs him. *Heart of the Angel* conveys, with sympathy and appreciation, the often dreary, frustrating work lives of the men and women who make a busy commuter train station function. *In the Company of Men* is a three-part documentary on The Prince of Wales's Company of the 1st Battalion Welsh Guards during their deployment in Northern Ireland as peacekeepers. The film explores the pressures of leadership, the pain of imposing harsh discipline, and the camaraderie of military men. While occasionally a soldier or an officer expresses annoyance at Dineen's presence, they generally accept her and are open with her about their doubts and dreams. *Home from the Hills* follows a British subject who is forced to relinquish his Kenyan farm and spend his last years in England. He accepts his

fate, wrapped in his acknowledged decline of white superiority, with sadness but also grace.

The closeness that Dineen achieves with her subjects suggests a limitation to the director-as-protagonist documentary. While filming, she intervenes only to ask questions, which we hear off camera. She is rarely, if ever, seen. But in a 2003 interview with David A. Goldsmith, she stresses that her approach is not that of a detached, uninvolved director (the "fly on the wall" once championed in observational documentary). She spends considerable downtime with her subjects, sometimes moving in with them. While filming, although off camera, she is "right there with them," interacting with them, drawing them out. But, she says, "I don't want me as a character." Nor does she violate the trust between her and her subjects; she deliberately leaves out anything that might embarrass them. And yet her off-camera involvement allows her, as Rubbo's on-camera method allows him, to shape reality in order to reveal it: while she and her sound recordist lived for a spell with Colonel Hook in *Home from the Hills*, "we cooked, and we shopped, and talked together, and it helped create the reality we were trying to capture."[12]

Perhaps the observational but engaged method, when employed by someone with Dineen's talent and attitude towards people, ultimately is more generous to its characters than a documentary featuring the director's strong on-camera presence can be, simply by granting the subject(s) all or almost all the screen time. At the end of *Home from the Hills*, Dineen asks Colonel Hook if he is happy. "Oh, blissfully happy, in your presence. Otherwise, I represent divine discontent." His comment is pretty strong evidence that in this film an "exchange of valuables" has occurred. In Dineen's films, one gets the feeling that her characters appreciated being taken seriously, that their lives were enriched at least a bit by the experience. The self-effacing *Soldier Girls* (1981), which Nick Broomfield codirected with Joan Churchill before adopting the director-as-protagonist approach, is far more interested in and empathetic to its subjects as individuals than is *Tracking Down Maggie* or *The Leader, His Driver and the Driver's Wife*.

But Winston underrates the filmmaker's responsibility to his audience. The effect of a film on its subjects is localized and can be deep, but a film's diffuse effect on its audience can have consequences, too,

however hard to measure; it contributes something to their view of the world. The former effect can hurt a person. The latter can harm society or alter its sense of history—which is misinformed easily. Here the issue of ethics morphs into the problem of truth. Hence the value of meaningful reflexivity in a film.

In his highly theoretical *Representing Reality: Issues and Concepts in Documentary*, Bill Nichols posits four modes of representation in documentary: expository, observational, interactive, and reflexive.[13] While acknowledging that these modes can overlap, Nichols places Rubbo's work, along with that of some others, neatly into the interactive mode, apparently because Rubbo interacts with his subjects in front of the camera.[14] He also says that such work is now untenable, because "what we learn in ... *Sad Song of Yellow Skin* or *Waiting for Fidel* is restricted to what Rubbo himself knows or learns since he places himself in the foreground as an inquiring presence."[15] This observation seems to ignore that Rubbo also narrates his films and, like all filmmakers, edits them (or supervises the editing), where the ultimate power of representation lies. I don't know how a film can deliberately show more than the director knows. It is limiting to conceive of reflexivity merely in terms of a self-conscious avowal and questioning of the filmmaker's stratagems.

Films often contain token reflexivity, but showing the sound man now and then tells a modern audience nothing it doesn't already know. Disclosing how an event was discovered or shaped certainly does. Rubbo doesn't always disclose a contrivance. He presents his meeting with Robitaille at the Communist Party rally as if it were their first. The pretense hardly adds to the film. Rubbo could have said that he had arranged to meet Robitaille at the meeting, and still filmed himself making his way through the crowd and looking for him. Little or no substance would have been lost. Similarly, there seems to be no reason for Rubbo to have downplayed Daisy's association with the Film Board. Daisy's interaction with the man waiting with her in the doctor's office was set up, but it is amusing and in character. Occasionally, Rubbo's contrivances add amusement but not much else. The swarm of Corvettes in *Yes or No* is an example. Harmless deceits, perhaps, but if you're aware of them and are unfamiliar with Rubbo's body of work,

you might become suspicious that there could be greater ones. Having followed and studied his work for years, I believe there aren't any.

Reflexivity, when done sincerely and well, helps the viewer judge the validity of whatever view of reality a film presents. Unfortunately, it can also work as a disclaimer, giving the filmmaker license to go ahead and do what he wants with his subject. A nod toward reflexivity, or even extensive use of it, doesn't guarantee the reliability of a filmmaker's presentation of reality. Used extensively, it can turn narcissistic, revealing more about the filmmaker than his ostensible subject. Reflexivity has disappointed the hopes documentary theorists had placed in it. It is not a fail-safe key to assessing a film's representation of reality. There is no such key.

The question of documentary "truth" has vexed theorists, critics, and filmmakers themselves. The relation of a documentary to the reality it purports to depict is ineluctably problematic. It's now a commonplace that regardless of approach, the filmmaker to some extent fabricates a view of reality. Seeking to determine a well-made film's truthfulness by comparing it against some idea of the objective reality it depicts is a fool's errand for anyone but an absolute expert in that reality. Rubbo seems to have intuited this early in his career. And he began to invent a repertoire of reflexive strategies that may not be noticed as such because they are done naturally and without intellectual self-consciousness. With reference especially to *Waiting for Fidel*, Jeannette Sloniowski observed that "the idea of getting to 'the truth' becomes impossible in a Rubbo film."[16] I trust documentary filmmakers who probe important but morally complex realities in search of truth but don't claim to have found it. Rubbo's films embody this attitude. The one common characteristic in the various techniques comprising Rubbo's documentary style is that each of them, in its way, undermines Rubbo's authority. For those who notice it, the painterly quality of his films acknowledges implicitly that his interpretation of reality is created from surfaces, or images. At this level, his interpretation is impressionistic. His often imaginative but distinctively self-deprecating reflexivity reveals his role in finding or shaping those images. His willingness to enter a situation without knowing how it might develop indicates an openness to experience that we often associate with significant art and literature. He'll even provoke reality by contriving situations likely

to bring out character. His occasional use of intermediaries further undermines any assumption that his films represent the views of an all-knowing director. When he and his film are only at the periphery of the real action, he acknowledges this implicitly or openly. His generosity to his characters resembles the empathy of a novelist, who can see the good and bad in people. Both literally and tonally, his own on-camera words and his voice-over narration imply uncertainty and often make explicit his doubts. And yet who, after watching any of his best films, can complain honestly of having learned nothing of importance about the subject at hand or the human condition? It's almost as if the reticence itself pulls back the veil on reality, revealing complexity and reinforcing uncertainty.

Reticence is an odd trait to accompany boldness; it is not often associated with the kind of personality that would put itself in the midst of the action as Rubbo does. His boldness probably owes something to his Australian origins. His reticence may have something to do with Canada. The documentaries that especially appealed to him as a film student, and which influenced his thesis film, were films made by the NFB's Unit B under Tom Daly's collaborative leadership. The Canadian critic Peter Harcourt's 1965 *Sight & Sound* essay on Unit B, "The Innocent Eye," noted that whatever the subject of a Unit B film, there was "something else as well, something not so easily defined ... a quality of suspended judgment, of something left open at the end, of something undecided."[17] Those words could apply to Rubbo's documentaries. And they were, roughly twenty years later. Piers Handling, in disappointment, applied the phrase "suspended judgement" to Rubbo's later work up to 1984.[18]

It was Unit B's films that drew Rubbo to Montreal. When he got a job with the Film Board, the unit system had just been disbanded, but he gravitated to Tom Daly, and made his breakthrough, *Sad Song of Yellow Skin*, with Daly as his producer. But there's a surprising irony here. Harcourt made another acute observation about Unit B: the films were "so much the product of a group that the names [of the filmmakers] do not matter."[19] From *Sad Song* on, Rubbo's best films were so much *not* the product of a group that the name of the director was what mattered most. Inserting himself into his films as a main, or even *the* main, protagonist was as contrary to the Unit B aesthetic as

could be. Harcourt had said of Unit B's personality that there "is something Canadian in all this."[20] And nothing Australian, one could add. And yet, despite his once-maligned but ultimately influential personal presence as narrator, participant, and instigator, Rubbo's films have a strong touch of that open-ended "quality of suspended judgment" that Harcourt saw in Unit B's best work.

Rubbo is of course not the only filmmaker of his generation who delivers insight without claiming to have discovered truth. Molly Dineen, Frederick Wiseman, and Errol Morris are three such filmmakers with a substantial body of work. Their styles are as distinct from one another's as they are from Rubbo's, but they each share Rubbo's openness to truth, and they each manifest that openness in their reluctance to tell the viewer what to think. All three are far better known than Rubbo. Documentary aficionados who are attracted to the intelligent open-endedness of their work likely would appreciate Rubbo's films as well. And younger filmmakers might benefit from seeing that it is possible to be personally involved in a documentary's storyline while remaining committed to the truth. Or better, to see that personal involvement and respect for truth can work in concert.

Michael Rubbo Filmography

(This list does not include films Rubbo has made and posted on YouTube; see below for a selected list of these titles.)

Adventures (1967)
Direction, script, editing. Cinematography: Igmar Remmier. Producer: Nick Balla. NFB. 10 mins.

All About Olive (2005)
Direction, cinematography, production. Editor: Henion Han. The Helpful Eye. 55 mins.

Atwood and Family (1985)
Direction, editing, narration. Cinematography: Andreas Poulsson, Zoe Dirse. Coproduced with Barrie Howells. NFB. 30 mins.

Bate's Car: Sweet as a Nut (1974)
Production. Direction, cinematography: Tony Ianzuelo. Editor: Malca Gillson. NFB. 16 mins.

The Bear and the Mouse (1966)
Editing, narration. Direction, camera: F.W. Remmler, Igmar Remmler. NFB. 8 mins.

Beware, Beware, My Beauty Fair (1972)
Production. Direction, editing: Jean Lafleur, Peter Svatek. Cinematography: Douglas Kiefer. NFB. 29 mins.

Cold Pizza (1972)
Production. Direction: Larry Kent. Cinematography: Savas Kalogeras. NFB. 19 mins.

Courage to Change (1986)
Coproduced with Tanya Tree. Direction: Tanya Tree. Editing: Hedy Dab. Cinematography: Kent Nason. NFB. 54 mins.

Daisy: The Story of a Facelift (1982)
Direction, editing, narration. Cinematography: Susan Trow. Coproduced with Giles Walker. NFB. 58 mins.

Here's to Harry's Grandfather (1970)
Direction. Cinematography: Tony Ianzelo. Producer: Tom Daly. NFB. 58 mins.

I Am an Old Tree (1975)
Direction, editing, narration. Cinematography: Andreas Poulsson. Coproduced with Tom Daly. NFB. 57 mins.

I Hate to Lose (1977)
Direction, editing, narration. Cinematography: Andreas Poulsson. Producer: Tom Daly. NFB. 57 mins.

Jalan, Jalan: A Journey in Sundanese Java (1973)
Direction, editing, narration. Cinematography: Paul Leach. Producer: Tom Daly. NFB. 20 mins.

Labour College (1966)
Narration. Director: Mort Ransen. Cinematography: Roger Racine. Editing: Alan Davis. Producers: John Howe and Morten Parker. NFB. 23 mins.

The Little Box That Sings (2000)
Cinematography, editing, narration, production. Codirected with Katherine Korolkevich-Rubbo. Editing: Geoffrey Wheeler. ABC. 55 mins.

Log House (1976)
Codirected with Andreas Poulsson. Cinematography: Andreas Poulsson. Editing: Les Halman. Producer: Roman Bittman. NFB. 28 mins.

The Long Haul Men (1966)
Direction. Cinematography: Tony Ianzelo. Editing: John Spotton. Narration: Stanley Jackson. Producer: John Kemeny. NFB. 17 mins.

The Man Who Can't Stop (1973)
Direction, editing, narration. Coedited with Graham Chase. Cinematography: Don McAlpine. Producers: Tom Daly and Richard Mason. NFB and Film Australia. 58 mins.

Margaret Atwood: Once in August (1984)
Direction, editing, narration. Coproduced with Barrie Howells. Cinematography: Andreas Poulsson and Zoe Dirse. NFB. 57 mins.

Mrs. Ryan's Drama Class (1969)
Direction. Cinematography: Tony Ianzelo, Paul Leach, and Martin Duckworth. Editing: Eddie Le Lorrain. Producers: Tom Daly and Cecily Burwash. NFB. 35 mins.

Much Ado About Something (2002)
Direction, cinematography, editing. Coproduced with Penelope McDonald Editing: Jane St. Vincent Welch. ABC/WHBH/The Helpful Eye/Chili Films. 85 mins.

Not Far from Bolgatanga (1982)
Editing, narration. Codirected and coproduced with Barrie Howells. Cinematography: Fred Coleman. NFB for the Canadian International Development Agency. 28 mins.

OK . . . Camera (1972)
Direction. Cinematography: Eugene Boyko, Pierre Letarte, Jacques Forget, Claude Pelland, Cameron Gaul, and Simon Leblanc. Editing: Marie-Hélène Guillemin. NFB. 27 mins.

The Peanut Butter Solution (1985)
Direction. Writing: Vojtec Jasný, Andree Pelletier, Louise Pelletier, and Michael Rubbo. Cinematography: Thomas Vámos. Editing: Jean-Guy Montpetit. Production: Rock Demers, Jim Kaufman, and Nicole Robert. Productions La Fête. 94 mins.

Persistent and Finagling (1971)
Direction, editing, narration. Cinematography: Jean-Pierre Lachapelle. Producer: Tom Daly. NFB. 56 mins.

The Return of Tommy Tricker (1994)
Direction, writing. Cinematography: Thomas Vámos. Editing: Jean-Pierre Cereghetti. Producer: Rock Demers. Productions La Fête. 97 mins.

River (Planet Earth) 1977
Writing, editing. Director: Peter Raymont. Cinematography: Robert Humble. Producer: Tom Daly. NFB/Environment Canada. 28 mins

Sad Song of Yellow Skin (1970)
Direction, narration. Coedited with Torben Schioler. Cinematography: Martin Duckworth and Pierre Letarte. Producer: Tom Daly. NFB. 58 mins.

Sir! Sir! (1968)
Direction. Cinematography: Tony Ianzelo. Editing: Alan Davis. Producers: Cecily Burwash and Tom Daly. NFB. 20 mins.

Solzhenitsyn's Children . . . Are Making a Lot of Noise in Paris (1978)
Direction, editing, narration. Cinematography: Andreas Poulsson, Michael Edols, and Michel Thomas-d'Hoste. Producer: Martin Cannell. NFB. 87 mins.

The Streets of Saigon (1973)
Direction, editing, narration. Cinematography: Martin Duckworth. Producer: Tom Daly. NFB. 28 mins.

Summer's Nearly Over (1971)
Direction. Coedited with Eddie Le Lorrain. Cinematography: Tony Ianzelo. Producer: Tom Daly. NFB. 29 mins.

Temiscaming, Québec (1975)
Coedited with Martin Duckworth, Serge Giguère, Gérard Sénécal, and Ginny Stikeman. Direction and Cinematography: Martin Duckworth. Producers: Dorothy Todd Hénaut and Len Chatwin. NFB. 64 mins.

That Mouse (1967)
Direction, editing, narration. Cinematography: Igmar Remmier. Producer: Nick Balla. NFB. 14 mins.

Tigers and Teddy Bears (1978)
Direction. Cinematography: Robert Humble and Andreas Poulsson. Editing: Torben Schioler. Producer: Tom Daly. NFB. 32 mins.

Tommy Tricker and the Stamp Traveller (1988)
Direction, writing. Cinematography: Andreas Poulsson. Editing: André Corriveau. Productions La Fête. 105 mins.

The True Source of Knowledge These Days (1965)
Direction, camera, editing, narration, production. Stanford University. 28 mins.

Vincent and Me (1990)
Direction, writing. Cinematography: Andreas Poulsson. Editing: André Corriveau. Producers: Rock Demers, Daniel Louis, Claude Nedjar. Productions La Fête. 100 mins.

Waiting for Fidel (1974)
Direction, editing, narration. Coproduced with Tom Daly. Cinematography: Douglas Kiefer. NFB. 58 mins.

The Walls Come Tumbling Down (1976)
Narration, editing. Codirected with Pierre Lasry and William Weintraub. Cinematography: Douglas Kiefer and Andreas Poulsson. NFB. 25 mins.

Wet Earth and Warm People (1971)
Direction, editing, narration. Cinematography: Paul Leach. Producer: Tom Daly. NFB. 59 mins.

Yes or No, Jean-Guy Moreau (1979)
Direction, narration. Cinematography: Pierre Letarte. Editing: Tina Viljoen. Producers: Judith Vecchione, Tina Viljoen, and Barrie Howells. NFB in coproduction with WGBH-TV Boston. 58 mins.

Michael Rubbo YouTube Films
[Selected]

An Artist of Malacca (2013)

Avoca Beach Theatre: Our Little Treasure (2012)

Bicycle Art Drawing (2012)

Bicycle Art Drawing: Part Two (2012)

Bike It Or Not (2010)

Bike Share and Helmets Don't Mix? (2009)

Bike Share for Fremantle? (2010)

Classical Australian Regional Cinemas (2013)

Councillor on a Bike (2010)

Electric Bikes—The Great Electric Bike Comparison (2009)

The Inlet Cinema (2013)

Maggie Chiou Here on Show (2013)

The Man Who Swam Away (2010–2014)

Notes

INTRODUCTION

1 Piers Handling, "The Diary Films of Michael Rubbo," in *Take Two: A Tribute to Film in Canada*, ed. Seth Feldman (Toronto: Irwin, 1984), 215.

2 *International Encyclopedia of Film*, ed. Ian Aitken (New York: Routledge, 2006), vol. 3, s.v.v. "*Sad Song of Yellow Skin*," "*Waiting for Fidel*."

3 D. B. Jones, *The Best Butler in the Business: Tom Daly of the National Film Board of Canada* (Toronto: University of Toronto Press, 1996) and *Movies and Memoranda: An Interpretive History of the National Film Board of Canada* (Ottawa: Deneau, 1981); Gary Evans, *In the National Interest: A Chronicle of the National Film Board of Canada from 1949 to 1989* (Toronto: University of Toronto Press, 1991).

1 | LEARNING THE CRAFT

1 Raymond Bellour, "Psychosis, Neurosis, Perversion," in *A Hitchcock Reader*, ed. Marshall Deutelbaum and Leland Pogue (Iowa City: Iowa State University Press, 1986), 311–331.

2 | MAKING IT PERSONAL

1 John Balaban, *Remembering Heaven's Face: A Story of Rescue in Wartime Vietnam* (Athens: University of Georgia Press, 2002), 183, 231, 281.

2 John Steinbeck IV and Nancy Steinbeck, *The Other Side of Eden* (New York: Prometheus Books, 2001), 291–296.

3 Michael Rubbo, "Remembering Tom," *Point of View Magazine*, Winter 2011, n.p.

4 Handling, "The Diary Films of Mike Rubbo," *Cinema Canada*, October 1977, 35.

4 | FILMMAKER FRONT AND CENTER

1 D. B. Jones, "On Rubbo: The Man in the Picture," *Lumiere*, April 1973, 8–9.

6 | HOW IT WORKS

1 Ray Argyle, *Joey Smallwood: Schemer and Dreamer* (Toronto: Dundurn, 2012), 19. Unless otherwise noted, all further references to Smallwood are drawn from Argyle's book.

2 Argyle, *Joey Smallwood*, 144.

3 Joey Smallwood, *I Chose Canada: The Memoirs of the Honourable Joseph R. "Joey" Smallwood* (Toronto: Macmillan, 1973).

4 Jeannette Sloniowski, "Performing the Master Narratives: Michael Rubbo's *Waiting for Fidel*," in *Candid Eyes: Essays on Canadian Documentaries*, ed. Jim Leach and Jeannette Sloniowski (Toronto: University of Toronto Press, 2003), 105.

5 Trish FitzSimons, Pat Laughren, and Dugald Williamson, *Australian Documentary: History, Practices and Genres* (Cambridge: Cambridge University Press, 2011), 166–167.

6 Alan Rosenthal, "*Sad Song of Yellow Skin* and *Waiting for Fidel*: Interview with Michael Rubbo," in *The Documentary Conscience: A Casebook in Film Making*, ed. Alan Rosenthal (Berkeley: University of California Press, 1980), 244.

7 | WHERE THE ACTION ISN'T

1 René Lévesque, *An Option for Quebec* (Toronto: McClelland and Stewart, 1968), 7.

2 Ibid., 27.

3 Daniel Poliquin, *René Lévesque* (Toronto: Penguin Canada, 2009), 119.

4 This recap is drawn from Graham Fraser, *René Lévesque and the Parti Québecois in Power* (Montreal: McGill-Queens University Press, 2001), 54–63.

5 Handling, "The Diary Films of Mike Rubbo," 38.

6 Handling, "The Diary Films of Michael Rubbo," 213.

7 Fraser, *René Lévesque and the Parti Québecois*, xlvi.

8 Poliquin, *René Lévesque*, 145.

8 | SOMETHING'S HAPPENING

1 Timothy Erwin, John L. Sutton, and Bill Monroe, "Introduction," *Chicago Review* 32, no. 3, "The French New Philosophers" (1981): 5.

2 John Hughes, "Michael Rubbo: Hiding Behind the 'I,'" *Cinema Papers*, January-February 1981, 44.

3 Ibid., 45.

4 Jonathan Dawson, "*Solzhenitsyn's Children ... Are Making a Lot of Noise in Paris*," *Senses of Cinema* 35 (April 2005), http://sensesofcinema.com/2005/35/solzhenitsyns_children/ (accessed 14 July 2016).

9 | FACIAL EXPRESSIONS

1 Joan Nicks, "The Documentary of Displaced Persona: Michael Rubbo's *Daisy: The Story of a Facelift*" in *Documenting the Documentary*, ed. Barry K. Grant and Jeannette Sloniowski (Detroit: Wayne State University Press, 1998), 302.

2 Ibid., 314.

10 | LONG SHOTS

1 Handling, "The Diary Films of Michael Rubbo," 215.

2 Ibid.

11 | A BREAK FROM "REALITY"

1 Steve Dobi, "Who's Who in Filmmaking: Mike Rubbo," *Sightlines*, Fall 1978, 20.

2 Michael Rubbo, "Love and Life in Children's Films," *Take One* 1, no. 7 (1967): 20.

3 Art Gallery of New South Wales, *Antonio Dattilo Rubbo*, Sidney, 2011, http://www.artgallery.nsw.gov.au/education/online-catalogues/antonio-dattilo-rubbo/ (accessed 17 July 2016).

4 National Film Board of Canada, *Michael Rubbo: The Man and His Films* (Montreal: National Film Board of Canada, n.d.).

12 | NEW TOOLS OF THE TRADE

1 Geoff Burton, "The Man Behind the Picture: An Interview with Mike Rubbo," in *Second Take: Australian Film-makers Talk*, ed. Raffaele Caputo and Geoff Burton (St. Leonard's, AU: Allen & Unwin, 1999), 193.

2 Ibid., 204.

3 "A Bard in the Hand? An Interview with Michael Rubbo," *Frontline*, WGBH-Boston, 9 December 2002, http://www.pbs.org/wgbh/pages/frontline/shows/muchado/etc/rubbo.html (accessed 19 July 2016).

4 Ibid.

5 Burton, "The Man Behind the Picture," 212.

6 Stanley Kaufmann, "On Films: Examined Lives," *New Republic Online*, 25 February 2002, https://newrepublic.com/article/66143/examined-lives (accessed 19 July 2016).

7 John Hartley, "Problems of expertise and scalability in self-made media," in *Digital Storytelling, Mediatized Stories: Self-representation in New Media*, ed. Knut Lundby (New York: Peter Lang, 2008), 205.

13 | PLEIN AIR DOCUMENTARY

1 Jones, *The Best Butler in the Business*, 228–229.

2 Rosenthal, "Interview with Michael Rubbo," 236.

3 Clifford Geertz, "Thick Description: Toward an Interpretive Theory of Culture," in *The Interpretation of Cultures*, ed. Clifford Geertz (New York: Basic Books, 1973), 29.

4 Roger Scruton, "Scientism in the Humanities," in *Scientism: The New Orthodoxy*, ed. Richard N. Williams and Daniel N. Robinson (New York: Bloomsbury Academic, 2015), 142.

CONCLUSION

1 Roger Ebert, *Roger Ebert's Four Star Reviews—1967–2007* (Kansas City, Missouri: Andrews McMeel, 2007), 651–652.

2 Nick Broomfield, "Five documentaries that broke the mould," *The Independent* (London), 31 October 2008.

3 Jon Dovey, *Freakshow: First Person Media and Factual Television* (London: Pluto Press, 2000), 32–33.

4 Dave Saunders, *Documentary* (New York: Routledge, 2010), 73.

5 Darrell Varga, *John Walker's Passage* (Toronto: University of Toronto Press, 2012), 63–64.

6 Brian McFarlane, Geoff Mayer, and Ina Bertran, eds., *The Oxford Companion to Australian Film* (Oxford: Oxford University Press, 2000).

7 Stella Bruzzi, *New Documentary* (New York: Routledge, 2006).

8 Bill Nichols, *Introduction to Documentary* (Bloomington: Indiana University Press, 2001), 1.

9 Brian Winston, *Lies, Damned Lies, and Documentaries* (London: British Film Institute, 2000), 158.

10 "Jean Rouch Interviewed by James Blue," in *Imagining Reality: The Faber Book of Documentary*, ed. Kevin MacDonald and Mark Cousins (Boston: Faber and Faber, 1998), 268–269.

11 Burton, "An Interview with Mike Rubbo," 202.

12 David A. Goldsmith, *The Documentary Makers: Interviews with 15 of the Best in the Business* (East Sussex, UK: Sheridan House, 2003), 26.

13 Bill Nichols, *Representing Reality: Issues and Concepts in Documentary* (Bloomington: Indiana University Press, 1991), 43–47.

14 Ibid., 47.

15 Ibid., 119.

16 Sloniowski, "Performing the Master Narratives," 107.

17 Peter Harcourt, "The Innocent Eye," *Sight & Sound* 34, no. 1 (Winter 1965): 21.

18 Handling, "The Diary Films of Michael Rubbo," 215.

19 Harcourt, "The Innocent Eye," 21.

20 Ibid.

Works Cited

Aitken, Ian, ed. *International Encyclopedia of Film*, Vol. 3. New York: Routledge, 2006.

Argyle, Ray. *Joey Smallwood: Schemer and Dreamer*. Toronto: Dundurn, 2012.

Art Gallery of New South Wales. Antonio Dattilo Rubbo. Sidney, 2011. http://www.artgallery.nsw.gov.au/education/online-catalogues/antonio-dattilo-rubbo/.

Balaban, John. *Remembering Heaven's Face: A Story of Rescue in Wartime Vietnam*. Athens: University of Georgia Press, 2002.

Bellour, Raymond. "Psychosis, Neurosis, Perversion." In *A Hitchcock Reader*, edited by Marshall Deutelbaum and Leland Pogue, 311–331. Iowa City: Iowa State University, 1986.

Broomfield, Nick. "Five documentaries that broke the mould." *The Independent* (London), 31 October 2008.

Bruzzi, Stella. *New Documentary*. New York: Routledge, 2006.

Burton, Geoff. "The Man Behind the Picture: An Interview with Mike Rubbo." In *Second Take: Australian Film-makers Talk*, edited by Raffaele Caputo and Geoff Burton, 193–214. St. Leonard's, AU: Allen & Unwin, 1999.

Dawson, Jonathan. "Solzhenitsyn's Children . . . Are Making a Lot of Noise in Paris." *Senses of Cinema* 35 (April 2005). http://sensesofcinema.com/2005/35/solzhenitsyns_children/.

Dobi, Steve. "Who's Who in Filmmaking: Mike Rubbo." *Sightlines*, Fall 1978, 17–20.

Dovey, Jon. *Freakshow: First Person Media and Factual Television*. London: Pluto Press, 2000.

Ebert, Roger. *Roger Ebert's Four Star Reviews—1967–2007*. Kansas City, MO: Andrews McMeel Publishing, 2007.

Erwin, Timothy, John L. Sutton, and Bill Monroe. "Introduction." *Chicago Review* 32, no. 3. "The French Philosophers." (1981): 5–10.

Evans, Gary. *In the National Interest: A Chronicle of the National Film Board of Canada from 1949 to 1989*. Toronto: University of Toronto, 1991.

FitzSimons, Trish, Pat Laughren, and Dugald Williamson. *Australian Documentary: History, Practices and Genres*. Cambridge: Cambridge University Press, 2011.

Fraser, Graham. *René Lévesque and the Parti Québecois in Power*. Montreal: McGill-Queens University Press, 2001.

Frontline. "A Bard in the Hand? An Interview with Michael Rubbo." WGBH-Boston, 9 December 2002. http://www.pbs.org/wgbh/pages/frontline/shows/muchado/etc/rubbo.html.

Geertz, Clifford. "Thick Description: Toward an Interpretive Theory of Culture." In *The Interpretation of Cultures*, edited by Clifford Geertz, 3–30. New York: Basic Books, 1973.

Goldsmith, David A. *The Documentary Makers: Interviews with 15 of the Best in the Business*. East Sussex, UK: Sheridan House, 2003.

Handling, Piers. "The Diary Films of Mike Rubbo." *Cinema Canada*, October 1977, 32–39.

———. "The Diary Films of Michael Rubbo." In Take Two: A Tribute to Film in Canada, edited by Seth Feldman, 205–216. Toronto: Irwin, 1984.

Harcourt, Peter. "The Innocent Eye." *Sight & Sound*, 34, no.1 (Winter 1965): 19–23.

Hartley, John. "Problems of expertise and scalability in self-made media." In *Digital Storytelling, Mediatized Stories: Self-representations in New Media*, edited by Knut Lundby, 192–212. New York: Peter Lang, 2008.

Hughes, John. "Michael Rubbo: Hiding Behind the 'I'."*Cinema Papers*, January-February 1981, 41–45, 81.

"Jean Rouch Interviewed by James Blue." In *Imagining Reality: The Faber Book of Documentary*, edited by Kevin MacDonald and Mark Cousins, 268–270. Boston: Faber and Faber, 1998.

Jones, D. B. *The Best Butler in the Business: Tom Daly of the National Film Board of Canada*. Toronto: University of Toronto, 1996.

———. *Movies and Memoranda: An Interpretive History of the National Film Board of Canada*. Ottawa: Deneau, 1981.

———. "On Rubbo: The Man in the Picture." *Lumiere*, April 1973, 8–15.

Kauffmann, Stanley. "On Films: Examined Lives." *The New Republic Online*, 25 February 2002. https://newrepublic.com/article/66143/examined-lives.

Lévesque, René. *An Option for Quebec*. Toronto: McClelland and Stewart, 1968.

McFarlane, Brian, Geoff Mayer, and Ina Bertrand, eds. *The Oxford Companion to Australian Film*. Oxford: Oxford University Press, 2000.

National Film Board of Canada. *Michael Rubbo: The Man and His Films* (pamphlet). Montreal: NFB, n.d.

Nicks, Joan. "The Documentary of Displaced Persona: Michael Rubbo's Daisy: The Story of a Facelift." In Documenting the Documentary, edited by Barry K. Grant and Jeannette Sloniowski, 302–317. Detroit: Wayne State University Press, 1998.

Nichols, Bill. *Introduction to Documentary*. Bloomington: Indiana University Press, 2001.

———. *Representing Reality: Issues and Concepts in Documentary*. Bloomington: Indiana University Press, 1991.

Poliquin, Daniel. *René Lévesque*. Toronto: Penguin Canada, 2009.

Rosenthal, Alan. "Sad Song of Yellow Skin and Waiting for Fidel: Interview with Michael Rubbo." In *The Documentary Conscience: A Casebook in Film Making*, edited by Alan Rosenthal, 232–244. Berkeley: University of California Press, 1980.

Rubbo, Michael. "Love and Life in Children's Films." *Take One* 1, no.7 (1967): 20–22.

———. "Remembering Tom." *Point of View Magazine*, Winter 2011, n.p.

Saunders, Dave. *Documentary*. New York: Routledge, 2010.

Index